PRAISE FOR
Write Away

"A useful book for the novice writer. . . . Both aspiring writers and fans of George's novels should enjoy the author's insights into the creative process."
—*Publishers Weekly*

"An impressively thorough and down-to-earth guide . . . a perfect do-it-yourself guide for the determined new novelist."
—*Sunday Times* (London)

"Elizabeth George knows her stuff. How well she knows it is readily apparent in *Write Away*."
—Bookreporter.com

"An inclusive and enlightening examination of George's thoughts on the craft of writing."
—*Seattle Post-Intelligencer*

"You should buy the book to learn her novel-writing specifics. They're there in spades."
—*Orange County Register*

"Ms. George breaks down the elements of a mystery novel with such clarity. . . . Even for a reader who doesn't dream of writing, it is useful to understand this principle because it will enhance the reading experience of good books and enable you to recognize more easily what is wrong with the bad ones."
—*New York Sun*

Figge Photography

About the Author

ELIZABETH GEORGE is the *New York Times* and international bestselling author of thirteen novels of psychological suspense set in England, and is the recipient of literary awards from France, Germany, and the United States. She lives in Huntington Beach, California, and in London.

WRITE AWAY

One Novelist's Approach to Fiction and the Writing Life

ELIZABETH GEORGE

HARPER

NEW YORK · LONDON · TORONTO · SYDNEY

For Tom and Dannielle,
Making many things possible

HARPER

A hardcover edition of this book was published in 2004 by HarperCollins Publishers.

HarperCollins books may be purchased for educational, business, or sales promotional use. For information, please e-mail the Special Markets Department at SPsales@harpercollins.com.

FIRST PERENNIAL CURRENTS EDITION PUBLISHED 2005.

An extension of this copyright page follows page 270.

Designed by Joseph Rutt

All photographs courtesy of the author

The Library of Congress has catalogued the hardcover edition as follows:

George, Elizabeth.
Write away : one novelist's approach to fiction and the writing life /
Elizabeth George.—1st ed.
p. cm.
ISBN 0-06-056042-8 (alk. paper)
I. Fiction—Authorship. I. Title.

PN3355.G36 2004
808.3—dc21 2003050946

ISBN 0-06-056044-4 (pbk.)

HB 12.18.2019

Contents

PART III. TECHNIQUE

PART IV. PROCESS

PART V. EXAMPLES AND GUIDES

Preface

I find it both fascinating and disconcerting when I discover yet another person who believes that writing can't be taught. Frankly, I don't understand this point of view.

I've long believed that there are two distinct but equally important halves to the writing process: One of these is related to art; the other is related to craft. Obviously, art cannot be taught. No one can give another human being the soul of an artist, the sensibility of a writer, or the passion to put words on paper that is the gift and the curse of those who fashion poetry and prose. But it's ludicrous to suggest and short-sighted to believe that the fundamentals of fiction can't be taught.

To believe this is akin to believing that *no* artistic medium can be taught. And to believe *that* is to believe that no artistic medium has tools and techniques, which the practitioner learns and then hones before she takes the leap from craft into art. Yet those who argue that writing can't be taught would probably be the first to agree that the basic principles of sculpture, oil painting, water color, musical composition, and so forth, ought to be dipped into before someone thinks herself a great master in any of those fields. Those very same people would also agree that everyone from Michelangelo to Johann Sebastian Bach probably had a bit of schooling in the field in which he excelled.

So, frankly, is the case for writing. Yet for some reason, this logic tends to be thrown out the window when it comes to the novel, to the poem, to the short story. It is indeed so much the case that I've discovered in my book-related travels over the past fifteen years entire countries where

people honestly believe that writing is a mysterious process that you either understand intuitively or do not.

We're lucky in the United States. Our tradition is that writers have long passed their craft along to other writers. For this reason, the novel, the poem, and the short story remain vital parts of our expanding literary tradition. Writing is no dying art form in America because most published writers here accept the wisdom and the necessity of encouraging the talent that follows in their footsteps. Saul Bellow, Philip Roth, Toni Morrison, Maya Angelou, Joyce Carol Oates, John Irving, Wallace Stegner, Michael Dorris, Ron Carlson, Thomas Kenneally, Oakley Hall . . . these are just a few of the writers who are or have been teachers as well. Their presence in the classroom demystifies the process. They share what they know, and the craft is better and stronger for it.

Craft is the point. Not art, which, as I've said, cannot be taught. Nor passion, which cannot be taught. Nor discipline, which is essential but which, alas, also cannot be taught. Pure craft will, of course, not make someone Shakespeare. It won't make someone William Faulkner or Jane Austen. But it can and will serve as a guide, as the soil in which a budding writer can plant the seed of her idea in order to nurture it into a story.

That, then, is the purpose of this book. As a teacher of writing for a number of years, I believe in the mastery of craft. More than that, I believe that an understanding of craft is essential for most writers. A thorough knowledge of the tools of our trade is what gives us something to turn to when we run into difficulties. Without this knowledge, we are at the mercy of a Muse who may turn fickle at the very moment when we're desperately depending upon her fidelity. Craft won't solve every problem a writer runs into during the creation of a piece. But it will eliminate a score of difficulties that the unschooled writer faces without it.

Although parts of my take on craft will be identical to that of other writers, much of it will be different. This is because each of us puts her own spin on the basic knowledge we've gathered over the years. I can only tell you what I believe, what I do, and what the result is. In short, I can only reveal my process to you and encourage you to develop your own.

But make no mistake about it. Developing a process means learning a craft because process itself *comes* from craft.

As for the art of writing . . . that is the mystery.

The art of writing is all about the inspiration of the moment and the excitement of riding the wave of an idea.

The art of writing is what you get to do once you become familiar with the craft.

PART I

AN OVERVIEW OF THE CRAFT

I

◆◆◆

Story Is Character

Am I kidding myself about being a "creative artist"? Can I possibly be a creative artist if I approach this effort in so methodical and left-brained a fashion?

Journal of a Novel,
June 25, 1997

A large piece of Plexiglas covers the top of my desk. Beneath this shield, I keep bits and pieces to serve as inspiration or to cheer me up in those moments of bleak despair when I'm wondering why I've taken on one difficult project or another. Among these items I have a copy of John Steinbeck's letter to Herbert Sturz on the subject of *The Grapes of Wrath*—I find his comments about critics particularly smile-producing—as well as pictures of my dog, of myself grinning inanely alongside a wax effigy of Richard III from Madame Tussaud's waxworks in London, and several quotations from writers on one subject or another. One of those writers is Isaac Bashevis Singer who, in an interview with Richard Burgis in 1978, said the following:

> When people come together—let's say they come to a little party or something—you always hear them discuss character. They will say this one has a bad character, this one has a good character, this one is a fool, this one is a miser. Gossip makes the conversation. They all analyze character. It seems that the analysis of character is the highest human entertainment. And literature does it, unlike gossip, without mentioning real names.

The writers who don't discuss character but problems—social problems or any problems—take away from literature its very essence. They stop being entertaining. We, for some reason, always love to discuss and discover character. This is because each character is different and human character is the greatest of puzzles.

That's where I want to begin, then, in laying the foundation for my exploration of craft: with character.

Not with idea? you may ask, aghast. Not with where a writer *gets* ideas? What a writer *does* with ideas? How a writer molds ideas into prose?

We will get to that. But if you don't understand that story is character and not just idea, you will not be able to breathe life into even the most intriguing flash of inspiration.

What we take away from our reading of a good novel mainly is the memory of character. This is because events—both in real life and in fiction—take on greater meaning once we know the people who are involved in them. Put a human face on a disaster and you touch people more deeply; you may even move them inexorably toward taking an action they might have only idly contemplated before that disaster was given a human face. Munich '72, the *Achille Lauro,* Pan Am 103, Oklahoma City, 9/11 . . . When these tragedies become human by connecting them to the real people who lived through them or died in them, they become imprinted indelibly on the collective consciousness of a society. We start with an event as news, but we almost immediately begin asking Who? about it.

It's no different with fiction. The trial of Tom Robinson is maddening, disturbing, and heartbreaking in its injustice, but we remember the trial long after it's over because of Tom Robinson's quiet dignity and because of Atticus Finch's heroic representation of the man, knowing all along that his client is doomed because of the time, the place, and the society in which they both live. *To Kill a Mockingbird* thus rises to the level of timeless, classic literature not because of its idea—the innocence of childhood set into an ugly landscape of prejudice and brutality—but because of its characters. This is true of every great book, and the names of those men, women, and children shine more brightly in the firmament of literary history than do

the stories in which they operated. Elizabeth Bennet and Mr. Darcy, Jem and Scout Finch, Captain Ahab, Hester Prynne, Sherlock Holmes, Heathcliff, Ebenezer Scrooge, Huckleberry Finn, Jack-Ralph-and-Piggy, Hercule Poirot, Inspector Morse, George Smiley, Anne Shirley, Laura Ingalls... The list can stretch from here to forever. With the exception of the last, not a single character is a real person. Yet all of them are, because the writers made them so.

Once we have begun it, we continue reading a novel largely because we care about what happens to the characters. But for us actually to care about these actors in the drama on those printed pages, they must become real people to us. An event alone cannot hold a story together. Nor can a series of events. Only characters *effecting* events and events *affecting* characters can do that.

I try to keep some basic guidelines in mind when I'm creating my characters. First, I try to remember that real people have flaws. We're all works in progress on planet Earth, and not one of us possesses physical, emotional, spiritual, and psychological perfection. This should be true of our characters as well. No one wants to read about perfect characters. Since no reader is perfect, there is nothing more disagreeable than spending free time immersed in a story about an individual who leaps tall buildings of emotion, psyche, body, and spirit in a single bound. Would anyone want a person like that as a friend, tediously perfect in every way? Probably not. Thus, a character possessing perfection in one area should possess imperfection in another area.

Sir Arthur Conan Doyle understood this, which is one of the reasons that his Sherlock Holmes has stood the test of time for more than one hundred years and counting. Holmes has the perfect intellect. The man is a virtual machine of cogitation. But he's an emotional black hole incapable of a sustained relationship with anyone except Dr. Watson, and on top of that, he abuses drugs. He has a series of rather quirky habits, and he's unbearably supercilious. As a character "package," he emerges unforgettably from the pages of Conan Doyle's stories. Consequently, it's difficult to believe that any reader of works written in English might *not* know who Sherlock Holmes is.

As individuals we're all riddled with issues of self-doubt in one area or another. This is the great commonality of mankind. So in literature, we want to see characters who make mistakes, who have lapses of

judgment, who experience weakness from time to time, and this is the second of the guidelines I try to remember when I'm creating a character.

As an example, consider the poor narrator in *Rebecca*. Here's a girl who is incapable of seeing her own appeal to the rich and brooding Maxim de Winter. She goes through life terrified of causing offense, so much so that when she breaks a figurine in her own home, she hides it in the drawer of a desk lest she get in trouble for having knocked it over! We cringe when she does this. But we also empathize with her humanity because we've all had moments when we've doubted who and what we are, when we've wondered if we could truly be lovable to another person. We identify with this narrator and we care about her, so when she finally says to the nasty Mrs. Danvers—housekeeper of Manderley and flamekeeper of Rebecca's memory—"*I* am Mrs. de Winter now," we want to cheer as she comes into her own. Of course, Manderley burns to the ground and that's too bad. But the characters continue to live.

They do this because, if the novel is well written, they have grown and changed during the course of the story, and this is the third guideline I try to keep in mind. Characters learn something from the unfolding events, and the reader learns something, too, as a character is revealed slowly by the writer, who peels away a layer at a time.

What the writer knows as she does this is that characters are interesting in their conflict, their misery, their unhappiness, and their confusion. They are not, alas, interesting in their joy and security. The first gives them a pit out of which they climb during the course of a novel. The second robs them of story.

If you're wondering about the truth of any of this, consider the following set of characters as they were revealed to me in a writing class that I taught a number of years ago.

One of my students was creating a private investigator who would work in Boston. She brought in her first ten or fifteen pages for the class to evaluate. In these pages we met the PI, his sister, their mother, and their stepfather. The PI was from a large Irish family. His sister worked for him. He and his sister got along well; they were practically best friends, and they loved each other to pieces. On the night in ques-

tion as the novel opens, the PI and his sister—loving each other to pieces—are going over to their mother's house for St. Patrick's Day dinner. They adore their mother and wouldn't miss a St. Patrick's Day dinner for all the corned beef and cabbage in County Clare. Plus, their mother is a superb cook, the best cook ever, in fact. Their childhood memories are filled with meals eaten around that old kitchen table, the joy of familial conversation buzzing in the fragrant room. So they go over to their mom's house, and the first person they see is their step-father. He's a wonderful man. They worship him. He made their childhood bliss. He married their mom when she was widowed and nothing could have pleased them more . . .

At this point in the chapter, one was praying for *someone* to come along and put all of these characters out of the reader's misery. Why? Because there was no conflict. There was nothing but happiness, joy, and familial bliss. Alas. There was no story.

So the basic guidelines in creating characters should be: Give them flaws, allow them to doubt themselves about *something*, see to it that they grow and change, and make certain you are putting them into conflict. Once you have committed yourself to following those guidelines, you can begin designing the characters themselves.

Note, I use the word *design*. For you are both the master architect and the general contractor here, and this is the most creative part of the entire novel-writing process, save for your manipulation of language.

When I'm designing a character, I begin with a name. To my way of thinking, it's impossible to create a character without one. The name I choose cannot be arbitrary, either. It's the first of the tools that I can use in revealing who and what my creation is, and silly is the writer who fails to recognize this and just slaps any old name on a character without realizing that name's import to the reader. Names can suggest just about anything to the reader. As Anne Bernays and Pamela Painter point out in their writing exercise book *What If,* names can suggest traits of personality (Ebenezer Scrooge, Uriah Heep, Roger Chillingsworth, Mr. Knightley). They can suggest social and ethnic background (Captain Ross Poldark, Tom Joad, Mrs. van Hopper, Maxim de Winter, Winston Nkata). They can suggest geography (Hank will be on a ranch, probably not at Harvard), attitude, or even events that are

yet to happen in the story.[1] Names influence how a reader will feel about a character. They also make it easier for the writer to create a character.

Consider the following, taken from the annals of my own literary history. When I was writing *In the Presence of the Enemy*, I created a very hard-edged and determined career woman whom I called Eve Bowen. To me that was a nice, hard, assertive name. A no-nonsense name. I had no trouble working with it to bring the character Eve Bowen to life. Set against her would be her husband. I wanted him to be her equal, a man capable of going *mano a mano* with her, a man not intimidated by her successful political career. He would be tough, a successful entrepreneur who grew up in Newcastle of a working-class family and essentially reinvented himself. He would brook no nonsense. He would not suffer fools.

So I began with his name. I called him Leo Swann. Then I sat and stared at my computer screen for a good twenty minutes, unable to write a thing about him until I realized that I'd given him the wrong name, that a character called Leo Swann could not be as I wanted this man to be. Once I changed his name to Alexander Stone—Alex Stone—I could work with him. That name suggested strength to me; it suggested determination and a refusal to be cowed. Leo Swann did not. And, more important, I did not believe Leo Swann would suggest that to a reader.

Once I have the name of the character, I create an analysis of that character, something that I will explore in more depth later. Suffice it to say now that the analysis begins with a basic list of facts about a character, which soon expands to a full report. In this report, I become the character's psychiatrist, psychoanalyst, probation officer, and biographer because I know that the more I know about my characters *before* I write the novel itself, the easier it will be to make each of them distinct and to give each of them a voice unlike any other character's voice.

The purpose of doing this work in advance of what seems like the "fun stuff" of writing the novel itself rests with my belief that you cannot bring a character to life in a book unless he or she is alive *before* the book begins. If I don't know a character before I place him into the crucible of the plot, I run the risk of either not knowing how that char-

acter is going to react to what happens or—just as bad—falling back on same-old, same-old to illustrate that reaction. The truth of the matter is that we all react to the circumstances of our lives differently. So should characters.

This is doubly true for how we speak, and the creation of characters allows me to understand how that character will talk—what his actual dialogue will be like—as well as how that character's narrative voice will sound if I choose to put a scene in his point of view. The words a character uses, the syntax he employs, and his diction thus become another tool to reveal character to the reader. A character's dialogue will illustrate not only his opinions and his personality, it can display his educational level, his economic background, his attitudes (one of the key elements of characterization), his beliefs, his superstitions, his pathology, and just about anything else. But it *can't* display any of this if I don't know what the "this" is in the first place because I haven't created him prior to putting words in his mouth.

If character is story, then dialogue is character. Take a look at the following abbreviated scene from Harper Lee's *To Kill a Mockingbird*.

"Are you the father of Mayella Ewell?" was the next question.

"Well, if I ain't I can't do nothing about it now, her ma's dead," was the answer.

Judge Taylor stirred. He turned slowly in his swivel chair and looked benignly at the witness. "Are you the father of Mayella Ewell?" he asked, in a way that made the laughter below us stop suddenly.

"Yes sir," Mr. Ewell said meekly.

Judge Taylor went on in tones of good will: "This the first time you've ever been in court? I don't recall ever seeing you here." At the witness's affirmative nod he continued, "Well, let's get something straight. There will be no more audibly obscene speculations on any subject from anybody in this courtroom as long as I'm sitting here. Do you understand?"

Mr. Ewell nodded, but I don't think he did. Judge Taylor sighed and said, "All right, Mr. Gilmer?"

"Thank you, sir. Mr. Ewell, would you tell us in your own

words what happened on the evening of November twenty-first, please?"

Jem grinned and pushed his hair back. Just-in-your-own words was Mr. Gilmer's trademark. We often wondered who else's words Mr. Gilmer was afraid his witness might employ.

"Well, the night of November twenty-one I was comin' in from the woods with a load o'kindlin' and just as I got to the fence I heard Mayella screamin' like a stuck hog inside the house—"

Here Judge Taylor glanced sharply at the witness and must have decided his speculations devoid of evil intent, for he subsided sleepily.

"What time was it, Mr. Ewell?"

"Just 'fore sundown. Well, I was sayin' Mayella was screamin' fit to beat Jesus—" another glance from the bench silenced Mr. Ewell.

"Yes? She was screaming?" said Mr. Gilmer.

Mr. Ewell looked confusedly at the judge. "Well, Mayella was raisin' this holy racket so I dropped m'load and run as fast as I could but I run into th' fence, but when I got distangled I run up to th' window and I seen—" Mr. Ewell's face grew scarlet. He stood up and pointed his finger at Tom Robinson. "—I seen that black nigger yonder ruttin' on my Mayella!"

So serene was Judge Taylor's court, that he had few occasions to use his gavel, but he hammered fully five minutes. Atticus was on his feet at the bench saying something to him, Mr. Heck Tate as first officer of the county stood in the middle aisle quelling the packed courtroom. Behind us, there was an angry muffled groan from the colored people.

Reverend Sykes leaned across Dill and me, pulling at Jem's elbow. "Mr. Jem," he said, "you better take Miss Jean Louise home. Mr. Jem, you hear me?"

Jem turned his head. "Scout, go home. Dill, you'n' Scout go home."

"You gotta make me first," I said, remembering Atticus's blessed dictum.

Jem scowled furiously at me, then said to Reverend Sykes, "I think it's okay, Reverend, she doesn't understand it."

I was mortally offended. "I most certainly do, I c'n understand anything you can."

"Aw hush. She doesn't understand it, Reverend, she ain't nine yet."

Reverend Sykes's black eyes were anxious. "Mr. Finch know you all are here? This ain't fit for Miss Jean Louise or you boys either."

Jem shook his head. "He can't see us this far away. It's all right, Reverend."

I knew Jem would win, because I knew nothing could make him leave now. Dill and I were safe, for a while: Atticus could see us from where he was, if he looked.

As Judge Taylor banged his gavel, Mr. Ewell was sitting smugly in the witness chair, surveying his handiwork. With one phrase he had turned happy picnickers into a sulky, tense, murmuring crowd, being slowly hypnotized by gavel taps lessening in intensity until the only sound in the courtroom was a dim pink-pink-pink: the judge might have been rapping the bench with a pencil.

In possession of his court once more, Judge Taylor leaned back in his chair. He looked suddenly weary; his age was showing, and I thought about what Atticus had said—he and Mrs. Taylor didn't kiss much—he must have been nearly seventy.

"There has been a request," Judge Taylor said, "that this courtroom be cleared of spectators, or at least of women and children, a request that will be denied for the time being. People generally see what they look for, and hear what they listen for, and they have the right to subject their children to it, but I can assure you of one thing: you will receive what you see and hear in silence or you will leave this courtroom, but you won't leave it until the whole boiling of you come before me on contempt charges. Mr. Ewell, you will keep your testimony within the confines of Christian English usage, if that is possible. Proceed, Mr. Gilmer."[2]

What Lee does in these paragraphs is to paint a picture of Bob Ewell almost entirely through his dialogue: ignorant, racist, unwashed, uneducated, hateful, licentious . . . Set against him, we see the gentility of Reverend Sykes and the firm intelligence of Judge Taylor, also depicted through dialogue. We learn about these characters from their words, and the author never does anything but play out the scene, secure in her own knowledge of who these men are and what they stand for. This is what we all aspire to with our dialogue: to wield it as a means of banishing doubt from the reader's mind.

But there are other tools to use as well to bring a character to life. If we take the opportunity (only when it's available) to relate something about the character's past, we are expanding the reader's understanding of character. Look at how Toni Morrison reveals the vulnerability of her main character, Sethe, from *Beloved,* utilizing two crucial and agonizing details of Sethe's past to do it.

124 WAS SPITEFUL. Full of a baby's venom. The women in the house knew it and so did the children. For years each put up with the spite in his own way, but by 1873 Sethe and her daughter Denver were its only victims. The grandmother, Baby Suggs, was dead, and the sons, Howard and Buglar, had run away by the time they were thirteen years old—as soon as merely looking in a mirror shattered it (that was the signal for Buglar); as soon as two tiny hand prints appeared in the cake (that was it for Howard). Neither boy waited to see more; another kettleful of chickpeas smoking in a heap on the floor; soda crackers crumbled and strewn in a line next to the doorsill. Nor did they wait for one of the relief periods: the weeks, months even, when nothing was disturbed. No. Each one fled at once—the moment the house committed what was for him the one insult not to be borne or witnessed a second time. Within two months, in the dead of winter, leaving their grandmother, Baby Suggs; Sethe, their mother; and their little sister, Denver, all by themselves in the gray and white house on Bluestone Road. It didn't have a number then, because Cincinnati didn't stretch that far. In fact, Ohio had been calling itself a state only seventy years when first one brother and

then the next stuffed quilt packing into his hat, snatched up his shoes, and crept away from the lively spite the house felt for them.

Baby Suggs didn't even raise her head. From her sickbed she heard them go but that wasn't the reason she lay still. It was a wonder to her that her grandsons had taken so long to realize that every house wasn't like the one on Bluestone Road. Suspended between the nastiness of life and the meanness of the dead, she couldn't get interested in leaving life or living it, let alone the fright of two creeping-off boys. Her past had been like her present—intolerable—and since she knew death was anything but forgetfulness, she used the little energy left her for pondering color.

"Bring a little lavender in, if you got any. Pink, if you don't."

And Sethe would oblige her with anything from fabric to her own tongue. Winter in Ohio was especially rough if you had an appetite for color. Sky provided the only drama, and counting on a Cincinnati horizon for life's principal joy was reckless indeed. So Sethe and the girl Denver did what they could, and what the house permitted, for her. Together they waged a perfunctory battle against the outrageous behavior of that place; against turned-over slop jars, smacks on the behind, and gusts of sour air. For they understood the source of the outrage as well as they knew the source of light.

Baby Suggs died shortly after the brothers left, with no interest whatsoever in their leave-taking or hers, and right afterward Sethe and Denver decided to end the persecution by calling forth the ghost that tried them so. Perhaps a conversation, they thought, an exchange of views or something would help. So they held hands and said, "Come on. Come on. You may as well just come on."

The sideboard took a step forward but nothing else did.

"Grandma Baby must be stopping it," said Denver. She was ten and still mad at Baby Suggs for dying.

Sethe opened her eyes. "I doubt that," she said.

"Then why don't it come?"

"You forgetting how little it is," said her mother. "She wasn't even two years old when she died. Too little to understand. Too little to talk much even."

"Maybe she don't want to understand," said Denver.

"Maybe. But if she'd only come, I could make it clear to her." Sethe released her daughter's hand and together they pushed the sideboard back against the wall. Outside a driver whipped his horse into the gallop local people felt necessary when they passed 124.

"For a baby she throws a powerful spell," said Denver.

"No more powerful than the way I loved her," Sethe answered and there it was again. The welcoming cool of unchiseled headstones; the one she selected to lean against on tiptoe, her knees wide open as any grave. Pink as a fingernail it was, and sprinkled with glittering chips. Ten minutes, he said. You got ten minutes I'll do it for free.

Ten minutes for seven letters. With another ten could she have gotten "Dearly" too? She had not thought to ask him and it bothered her still that it might have been possible—that for twenty minutes, a half hour, say, she could have had the whole thing, every word she heard the preacher say at the funeral (and all there was to say, surely) engraved on her baby's headstone: Dearly Beloved. But what she got, settled for, was the one word that mattered. She thought it would be enough, rutting among the headstones with the engraver, his young son looking on, the anger in his face so old; the appetite in it quite new. That should certainly be enough. Enough to answer one more preacher, one more abolitionist and a town full of disgust.

Counting on the stillness of her own soul, she had forgotten the other one: the soul of her baby girl. Who would have thought that a little old baby could harbor so much rage? Rutting among the stones under the eyes of the engraver's son was not enough. Not only did she have to live out her years in a house palsied by the baby's fury at having its throat cut, but those ten minutes she spent pressed up against dawn-colored stone studded with star chips, her knees wide open as the

grave, were longer than life, more alive, more pulsating than the baby blood that soaked her fingers like oil.[3]

Sethe's reflection on acquiring the tombstone—integral to the narrative, by the way, and not just plopped in there like the dread flashback, which is the bane of neophyte writers—puts us in touch with the profound pain at the heart of the character. She is detached from it, detached from the murder of her child, committed by her own hand. Her very distance from the horror of her past makes her vulnerable. More important, it makes her believable and unforgettable.

Once again, though, Toni Morrison could not have created this moment about Sethe had she herself not known that moment, had she herself not known her character well enough to understand that no matter what Morrison herself is like, the *character* she's writing about would be detached in this instance instead of angry. Or anything else.

Creating character in advance thus allows a novelist to write convincingly in the voice and of an experience totally unlike her own. Creating a character in advance allows a writer to adopt a persona, to dissolve the boundaries between herself and her creations, giving her the opportunity to become them and through that means to render their experiences.

Personality quirks and telling details fill in whatever blanks are left. Annie Wilkes's sudden fugue states in Stephen King's chilling and hilarious *Misery* combine with her bizarre choice of expletives ("You dirty birdie") to paint a portrait of madness that no reader is likely to forget. Mr. Bridge's reaction to the coming tornado in Evan Connell's masterful *Mrs. Bridge* along with his wife's bland cooperation with him says volumes more and with far more impact than any diatribe on the part of the author could have done. There the Bridges sit, determinedly eating their dinner in the country club restaurant as it's being evacuated and the tornado is bearing down on them, Mr. Bridge refusing even to address the topic of approaching death as he bolts down his meal and Mrs. Bridge oh-my-ing and tee-hee-ing along, completely impotent. This sort of writing comes from knowing who your characters are. Know who they are, and you know how they'll react. That will put you out of the reach of potential creative blockage.

So let me recap what I believe before we move on.

Character is story.

Dialogue is character.

Bringing a character to life depends upon prior and complete knowledge of that character followed by an understanding of dialogue's functions and the select use of telling details.

A lot to remember? Yes. But in this book I'll be telling you how I put all of that into practice.

2

<div align="center">⋘—⋙</div>

Setting Is Story

What on earth am I doing? That's the bottom line. And do I need to go back to England to walk through the places where the story occurs just to ground myself in it? Something tells me that I do.

<div align="right">Journal of a Novel,
May 10, 1994</div>

We're moving on to setting prior to any discussion of plot in our overview of craft because setting explored and used to its fullest is not only part of character, it can also be a key to plot. Ideas can come from setting if the writer gets herself out to explore the place she wishes to use in her novel. Likewise, setting can be yet another tool that illuminates everything from character to theme.

To make sure we're all on the same page, let me begin by defining this term. Simply put, setting is where the story will take place. Further, however, it is *each* of the separate locations in which the story's individual scenes will play out. Like all other tools of this craft, it has several functions.

The first and most obvious is to create atmosphere. Setting not only promotes the reader's understanding of what kind of novel he's reading, it also establishes a feeling that the reader takes into the experience. Setting triggers mood as well. And since one of the objectives of the writer is to stimulate emotional response on the part of the reader, setting is yet another tool that can be used to do this. Consider the setting description from one of the final chapters in my novel *For the Sake of Elena*. The book begins in the tenebrific fog of Cambridge, England, a miasma that rises from the fens that surround the city and reduces

everything to mere shape and shadow. Here in the end of the novel, the
fog returns.

> The fog lay heavily on the city the next morning, a grey
> blanket of mist that rose like a gas from the surrounding fens
> and billowed into the air in amorphous clouds that shrouded
> trees, buildings, roadways, and open land, changing everything
> from common and recognisable substance into mere shape.
> Cars, lorries, buses, and taxis inched their way along the damp
> pavements of the city streets. Bicyclists slowly swayed through
> the gloom. Pedestrians huddled into heavy coats and dodged
> the constant spattering of the drops of condensation that fell
> from rooflines, window ledges, and trees. The two days of
> wind and sunshine might never have existed. Fog had returned
> like a pestilence in the night. This was Cambridge weather
> with a vengeance.
> "Makes me feel like a case for the tubercular ward," Havers
> said. Encased in her pea-soup coat with its hood pulled up and
> a pink knit cap on her head for additional protection, she beat
> her hands against her upper arms and stamped her feet as they
> walked to Lynley's car. The heavy mist was creating a bead-
> work of damp on her clothing. Across her brow, her sandy
> fringe was beginning to curl as if exposed to steam. "No won-
> der Philby and Burgess went over to the Soviets while they
> were here," she continued darkly. "They were probably looking
> for a better climate."
> "Indeed," Lynley said. "Moscow in the winter. That's cer-
> tainly my idea of heaven on earth."[1]

The gloom of the earliest chapters in the novel—harbinger of the
confusion to come—descends once again. But this time it doesn't act as
a force for misdirection (the killer eliminates Georgina Higgins-Hart
thinking she is Rosalind Summers, an error made because of the earlier
fog in the book). Rather, it serves as backdrop of despair against which
the last moments of the drama play out.

That's the most obvious use of setting, the sort of use you always

hear about in your comparative lit courses: setting as metaphor. But it also can be used to reveal character.

Whatever else you might think, you *are* what you wear, what you collect, what you read, etc. You *are* the environment in which you live and work. So it is for your characters. Their individual settings thus can be used to tell readers volumes, without the writer having to say a single thing directly. This is the very essence of what writing instructors mean when they say, "Show, don't tell." Through a character's environment, you show who he is. Everything else is interpreted by the reader.

Consider the masterful way in which Michael Dorris and Louise Erdrich use setting to reveal a character's personality in this brief section from their novel *The Crown of Columbus*.

I drove past the house, slowly but without stopping. Every light downstairs was on and I caught a glimpse of Roger through a window. He was walking into the kitchen carrying what looked like the Sunday *New York Times*. I circled the block and paused at the corner of his street. I called myself every kind of fool—first, for coming at all, and second, for my indecision once I was here. I made a contract with my future. If Roger did not come out of the kitchen I would go home, write him a postcard with my apologies, and get on with my life. I would leave him in the hands of his Book Review and Arts & Leisure and Week in Review and get a grip on my emotions. I would stop at Ben & Jerry's and treat myself to a fattening double chocolate milkshake. I would challenge Grandma to a tournament of silent cribbage, and win for once. I would write the damn Columbus article, then graduate to something less predictable.

The front door was open. Roger was silhouetted, turned in the direction I would come. He waved.

I honked my horn, and stalled.

But really, who could resist this Roger Williams? What did he have to eat, stored in the refrigerator in case I called? Not just Brie. *Danish* Brie. And on the stereo? Not his usual Bach

but the vintage Aretha Franklin record I gave him for his birthday, with the volume turned up to my preferred level.

This was a man screaming "compromise."

Violet, on the other hand, was simply screaming, from the moment I unhooked the safety belt around her car seat and brought her into her father's house. With her eyes squeezed shut, her back arched, her mouth wide, she was pure protest, a raging fury, Old Testament in her wrath. I rocked her against my breast, hummed into her ear, even in desperation gently pried open the muscular lid of her right eye so that she could see it was me—familiar food source—at whom she railed. This intrusion of reality, however, only increased her hysteria.

"It's not you," I consoled Roger, who looked stricken. This was clearly not the meeting that he had imagined with the fruit of his loins.

"What, then?" he demanded above Violet's din.

"The lack of motion," I explained. "She likes the car, the motor rumbling underneath. She hates being still. Give me a minute with her. She's overstimulated."

Nash had been a sensitive baby too, reacting with alarm to all unexpected sound or light or touch. The only thing that worked with him had been total sensory deprivation, a quick-fix return to the womb. Now, standing in the brilliantly illuminated foyer of Roger's house, even I felt overwhelmed. The polished blond wood floors reflected the laser beams of the futuristic chandelier. An Azerbaijani rug on the facing white wall throbbed with dark reds and blacks. Aretha demanded respect, and there was the distinct tang of sautéed garlic and onions in the air.

"I'll just be a moment," I shouted, and disappeared into the hall closet. With the door closed, the sounds and smells and eye-popping illumination of Roger's world were muted by the soft brush of good wool. Coats of all kinds hung from expensive wooden hangers, thickly layered and faintly musty. Despite the dark I could sense neatness, order. A gulf of habit separated Roger's existence from my own. Even Tupperware

hadn't helped me. There was no closet in my house in which Violet and I could fit, much less stand upright, without disrupting chaos, without tipping balanced stacks of partially read magazines or stumbling over unmatched shoes. Roger knew the precise location of everything he owned. Nothing broken of his was left unfixed overnight. Unwanted gifts he returned for store credit, old items of apparel he bundled and had collected by the Goodwill, and since Roger never purchased anything on impulse, he used whatever he bought.

Violet was calming by degrees, like a kite descending to earth after a strong blow, and I took the opportunity to prepare myself. The enclosed space of the closet was, compared to what awaited me, a relief. Roger had completely gutted his eighteenth-century house, knocked out all the downstairs walls and created an open arena disrupted only by shoulder-high shelves and furniture that was made to be viewed from all sides. An inverted garden of copper pots hung above his island stove, and the color scheme of his upholstery and throw rugs and metal-framed prints was a descending spectrum, dark to light, from front door to back. There were no extraneous objects, no misplaced books. If the current issue of the *American Scholar* or *Daedalus* or *Caliban* lay across the glass coffee table at an odd angle, it was a sure bet that Roger had a new poem or article in print.

"Shh," I murmured to Violet. "Be nice for Daddy. He's not used to crazies." Her face was more relaxed now, but still wary. One false move on my part, one break in the rhythm of the swinging cradle of my arms, and I would pay.[2]

By the end of this introduction to Roger's house, we know much about the man himself. We also learn about the narrator and, through her reaction to Roger's personal environment—his "space," if you will—we learn about the nature of their relationship. We can make certain predictions about how things will go for them. We can make certain assumptions about how things have gone for them in the past. By giving Roger a setting that is in no way generic, by taking the time to think through what his individual environment would be like,

Dorris and Erdrich have made their job simpler than it otherwise would be if they had decided to rely upon tedious exposition to do what setting did expeditiously.

Finally, setting can act as a contrast to the event that occurred within it. Doing this, the writer can heighten the emotional reaction he wishes to evoke in the reader. In her novel *A Taste for Death,* for example, P. D. James places a gruesome double murder in the hushed vestry of a church. Her powers of description give us the church itself first, through the reverential eyes of the elderly woman who's come to clean the lady chapel. With her we enter a world in opposition to this one: two bodies with their throats slit and blood. Everywhere. Lots of blood.

Similarly, T. Jefferson Parker deftly contrasts his setting with the horror contained within it in *Laguna Heat.* Instead of using the familiar elements of Christian worship as P. D. James did, he chooses something quite simple: white.

> The stairway carpet changed from green to white where it began its rise to the third story. Shephard felt a quick flicker of vertigo when he reached the final floor: the relentless white skewed his sense of balance. He called again.
>
> The third floor was as vast as it was colorless. The white carpet opened before him to a capacious anteroom whose walls, furniture, even fireplace, were crisp white. Unlike the downstairs rooms, the anteroom stood bleached in sunlight, which entered two west-facing windows unobstructed by shades or curtains and parceled itself into bright rhomboids on the carpet. Shephard noted again, as he had as a child, that in shafts of sunlight dust settles upward rather than the more logical down. He crossed the pristine carpet to a set of double doors, white, at the far end. Swinging them open he found still more of the pale carpet, expanding before him into the master bedroom.
>
> Shephard thought it was the brightest room he'd ever seen. A cream-colored settee was backed against the wall to his left, over which hung a mirror framed in white that reflected more white from across the room. In the center stood a king-sized

bed that seemed magnified by its lack of color. Shephard suffered the momentary illusion that everything was made of plaster. When he pressed his hand against the bed, the soft texture felt incongruous.

He stood in the bathroom doorway, faced with a full-length reflection of himself. The mirrored partition gave way on the right to a large vanity area consisting of two sinks fitted with white porcelain fixtures, a mirror that ran the length of the wall in front of the sinks, a white wooden chest fastened to the far wall beside a toilet, and a sparkling bidet. He turned back to the bathroom entrance, moved past the entryway mirror again, and found himself in a similar room: white walls, white tile.

But rather than a toilet and bidet, along the far wall was a bathtub, and Shephard's first reaction when he looked at it was, Well, my sweet God Jesus, there is something that isn't white.

Lying in the tub is something definitely not white.

He backed against the wall as a flood of sweat erupted along his back, and stepped back out to the bedroom. He stood watching the dust settle upward, breathing rapidly. . . .

The vortex of all the whiteness that spread around him was a naked woman. She was blackened so badly by fire that she seemed to have been reduced to some birdlike creature, a pterodactyl perhaps, with claws at the end of feeble wing-arms, a puffy underbelly, foreshortened legs that spread open obscenely and looked as if they could do little more than grasp a branch or fold flush to the body in flight. He saw a narrow face on which only the eye sockets and mouth were recognizable. One of the tiny hand-claws clutched the end of a shower curtain rod, which was blackened to its midway point. The shower curtain itself lay jammed into a white wicker wastebasket.

The discoverer of such secrets is always first aware of his own uselessness. And Shephard, much as he had done when he looked down at the sleeping mystery of Jane Algernon, looked down at this changed woman and wondered what to do. He wanted to cover her. He felt as if he should pray. He knew he should call other policemen to divvy up the problem: Pavlik to

the minutiae, Pincus to the press, Grimes to the crowd that would form outside and inquire shyly about the nature of the tragedy; Chief Hannover to the mayor, Lydia Worth and other officers to search the neighborhood fruitlessly, Robbins to remove the body, and Yee's dispassionate hands to interpret it. And he, the detective, to gather the essential from what the others found, fit the pieces together, discard the falsehoods, and approach the killer on his own.

Good Jesus Christ, he thought. What he really wanted to do was sleep. His legs weakened as he backed to the wall and eased himself down it, the Python clanging and spilling from his hand when it hit the tile.[3]

By placing his torched corpse within a world of white, he increases the horror of the situation, makes the detective's reaction to it believable, and most important, stimulates the reader to identify strongly with the protagonist.

So how should you choose a setting?

One piece of advice that neophyte writers are always given is "write about your own backyard." Loosely translated this means to write about an environment with which you are familiar. Broadly translated it means to write what you know.

To this I say balderdash. If I had believed that, I'd have spent years attempting to write about Huntington Beach, California, a place that could not interest me less as a setting. What I believe is that your setting should be a place that you want to know about, a place you are interested in exploring, a place you want to describe, a place that resonates with you, or a place that evokes a personal and intensely visceral response in you. It should also be a place that you can get to. Research in libraries, on films, and through the Internet will take you a great distance. But it's tough to make a place come to life unless you've been there and allowed your five senses to experience it. Writing about a place should involve *all* the sensory impressions you take from it, by the way, not just those you see (or read about on the Internet). You can try to fake the other sensory details, of course. But I hate doing that.

If you're lucky, the place in which you live is a place that resonates

with you. If that's the case and if you can remain alive to and aware of the details that make that place unique, you should certainly consider using it for a setting because you'll more than likely be able to *render* it and not merely *report* it.

That's what I attempt to do when I'm writing about a setting, whether it is the individual setting in which a character operates (his home, his office, his car, his backyard) or the broad setting in which the entire novel takes place. In rendering a setting, I rely on details, the most important of which is what Bernays and Painter aptly call the telling detail[4]: that single piece of information that contains within it a volume of *additional* information that can then go undocumented because the reader understands what it is intuitively the moment she sees it. Each of the details that I choose, however, is a detail that is concrete and not abstract. It attempts to make a statement; it *shows,* in other words.

To avoid merely reporting on a setting, to render it instead—which implies bringing it to life—the craftsman puts place into action, knowing that the best use of details comprises details in motion. Look at this common place rendered unforgettable by Barbara Kingsolver in *The Bean Trees.*

I had no intention of asking the dumb guy for help. The tire looked like it was done-for anyway so I drove on it for a few blocks. There were a bank, some houses, and a park with palm trees and some sick-looking grass. Some men with rolled-up blankets tied around their waists were kicking at the dirt, probably looking for bugs to step on. Just beyond the park I could see a stack of tires. "Will you look at that," I said. "I'm one lucky duck. We should have gone to Las Vegas."

The stacked-up tires made a kind of wall on both sides of a big paved corner lot. Inside the walls a woman was using an air hose to chase bugs off the pavement, herding them along with little blasts of air. She was wearing blue jeans and cowboy boots and a red bandana on her head. A long gray braid hung down the middle of her back.

"How do," I said. I noticed that the name of the place was Jesus Is Lord Used Tires. I remembered wanting to call 1-800-THE LORD, just to see who you'd get. Maybe this was it.

"Hi, darlin'," she said. "These bugs aggravate the dickens out of me after it rains, but I can't see my way clear to squashing them. A bug's just got one life to live, after all. Like us."

"I know what you mean," I said.

"Oh, bless your heart. Looks like you've got a couple of flats."

I did. I hadn't seen the rear on the right side.

"Drive it up onto the big jack," she ordered. "We'll get them off and have a look. We'll fix your little wagon right up."

I asked if Turtle could ride up on the jack, but she said it wasn't safe, so I took her out of the car and looked for a place to put her down. All those tires around made me nervous. Just out of instinct, more or less, I looked up to see if there was anything tall overhead to get thrown up onto. There was nothing but clear blue sky.

Off to one side there were some old wheel rims and flat tires. An empty tire couldn't possibly explode, I reasoned, so I sat Turtle down in one of those.

"What's your little girl's name?" the woman wanted to know, and when I told her she didn't bat an eye. Usually people would either get embarrassed or give me a lecture. She told me her name was Mattie.

"She's a cute little thing," Mattie said.

"How do you know she's a girl?" I wasn't lipping off, for once. Just curious. It's not as if I had her dressed in pink.

"Something about the face."

We rolled the tires over to a tub of water. Mattie rubbed Ivory soap on the treads and then dunked them in like big doughnuts. Little threads of bubbles streamed up like strings of glass beads. Lots of them. It looked like a whole jewelry store in there.

"I'm sorry to tell you, hon, these are bad. I can tell you right now these aren't going to hold a patch. They're shot through." She looked concerned. "See these places here along the rim? They're sliced." She ran her hand along the side of the tire under the water. She had a gold wedding band settled into

the flesh of her finger, the way older women's rings do when they never take them off.

"I'm sorry," she said again, and I could tell she really was. "There's a Goodyear place down the road about six blocks. If you want to roll them down there for a second opinion."

"That's okay," I said. "I'll take your word for it." Turtle was slapping at the side of her flat whitewall with one hand. The other had caught hold of the doohickey where the air goes in. I tried to think what in the world we were going to do now. "How much for new ones?" I asked.

Mattie considered for a minute. "I could give you a pair of good retreads, five thousand miles guaranteed, put on and balanced for sixty-five."

"I'll have to think on that one," I said. She was so nice I didn't want to tell her flat out that I couldn't afford new tires.

"It's too early in the morning for bad news," Mattie said. "I was just brewing up a pot of coffee. You want a cup of coffee? Come sit."

"Okay," I said. I collected Turtle out of the tire and carried her to the back of the shop. It was a big old two-story place, and there at the back of the garage was an area with a sink and some shelves, some folding chairs painted blue, a metal table, and a Mr. Coffee. I scooted another flat over next to the chairs and set Turtle down in it. I was glad to be away from that wall of tires, all of them bulging to burst. Hanging around here would be like living in a house made of bombs. The sound of the air hose alone gave me the willies.

"These come in pretty handy," I said, trying to be cheerful. "I know what I can use those two flat tires for."

"I've got some peanut-butter crackers," Mattie said, leaning over Turtle. "Will she eat peanut butter?"

"She eats anything. Just don't let her get hold of anything you don't want to part with. Like your hair," I said. Mattie's braid was swinging into the danger zone.

She poured coffee into a mug that said "BILL with a capital B," and handed it to me. She poured a cup for herself in a

white mug with cartoon rabbits all over it. They were piled all over each other like the rocks in Texas Canyon. After a minute I realized that the rabbits were having sex in about a trillion different positions. I couldn't figure this woman out. This was definitely not 1-800-THE LORD.[5]

Note how Kingsolver doesn't stop the action to describe the tire store. Both the description of the place and the description of the character are part of the narrative and don't interrupt the flow. Note also the individual details she's selected: the details of character that imprint Mattie indelibly in the reader's mind—that wedding ring sunk into her flesh—and the details of place that tell us something about the character—that questionable bunny mug.

This is setting used to its fullest. It's that commitment to place on the part of the writer that elevates what might be an ordinary scene in an ordinary place and makes it unforgettable.

3

Nothing Without Landscape

Sometimes my life seems so insular and safe. There seems nothing worthy in it from which I might draw deeper meanings for my books and my characters. What am I doing pretending to be a writer?

<div align="right">

Journal of a Novel,
May 24, 1994

</div>

On the surface, it would appear that landscape and setting are the same creatures, identical twins given different names just to confuse the beginning writer. This, however, would not be the truth since setting is where a story takes place—including where *each scene* takes place—while landscape is much broader than that.

Landscape in writing implies much the same as that which is implied by the word when it's used to refer to a location in a country: It's the broad vista into which the writer actually places the individual settings of the novel, sort of like the canvas or other medium onto which a painter has decided to daub color. As the media that the painter uses change, so do the effects achieved when paint is placed on them. So it is for landscape.

Since we're talking about a broad vista when we discuss landscape, we're also talking about not only the setting but also the emotions that are evoked by the setting. In John Steinbeck's *The Grapes of Wrath*, for example, the landscape is Dust Bowl America, a place with people on the move, attempting to escape the desolation and despair of their circumstances. The place mirrors the condition of the characters. William Faulker, on the other hand, uses a number of settings in his novels, but the landscape is generally Yoknapatawpha County in

Mississippi, which is hot and humid, teeming with the passions of life and death. Perhaps most easily put, then, landscape is the *total place experience* in a novel.

You need to think about the landscape of your book because if you're able to make the landscape of place real, you can make the land itself real, which gives you a leg up on making the entire novel real for the reader. In doing this, you essentially invite the reader to *own* the landscape because you show that you yourself already own it. If the reader owns the landscape, you are halfway home in your job as a writer since owning the landscape will promote both emotion and connection on the part of the reader. Emotion and connection are what it's all about, by the way. No one on earth keeps reading a story without feeling emotion and connection to some extent ... unless he's ordered to do so by his English teacher, of course. Even then, odds are he'll buy the Cliff's Notes if he's not feeling anything toward the material.

Let me give you an example of landscape from Martin Cruz Smith's fine novel *Rose*. *Rose* takes place during the Industrial Revolution, in an incredibly dismal English town called Wigan, in the heart of the Midlands, which was itself the heart of industry during the nineteenth century. Wigan as depicted by Martin Cruz Smith is the kind of place you don't even want to visit, let alone to live. It's dirty, claustrophobic, polluted, and disease-producing. In other words, it's hell on earth.

> The dark sky turned darker, not with clouds but with a more pungent ingredient. From the window, Blair saw what could have been the towering effluent plume of a volcano, except that there was no erupting volcanic cone, no mountain of any size, in fact, between the Pennines to the east and the sea to the west, nothing but swale and hill above the long tilt of underground carboniferous deposits. The smoke rose not from a single point but as a dark veil across the northern horizon, as if all the land thereafter was on fire. Only closer could a traveler tell that the horizon was an unbroken line of chimneys.
>
> Chimneys congregated around cotton mills, glassworks, iron foundries, chemical works, dye works, brick works. But

the most monumental chimneys were at the coal pits, as if the earth itself had been turned into one great factory. When Blake wrote of "dark Satanic mills," he meant chimneys.

The hour was almost dusk, but this darkness was premature. Even Earnshaw stared through the window with some awe. When enough chimneys had passed one by one, the sky turned the ashen gray of an eclipse. On either side private tracks connected pits to the canal ahead. Between the pall and the lines of steel lay Wigan, at first sight looking more like smoldering ruins rather than a town.

Coal was worked into the town itself, creating coal tips that were black hills of slag. On some, coal gas escaped as little flames that darted from peak to peak like blue imps. The train slowed along a pit as a cageload of miners reached the surface. Coated in coal dust, the men were almost invisible except for the safety lamps in their hands. The train slid past a tower topped by a headgear that, even in the subdued light, Blair saw was painted red. On the other side, figures crossed single file across the slag, taking a shortcut home. Blair caught them in profile. They wore pants and coal dust too, but they were women.

The track bridged the canal, over barges heaped with coal, then traveled by a gasworks and a rank of cotton mills, their high windows bright and the chimneys that drove their spinning machines spewing as much smoke as castles sacked and set ablaze. The locomotive slowed with its own blasts of steam. Tracks split off to goods sheds and yards. In the middle, like an island, was a platform with iron columns and hanging lamps. The train approached at a creep, gave a last convulsive shake and stopped.[1]

In *Rose,* what Martin Cruz Smith does is what every writer aspires to do with landscape. Realizing that he cannot address himself to landscape in a single paragraph, he works it in *throughout* his narrative, interweaving elements of it with the action for the length of the novel. He does it in such a way that he doesn't inhibit the forward movement of the plot. He's dealing with a complicated place, and he has the wisdom

and the experience to know that he can't just make a simple bow to setting in the opening chapters. Thus he doesn't lather up the initial moments of the book with descriptions of this godforsaken town, only to dismiss those descriptions out of hand as he trots along toward the finish line of the book. Instead, by dealing with the landscape of Wigan throughout the book, the author depicts the town as oppressive a place as it no doubt was to the people who lived there over one hundred years ago. More important, however, Wigan becomes as *real* to the reader as it was to its Victorian inhabitants.

Any reasonable student of writing would now ask how on earth a writer does this. How does *anyone* ever make a place come to life in such a way that it becomes an unforgettable part of the reading experience?

I can only answer by explaining how I develop landscape in my own books. What I generally do is begin by going to the place about which I'm intending to write. There, I consider the land itself. I ask myself what grows upon it and what does not. I note its shape and its texture. I note the marks that succeeding cultures have left upon it. I examine its buildings and how they alter from one area to another within the landscape.

The sky in each place is completely different from the sky anywhere else, and that doesn't escape me. Some skies have clouds; some do not. Some skies have deep color; some do not. The moisture in the air of the Highlands of Scotland makes the sky appear altogether different from the sky in Huntington Beach, California, while the sky of Los Angeles could not be more unlike the sky in Vancouver. And sky is part of what I consider when I think about landscape, as are the clouds, the stars, and the lack thereof.

The climate of a location is also part of landscape. So is the weather of an individual day. So are the sounds and the scents of a place.

Wildlife or the lack of wildlife helps define a place. What people do there or are not able to do there brings a place to life, too.

No matter what type of novel you are writing, the emerging landscape of the place in which the story is set should stimulate the reader's senses and his imagination, no matter the level of the book: children's literature, young adult literature, or adult literature. If you doubt this, read Laura Ingalls Wilder's *Little House* books. Or experience the Prince

Edward Island that L. M. Montgomery portrays in the *Anne of Green Gables* books. A good writer *makes* a place her own, whether it's the entirely imaginary world of Frank Herbert's *Dune* or the extremely real world of Tony Hillerman's American Southwest. By the end of a novel in which the author deftly handles landscape, the reader feels as if he has been there and has experienced the location firsthand.

Beyond this location, which we hope is skillfully depicted by the writer, however, landscape applies to characters as well. This is because every character a writer creates actually possesses his *own* individual landscapes. And that wasn't a typographical error you just saw. I am indeed talking about landscapes in the plural. Each character you create has two.

Every person we know has an external landscape of person. Superficially applied to a character in a novel, this means that every person you write about *looks* a certain way and operates in a certain environment. What a character looks like, how he dresses, the house in which he lives, his office, his car, his bicycle, his boat, his apartment, his cubicle at work, his bumper sticker, his political button . . . all of these are part of his landscape of person, so all of these are capable of passing along information to the reader. The wise writer employs them, knowing that doing so adds to characterization as it simultaneously promotes a connection between the reader and the character.

Landscape of person brings characters to life in an efficient manner. It is the very epitome of *showing* something about a character instead of *telling* it outright. When you show something rather than tell it, you imprint an impression of a character in the reader's mind. It may not be exactly what you wish to imprint. But showing imprints something, at least, whereas telling imprints nothing at all.

The simplest way to achieve landscape of person is to use *specific and telling details*. These are details with a message attached to them, the kinds of details that no reader forgets. They fix within the reader's mind the sort of character the writer is creating.

My favorite use of telling details to create external landscape of character comes from Michael Dorris's fine book *A Yellow Raft in Blue Water*. In the following scene, Dorris introduces the reader to Aunt Ida though the eyes of her granddaughter, who's coming to visit with her mother.

As soon as we clear the top of the ridge, Aunt Ida comes into view. Her house, its boards warped and turned gray by too much weather, is the only structure you can see in any direction, and Aunt Ida is in front of it. She's not an unusually tall woman, but her arms and legs are long. A black bouffant wig is tacked to her head by bobby pins that shine in the sunlight, and beneath men's bib overalls, a dark blue bra dents deeply into her back and shoulders. Her skin is a darker brown than Mom's, though not as deep as Dad's or mine. Behind her sunglasses, her eyes are invisible.

Aunt Ida is pushing an old lawn mower back and forth across a plot of scrub grass. As we get closer I can see that it's not doing any cutting. Either the blades are dull or the grass is too tough: the stems flatten as the mower passes over, and then spring back. But she isn't aware of it, or of us. The speakers of the Walkman we sent her last Christmas are plugged into her ears. Her craggy, accented voice, surprisingly familiar to me, is off-key but loud as she accompanies the tape.

"*I've been looking for love in all the wrong places,*" she booms out, and then something makes her notice us. At first she pretends not to have seen anything out of the ordinary, and goes back to her pushing.

"*Looking for love in too many faces,*" she shouts, then stops again and drops her forearms on the handle of the mower. Finally she glances over her shoulder and sighs as she pulls off the headset.

"Well, what did the cat drag in," she says in Indian, in a voice as scratchy and knotted as a fir tree. "My favorite thing, a surprise visitor."[2]

What Dorris does effectively here is to select details that will resonate with the reader, details that depict not only an individual but a collective *type* of individual that most people have seen at one time or another. So we have the overalls, and we have the bra straps denting her shoulders. To give the description distinction, he puts a spin on it: He gives us that bobby pin in the wig and then on top of Aunt Ida's head he places the headphones. These offer him one final opportu-

nity—which he gladly takes—to make Aunt Ida unforgettable: the song Aunt Ida is singing along to. Thus does his character emerge within a few paragraphs. We know her. We have seen her. Most important, we will not forget her.

Dorris places her within the landscape of the reservation as well, and note that her lawn mower doesn't cut the grass at all; it merely flattens it for a moment. Why? Because things don't work as they ought to work on the reservation.

My point here is that Dorris doesn't miss a single chance to *show* you something defining about the character. He does this purely through externals: what she looks like and what the area that surrounds her looks like. He could have gone in another direction had he chosen to do so, though. He could have explored her internal landscape.

As soon as I mentioned external landscape of character, you must have assumed that an internal landscape of character was on its way, and it is. We aren't merely the sum of our external parts, and neither should our characters be. For we all possess emotions, psyches, and souls. We have wants and needs. We engage in reflections, speculations, obsessions, and the like. All of these comprise our internal landscape.

A character without an internal landscape runs the risk of becoming a stereotype or, worse, a cardboard character. Giving him an internal landscape gives him human dignity. It also adds to the depth of the novel because the character—more fully explored—is now more fully real.

I like to go into my characters' heads when it comes time to explore their internal landscapes. Frequently, I'll allow them a moment to reflect upon something, and I'll use that reflection to illuminate part of their psyche for the reader. I'll try not to be direct in what I'm saying. Instead, I'll attempt to choose an incident or a topic that, reflected upon, can serve as a metaphor for the state of a character's soul.

Internal landscape exists in characters' monologues, too, whether these monologues be spoken or thought. It's also present in their actions, their reactions, and their words.

Consider the internal landscape of Chas Quilter from my novel *Well-Schooled in Murder*.

The library smelled largely of pencil shavings and books.
The former odour emanated from the electric pencil sharp-
ener that was used by students with more delight and enthusi-
asm than actual need. The latter drifted from the tall serried
shelves of volumes that jutted out from the walls, their ranks
broken intermittently by broad study tables. Chas Quilter sat
at one of these, finding it inexplicable that he should feel so
numb as his world continued to crumble round him, like a
building caught in a conflagration that gives itself up, piece by
piece, to the flames. He remembered a Latin phrase that had
been one of many he had been forced to memorise as a fourth
form student. *Nam tua res agitur, paries cum proximus ardet.*

Alone, he whispered the translation into the listening
room. " 'For it is your business, when the wall next door
catches fire.' "

How true the aphorism was proving. How assiduously he
had avoided facing it. It was as if, without knowing, he had
been running from that fire for the last sixteen months, yet
every path he had chosen only brought him face to face with
another wall of flame.

His flight had begun the previous year with his brother's
expulsion from the school. How well he remembered the
course of those events: his parents' outrage at the initial accu-
sation made against an older son who wanted for nothing;
Preston's hot denials and insistence upon proof; his own
impassioned defence of his brother at gatherings of supportive
but sceptical friends; and then the humiliation attendant to
the knowledge that the accusations were true. Money, cloth-
ing, pens and pencils, special food brought in tuck boxes from
home. It hadn't mattered to Preston. He had stolen without
thinking, whether he wanted the item or not.

In reaction to the revelation of his brother's sickness—for
it *was* a sickness and Chas knew that—he had run from
Preston. He had run from his brother's need, from his shame,
from his weakness. All that had seemed important at the time
was to disassociate himself from disgrace. He had done so,
throwing himself into his studies and avoiding any circum-

stance during which his brother's name or his folly might arise. Thus, he left Preston alone in the flames. Yet even as he did so, he faced the fire himself, where he least expected to find it.

Sissy, he believed, would be his salvation, the one person in his life with whom he could be perfectly honest, entirely himself. In the months that followed Preston's expulsion from the school, Sissy had learned all of Chas' weaknesses and his strengths. She had learned of his pain and his confusion, of his hard-edged resolve to make up for Preston's mistakes. Through it all she had been there for him during his lower sixth year, calm and serene. Yet as Chas allowed himself to grow closer to her, he failed to see that she was just another wall, that she too would give over to fire and destruction.

So the wall next door had indeed caught fire. The fire had spread. It was time to put an end to the burning. But to do so would put an end to himself as well. If only his own life hung in the balance, Chas knew it wouldn't matter what he did at this point. He would speak without caring what consequences might follow. But his life touched upon other lives. His responsibilities did not end at the boundaries of Bredgar Chambers.

He thought about his father and his generous expenditure of time in Barcelona where each year during his own holidays he offered his services as a plastic surgeon to those who could not otherwise afford to see one, repairing cleft palates, rebuilding the faces of accident victims, grafting skin over burns, reshaping deformities. He thought about his mother and her lifetime of selfless devotion to both husband and sons. He thought about their faces on that final morning last year when they packed Preston's belongings into their Rover and tried not to let the depth of their confusion and humiliation show. They had not deserved such a blow as Preston's fall from grace had dealt them. So Chas had thought. And so he had determined to alleviate their suffering, to replace it with pride. He could do that, he thought, for he was not Preston. He was *not* Preston. He was not.

Yet even as he swore this to himself, words came swimming

into his mind without provocation, like incantations in a night-mare. He had read them this morning while waiting for his meet-ing with the Headmaster, and now he saw and heard them all again. *Acrobrachycephaly. Syndactyly. Coronal suture.* Without wanting to, he heard Sissy weeping. Without wanting to, he felt guilt and grief. Again he faced that burning wall and tried futilely to tell himself it was not his business.

But he failed to convince himself of anything at all save the extent of his personal culpability in the damage he had inflicted upon the people in his life.[3]

The effect I'm going for is to show the reader Chas's enormous sense of responsibility failed. His despair is growing daily. His suicide is on its way. But he could not commit suicide in the novel—believ-ably—without having an internal landscape that I explore. I could write the suicide, certainly. But chances are it would be just another ho-hum incident to the reader if I wrote it without also exploring Chas's inner self.

What you should keep in mind is that *anything* in a character's envi-ronment can serve as an indicator of his internal landscape if you use it wisely. I frequently give my writing students the assignment of using a refrigerator to show a character's state of mind. But a car would work for this assignment as well. So would a bulletin board or a pair of shoes.

The thing you use doesn't matter when it comes to showing some-thing about a character. It's *how* you use it in your writing that counts.

4

<div align="center">～∞∞∞～</div>

Plotting: "It Is the Cause, My Soul"

I am filled with doubts. Why isn't Steinbeck filled with doubts? I think he's had one lousy day of doubt throughout the time of East of Eden. Is it because he has so many outside interests? Probably. I have so few. I've never been a hobby person, and when I start working on a project, all I can think of is finishing the damn thing. And there's Steinbeck, building desks, carving oars for his sons, buying a boat, decorating his little house in New York. Should a future Nobel Laureate have a little more angst? I'd certainly appreciate it.

<div align="right">

Journal of a Novel,
October 12, 1994

</div>

Writers get asked the "idea" question all the time. At the end of a public appearance or a reading, the writer inquires if there are any questions and invariably someone wants to know, "Where d'you get your ideas?"

I suppose every writer has a different answer to this question. For my part, I frequently wish there were an idea store somewhere. I could hop on over, make a quick purchase, and sit down to work. But it's not that easy. Yet without having an idea, there is no way for the train to leave the station.

For me, ideas pop into my head from several sources. The first is from character. Sometimes I decide that I want to write *about* a particular sort of character caught up in a particular sort of situation, and from that grows the expanded idea of the novel from which grows the plot.

An example of this would be my novel *Missing Joseph,* in which I made a conscious decision to write about the death of a perfectly good person at the hands of another perfectly good person. Given that as my starting point, I began asking myself a series of questions about these two individuals, starting with the most obvious: "What would prompt a perfectly good person to kill another perfectly good person?" Answering these questions allowed me to expand the idea to encompass the arc of the story so that ultimately I had the beginning and the ending. Developing the characters themselves would give me the rest.

Sometimes, however, I develop an idea based on a challenge. In a seminar I attended with her as instructor, P. D. James once said that a writer cannot create a scene from the killer's point of view *after* the killing has occurred because the killer would naturally be thinking about the killing, and to make the killer think of anything *else* would not be playing fair with the reader. I took this as Phyllis's laying down the gauntlet of challenge. Then and there I decided that I would write a book in which scenes would take place in the killer's point of view after the killing, scenes in which the killer would indeed be thinking about the killing, but scenes in which I would make the reader believe that the killer was actually thinking of something else. Thus was *For the Sake of Elena* born. Similarly, when Sue Grafton told me that she'd tried to write *K Is for Kidnap* but finally tossed the effort out, I decided to see if I could write a kidnap novel. Thus was *In the Presence of the Enemy* born.

Ideas are everywhere if you remain alive to them. I also get mine from intriguing newspaper stories (*Well-Schooled in Murder*), from a beguiling turn of phrase (*Playing for the Ashes,* explained to me at dinner one night with my English publishing team), from some topic I find interesting and wish to pursue (*Deception on His Mind*), from something I've heard and never forgotten ("Remember, I'll Always Love You"). The point is that I work with the idea. It doesn't plop into my head, all of a piece, as a finished plotline. I think about it and ask myself questions about it until I can develop it into an expanded idea from which I will draw my characters. These characters I will then develop in turn and they will work with me to design the plot.

So what is plot, then? Here you were, believing that plot was all about coming up with a story and applying characters to it, and I appear to be telling you something altogether different. That is indeed

the case: Essentially and most simply put, plot is what the characters *do* to deal with the situation they are in. It is a *logical* sequence of events that grow from an initial incident that alters the status quo of the characters.[1]

Consider an example for purposes of elucidation: Sudden widowhood alters the status quo of Mary Jones, who was previously happily married. How Mary Jones learns to cope with her widowhood, the challenges she faces, the difficulties she surmounts, and the changes she experiences as a result all constitute the plot. I call her sudden widowhood the *primary event.* It is that which gets the ball rolling in the novel. It may take place at the beginning of the novel; it may have taken place before the novel opens. But it gives the novel its sense of direction. More important, it gives the writer a sense of direction.

To have a plot, it goes without saying that you must have characters, but you would be amazed to discover how many would-be writers don't realize that you also must have conflict. A number of years ago, a hopeful novelist asked me to read his timeless epic and comment on it. It was sixty-five pages long, he told me, and he'd reached the end of the story. He'd thought it was going to be a novel along the lines of the work of Robert Ludlum, and he couldn't figure out what was wrong with it, why the whole thing—which was some sort of nuclear holocaust occurrence, as I recall—played out in so few pages. I said, "What's the conflict?" He stared at me, amazed. His reply, "*Oh!*"

So that's what you need in order to have a story that is capable of being rendered in an interesting, compelling, and artistic fashion: conflict. But you also must have events that occur as the conflict unfolds, and these events must be organized with an emphasis on causality. If they aren't organized with an emphasis on causality, what you end up with is either a picaresque novel in which we explore episodes of someone's life without there being a relationship between these episodes, or characters engaged in a tedious search for a plot. The first—the picaresque novel—is definitely a *type* of book. It's not my cup of tea, but some people love them. The second—characters in search of a plot—is just bad writing.

To avoid bad writing, think of the events in your novel as dominoes. Let's call them dramatic dominoes. The first event in the novel— and for that you can read "the first scene"—must trigger an event that

follows. In a first-person narrative or a narrative with a limited third-person point of view, the first event will trigger the event that *immediately* follows it. In other words, something in scene one *causes* scene two to happen. In the types of books that I write, which have a shifting third-person point of view, the first event must trigger *some* later event in the novel, but not necessarily the one that immediately follows it.

The key here is to remember that scene one is the first domino. It knocks the next one over and so forth. If that doesn't happen, you have failed in your duty to make your scenes causally related.

Additionally, your plot has to have high points of drama in which the reader is—one can only hope—deeply involved. In a crime novel, this is a fairly straightforward business since there are many events in the course of an investigation that can provide the reader with what my editor would call "that frisson of excitement." In a crime novel, you can use the actual killing to do this. You can also use the discovery of the body, a scene of menace, a character at risk, a chase scene, etc. But in *any* kind of novel, you can create that frisson with a scene of direct conflict between characters, or a scene of discovery or revelation of information, or a moment of personal epiphany.

Beyond that, your plot must have a climax, and the climax itself must have a climax. I call this the "bang within the bang." In *Missing Joseph,* for example, the climax is a chase across the moors in which the detectives pursue the killer and her daughter, homing in on a place called Back End Barn, where they believe she is holed up. Their scramble across the moors in the snow, their arrival at the barn, their bullhorn announcements to Juliet Spence, and one police constable's foolhardy dash into the barn constitute the climax of the novel. The moment when a shotgun goes off in the barn constitutes the climax within the climax. Literally, the bang within the bang.

Post climax, you must have resolution (although John le Carré, in an example of flagrantly risky writing, ends his novel *Singer and Singer* in the middle of the climax!). During this part of the novel, you are tying up the loose ends and illustrating the nature of the change that has occurred in the lives of your characters.

That all sounds fairly straightforward, doesn't it? Why, then, do people reach sudden dead ends? Why do they become afflicted by the dread writer's block?

I believe it's because they don't create their characters in advance and they don't have enough craft in their repertoire. Put another way, they have no toolbox to root through to repair a mistake in the house they're trying to build.

Skilled writers know that what you're supposed to do is continually *open up* your story. You do this by creating scenes in which you lay down—*but do not answer!*—dramatic questions. You do this by making sure that if you do answer a dramatic question in a scene as the novel progresses, you've already laid down another. You do this by making partial disclosures instead of giving out all the information you possess. Most important, you do this by creating suspense.

Sometimes would-be writers forget that all suspense actually *is* is that state of wanting to know what's going to happen to the characters and how it's going to happen to them. Sure, there are other kinds of suspense: Is the bomb going to explode before our hero rescues the precious puppy to which the dreadful bomb is tied? But if a novelist is doing her job, no matter *what kind* of novel she's writing, it contains suspense because it contains characters the reader cares about.

Really, that's the key. Create characters who are real to the reader, who evoke an emotional response *within* the reader, and you create suspense because the reader will want to know what's going to happen to these people once the status quo is shattered by the primary event.

One way to do this is to give the character an intention. In Shakespeare's *Richard III*, the wily Duke of Gloucester—our boy Richard—*intends* to pit his two brothers "in deadly hate" against each other. He *intends* to plant a phony prophecy in King Edward's ear that George plans to murder Edward's heirs. He *intends* George to be imprisoned as a result of this phony prophecy because he *intends* to clear the way to the throne for himself. We learn all this in his opening soliloquy, and he's such an engaging rascal that we get caught up in wondering if he's going to manage to carry it all off.

Similarly, Jane Austen gives us the news of Mr. Bingley's arrival in the neighborhood in the opening scene of *Pride and Prejudice*. From the first moment, Mrs. Bennet intends that he should marry one of her five daughters. The story grows from there.

The point is that intention produces interest in the reader. It produces anticipation. If the reader cares about a character, the reader anticipates the problems he's going to face. We care about Macbeth, an

unstoppable and tremendous war hero. Once he kills King Duncan at the behest of his Machiavellian wife, we hunker down and wait for the disasters that will follow.

Using time also works to promote suspense. So does creating tension by making a promise to the reader in the beginning of a novel. Of course, a promise made to the reader is not a specific promise. It's something that triggers anticipation: The gun that is introduced in the beginning must be used by the end.

Perhaps the most useful thing I've ever heard about plot was said years ago by California novelist T. Jefferson Parker at a writing conference: "When my story stalls out on me, I've played my hand too soon." I always keep this in mind because the type of novels I write require information to be played out with great care. If I give something away too soon, the entire house of cards collapses. Think about this when you're doing your own writing.

PART II

———⟨∞⟩———

THE BASICS

5

Yes, There's More About Plot. But First . . .

I'm trying to work for an hour each day. That's all I can demand of myself . . . When I was creating For the Sake of Elena, *I became so incapacitated by fear that I was having trouble getting out of bed in the morning. I finally resorted to saying, "These are only words and I will not let words defeat me" in order to get up and get to work. Thus I struggled to the end of the novel. But now, nothing seems to work. I flounder. . . .*

Journal of a Novel,
August 31, 1995

If there's one rule about writing, it's that there are no rules. Anytime someone tells me about a rule, I set out immediately to break it.

There is one rule I do live by in my writing, however, and since I invented this rule, it's fine by me to obey it: I always plan before I write, which means I always know the end in advance. I do not blithely set off on some big literary adventure, ever hopeful that my characters are going to elucidate matters for me as we travel on toward who-knows-where.

So I engage in a few activities in the preplotting days and weeks of the novel-writing process. During this time, I primarily try to find out exactly what *kind* of story I want to write. To learn this, I trust my body rather than my mind. Writing is not only an intellectual endeavor for me, it's also very much a physical one. When I'm on to the right story, the right location, the right situation, the right theme, my body tells me. I feel a surge of excitement in my solar plexus that literally sends

the message *Yes yes yes!* to my brain. Until I feel that surge of inner excitement, I remain in the preplotting stage simply because I have *nothing* to plot about.

Once I have a grasp of the basic idea, the character, the location, or the *whatever* that's caused me to feel charged up, I set off creating an expanded story idea from it. If you consider the idea for my novel *Missing Joseph,* which I mentioned in the previous chapter, then creating an expanded idea would work like this:

Since I wanted to write a novel about the death of a good person at the hands of another good person, the first question I had to answer in order to expand the idea was, "What's the motive for the murder?" After I thought about it for a while, the answer seemed to be that the victim must know something about the killer that the killer can't afford to have made known.

The next question logically was, "What is it, then, that the victim knows?"

The victim could have known anything, naturally, but I decided that the answer was that the victim knows that the young daughter of the killer could not possibly be the killer's child.

That opened up several more questions: Who *is* the daughter if not the child of the killer? How does the victim actually know that the killer's child isn't hers? Why does the victim decide to confront the killer with this knowledge? If indeed the child isn't hers, how did the killer get the child?

The questions you might think a crime writer would ask first—such as, How does the killer murder the victim?—are generally secondary issues for me when I'm creating the expanded idea. I'd like to know the answer to them, but they're not as crucial as the questions and answers relating specifically to the arc of the story. The arc of the story is my guide, following the trail from commission of crime to crime's solution, hence from the beginning to the ending of the story.

Ultimately, for that novel I came up with an expanded idea that told me that my victim (Robin Sage) would be murdered by a woman called Juliet Spence because he knows when he meets her daughter that Maggie could not possibly be her child. He knows this, I decided, because Maggie is the exact age that his own son would have been had he survived infancy. And since Juliet Spence was the mother of that

long-dead child, she could not also be the mother of Maggie. So he does a little research, and he discovers the truth about Juliet and Maggie. For that, he has to die.

Once I have my expanded idea, the characters come. They come first in a generic list (Victim, Killer, Daughter of Killer, Daughter's Boyfriend, Local Constable, etc.). That list gets turned into a specific list of names and ages (Robin Sage, Juliet Spence, Maggie Spence, Nick Ware, Colin Shepherd). That specific list then gets turned into a detailed analysis of each character.

This may come as something of a surprise, especially if you tend to think of crime novels—or any novels, for that matter—as all about plot. I don't see novels in that manner, however, and for that reason when I'm writing one, I hammer down the idea and the expanded idea and turn at once to character in order to learn more about my story.

Doing this, I create an analysis of each character who may (or may not) appear in the novel. This analysis is a present-tense narrative in which I write about the character as if I know everything about him. As I said earlier, I become the character's analyst. What makes me different from a real psychologist, however, is that I include in my "report" more information than a psychologist ever has, and I also free write in a stream-of-consciousness fashion to trigger the right side of my brain. This is the creative side. This is the side that makes me— however briefly—a god.

When I free write and when I employ stream of consciousness, what happens is that the essential elements of the plot become apparent. Why? Because I begin to see the relationships between the characters, I learn what the characters' strengths and weaknesses are, I see the conflicts clearly, and I begin to understand the theme. I also get ideas for subplots. Indeed, I generally end up with many more ideas than I can possibly use in one book. It's an amazing process and it never fails.

Frankly, a writer can start anywhere when analyzing a character. Sometimes I begin with a physical description. Sometimes I begin with the character's family background. I keep what I call a *character prompt sheet* next to me as I do this work (and you'll find an example of that in Part III), but I use this sheet just to remind me of the areas that I wish to touch upon as I create the character. I hit upon all these

areas as I free write, but I especially hit upon five that I consider the most important.

The first of these is the character's core need. We all have them: single needs that are at the core of who we are. We're born with them, and during our lifetimes, we mold most of our behavior to meet our core need. This is something essential to a person, an automatic striving within him that, when denied, results in whatever constitutes his psychopathology.

Every character's behavior has a number of motivations behind it. Some of these are superficial: right there on the surface for everyone to see. You beat your dog; I club you over the head. The event that prompted my action is right there, perfectly understandable to the casual observer. But some motivations are buried within our personalities, part and parcel of who we are. These are essentially basic needs although some of them are more complicated than others. A few of them are the need to be competent (good at everything you do), the need to do your duty, the need to belong, the need for excitement or what's called "the impulse life," the need to be authentic, the need to be right at all costs. If you think of mankind pared down to psyche alone, you will be able to come up with core needs for your characters.

I believe it's critical to know the basic need each character has in his life because the denial of that need leads directly to the second area that I consider crucial in developing a character. This is his pathological maneuver. Better said, it's what the character does when he's under stress. The supreme stress he's ever under, by the way, is having his efforts to meet his core need thwarted. When a character (or anybody, in fact) is engaging in a pathological maneuver, he is going to be acting in a way that demonstrates this. The pathological maneuver is generally the flip side of the core need.

Let me give you an example. Someone whose core need is to have excitement or to experience the impulse life is someone whose fulfillment of need has an external manifestation, no? Obviously, someone needing the impulse life is not going to spend vast amounts of time in the library researching the existence of leprechauns or the nature of black holes. That person is going to be out there *doing* something, and the something he's doing is going to be exciting: hang gliding, bungee jumping, roller coaster riding, surfing.

When his need for excitement is stymied in some way, he's under stress. His reaction to this stress will take an overt form, just as his need for excitement will.

Picture this individual in the classroom, forced to sit quietly and listen to a rather boring lecture while needing desperately to be out there doing doing doing. His anxiety builds as he has to continue to sit there. When it reaches the boiling point . . . ? Of course. He acts out. He does not turn inward for a good round of self-castigation as does the person striving for competence. The person striving for competence would *never* act out because, to him, acting out is the height of incompetence. Thus, the pathological maneuver in its manifestation is a core need flipped over.

Here are some potential pathological maneuvers human beings show: delusions, obsessions, compulsions, addictions, denial, hysterical ailments, hypochondria, illnesses, behaviors harming the self, behaviors harming others, manias, and phobias. Go to your local bookstore and check out the psychology section. You'll find a treasure trove of material there. The important thing to remember is to keep the core need of each character and the pathological maneuver aligned. A core need that plays itself out in someone's internal life is generally not a core need whose flip side will be external.

The third area that's critical to understanding a character is, I believe, his sexuality. This includes his attitudes toward sex as well as his sexual history. This aspect of the character may not play out openly in my novel, but when I understand it, I find it influences a great deal of what he's doing in his life.

A circumstance in a character's past that had a huge impact on him constitutes the fourth vital area of the analysis for me. If in the analysis, I create this circumstance and let it play out, I get to see the character in action or reaction before writing anything of the novel, and this firms the character in my mind. This circumstance may make an appearance in the novel. More likely, however, it won't. It will merely serve as a guide that illustrates *how* my character came to be the person he is today, because the nature of the circumstance I describe in the analysis is important to the development of the character's personality. I always carry this part of the analysis one step further, including an anecdote that best illustrates the character's personality today. Again,

that's an anecdote that never appears in the novel. But it's something that I know, and consequently it colors my rendering of the character, even subtly.

The final important area that I include in my analysis is to decide what the character *wants* in the novel. (I make this decision about each scene as well, giving an agenda to each character in a scene.) In doing this, I try to keep in mind that what someone wants isn't always directly expressed, nor is it always simple. It can arise from mixed motives, and it will be colored—in any individual scene—by the character's core need.

There are other elements that I put into analysis, but we don't need to explore them here. The point of pausing here to discuss character analyses was this: There is no plot without character. In the world of chicken and egg, characters come first.

6

Onward from Idea

I'm reading John le Carré's The Constant Gardener *right now. Frankly, it's making me feel more inadequate than I've felt in a long time. He's a tremendous writer with a touch for character that amazes me. And his plotting—that take-no-prisoners approach that I've always found so admirable—makes me want to worship at the shrine of his yellow legal pad.* The Constant Gardener *is meticulously researched, but he's buried the research or rather he's worked it seamlessly into the novel as it should be worked. The man's a genius. The Cold War ends and he's liberated by it, not defeated or thwarted as his critics thought he might be. I admire him more than any other living author. A superb stylist, a brilliant technician, an incredible creative artist.*

<div align="right">

Journal of a Novel,
June 1, 2001

</div>

So you've come up with an idea from one source or another. You've expanded that idea so that you have a story arc that comprises beginning and end while it simultaneously answers key questions that you've asked yourself. You've decided where you want to set your epic, based on your passion or your interests. You've made a generic list of characters, based on the expanded idea. You've turned them into a specific list of characters with names and possibly ages assigned to each. You've analyzed every one of them.

Now at long last you are ready to plot.

My writing friend T. Jefferson Parker never used to plot his novels in advance. He'd just start writing. When he was finished with the

book, he'd set it to one side and begin all over again, rewriting. He'd continue creating draft after draft until he had one he liked. Then he'd send that one to his editor and await judgment.

He and I would have lunch together from time to time when we both lived in Orange County, California. He would explain this process to me and I would look at him as if he were a madman. I could not imagine going through all that to write a novel. If I knew I was going to have to write an entire draft and then set it to one side and not refer to it in order to write *another* draft and then possibly have to do *that* again . . . I'd still be teaching English at El Toro High School.

For my part, I have always had to have an outline: the plot in advance. I haven't had to have the *entire* plot worked out prior to writing a novel, but after I have the expanded idea, I have to have a sense of where I'm going to be heading in the first 150 pages or so.

To give myself a sense of direction, I do two things. I create a step outline. I then expand it to a running plot outline.

A step outline for me is just a list of scenes in the order in which I envision them in the novel. Note, I'm not saying these are all the scenes in the novel from start to finish. On the contrary, they are the scenes that comprise whatever section of the novel I'm going to be writing. Since I write my novels *in the order* in which they are read (some writers—notably P. D. James—don't do this, by the way), when I list my scenes, I shift them around until the list I have in front of me is the actual chronology that will appear in the novel. I list scenes until I hit the wall and literally can think of no more. Sometimes I get fifteen scenes on my list. Sometimes ten. Sometimes fewer.

When I've got the step outline completed, it looks something like this, the exact step outline I used to create the plot outline for the beginning of Day Five from my novel *A Place of Hiding*:

1. SJ talks to Le Gallez: Prints on bottle; money missing—suggests payoff which takes SJ to Adrian (can he phone Lynley at this point?)

2. Deb at Abbotts' house on north end of island; talks to Anaïs (end of Anaïs story here?); talks to Stephen re Cynthia; Stephen really bitter (China goes with her?)

3. Valerie goes to see Henry at last; "You weren't the only one to tell me."

4. Ruth (her POV) Margaret confronts her re ownership *Le Reposoir*; tells her Paul stole something; Margaret phones police (Paul could be there on grounds or—better yet—the police go to pick him up!)

5. SJ in town re missing money; with Le Gallez and banker, they trace it to London bank

6. (Valerie here? Valerie and Kevin here?)

7. Paul Fielder: learns he's not getting £750,000 (some sort of resolution to Billy? No, not yet.). Police come for Paul.

8. Deb and China: learn Cynthia gave Guy the fairy wheel.

On and on I go until I've exhausted all the possibilities for the section of the novel I'm writing about. As I list these potential scenes, I note every opportunity for causal relationships to be developed. Every scene contains something within it that triggers a scene that follows. Note that scene one triggers scene five; scene two triggers scene eight; scene three might trigger scene six (you can see I have my concerns about that, as indicated by the question mark); scene four triggers scene seven.

Doing a step outline on a single sheet of paper thus allows me to see if I'm setting up causally related scenes, which is crucial to creating a novel that moves relentlessly and consistently forward and doesn't disintegrate into characters looking for a plot.

The step outline doesn't take me more than a few hours. I may get up and walk around. I may write down a bunch of ideas and line them out. I may draw arrows to indicate potential relationships. I may underline, squiggle, and exclaim. But in the end, I have a list. That list is what I turn into the running plot outline.

Yes, I hear your protest, voiced though it is as questions: If I have a list of scenes, why don't I just go ahead and write them? Why throw in *another* step to the process? Am I avoiding the entire act of writing the novel itself?

Let my explanation of the running plot outline suffice as my answer.

The running plot outline—like the character analysis—is a present-tense stream-of-consciousness affair. I am strongly left-brained, as you can probably tell from my having such an intricate process in the first place, and I must do whatever I can to get the right side of my brain up and operational. Present-tense stream of consciousness does this for me. Writing in this fashion, I'm not worried about typographical errors, spelling, punctuation, sentence structure, figurative language, or anything else that might make me stop, consider, and thus get derailed. I just start firing away at the computer keys, writing down what I see happening in each scene on my step outline.

I generally begin by indicating in whose point of view the scene will be rendered. I then decide what's going to be going on in the scene. If the scene is destined to be largely one of dialogue, I decide in advance what sort of THAD I'm going to use. A THAD is what my writing students and I call a Talking Head Avoidance Device, and it's an activity going on in a scene that would otherwise consist of dialogue. It serves several purposes: It eliminates the possibility that a scene will become nothing more than two or three talking heads; chosen wisely, it reveals character; it may in and of itself contain important information; it can be used as a metaphor. I choose my THAD carefully and as I'm writing in stream-of-consciousness fashion, I toss THADs onto the computer screen until I find the THAD that fits. How do I know it fits? I listen to my body. When I feel that surge of excitement, I know I've hit upon the right THAD for a scene.

Here are examples of THADs that I've used. They've served several purposes, beyond the avoidance of talking heads:

Deception on His Mind: The THAD in a scene between Barbara Havers and her father-daughter Pakistani friends Taymullah Azhar and Hadiyyah deals with Hadiyyah presenting to Barbara a bee that she's captured and put in a jar. It becomes a metaphor for people being removed from their communities and consequently a metaphor for the Pakistani experience in Great Britain.

In Pursuit of the Proper Sinner: The ongoing scenes between Lynley and his wife Helen have as their THAD choosing wallpaper for the

guestroom. This activity becomes a metaphor for Helen's troubled internal life and the sense of personal unworthiness that plagues her.

Well-Schooled in Murder: The selection of the correct sweater for afternoon games is a THAD but it's also a clue.

In *Playing for the Ashes:* The animal rescue scenes are THADs but they also illustrate Chris Farraday's character at the same time as they act as metaphors for his relationship with Olivia Whitelaw.

So when I'm writing my running plot outline, one of my first considerations after point of view is the THAD. There are other elements, too. I'll include some description, possibly some actual narration and dialogue, agendas for the characters, and a purpose for the scene. I'll block out the scene as it's going to appear in the book, showing myself what the basic structure is going to be. I might make my decision on the style I'm going to use to get myself into the scene: Will I start *in media res* (in the midst of an action) and then back off and tell how we got there? Will I start with a line of dialogue and then back off and set the scene? Will I set the scene and then begin the action? Will I be in someone's mind?

All of these questions I answer in the running plot outline. I take it scene by scene from the step outline, until I have a running plot outline that comprises all the scenes on the step list. As I write the running plot outline scenes, because I'm in stream-of-consciousness mode, more ideas come to me for plot elements later on in the novel. Why? I don't know. That's just how it has always worked. As the theater manager in *Shakespeare in Love* kept declaring, "It's a mystery."

Here is an example of what my running plot outline looks like. What follows is the outline for the first scene of *In the Presence of the Enemy.* I've made not a single change in it, which is why you may well see typographical errors and misspellings, not to mention grammatical errors.

Plot Outline #1

WEDNESDAY
SCENE ONE

 We are in Charlotte Bowen's head. It's dark because the windmill windows are boarded over and

because she is on the ground floor where there are no windows at all. She comes to, out of a drugged sleep.

We begin with: This is what she remembered. Or, When Charlotte Bowen lifted her head from the damp hard surface that served as her pillow, this is what she remembered. Or: Charlotte Bowen— called Lottie by her friends and Elle by her mother and Hedge by her stepfather and Tick by the people who wished she wasn't quite so persistent and irritating a presence—opened her eyes to the darkness. (too convoluted).

What she remembers in this opening scene is fragments of what happened. It should not be clear whether she knows the kidnaper or not . . . let's go for definitely vague. She remembers the kind voice and the face filled with concern. "Lottie, your mother's sent me to fetch you. There's been a small accident." He tells her there's nothing to worry about. BUt Charlotte is worried and frightened because her mother is a law-and-order MP who is heavily into the debate over NOrthern Ireland and additionally into the debate over the right to remain silent and additionally into the debate over what to do about the proliferation of guns in England and all sorts of other debates that make her a target for extremists of every colour, shape, and philosophical bent. So when the Scent (he smells of after shave lotion or something like that or perhaps his body gives off a peculiar smell) says that there's been an accident, the first thing Lottie believes is that her mother is dead. She knows Cito has been worried for ages about her mother's high profile positions. She's a sitting duck, an unmoving target, a fox run to ground, etc, etc. The Scent (or whatever she calls him . . . Maybe the name of a villain from a storybook or fairytale or maybe the

name of a WInnie-the-Pooh character. . . . Or maybe
Christopher, the other half of Christopher Robin)
gives her a bottle of her favorite drink, apple
juice. She drinks it, her eyes get heavy, she falls
asleep. SHe feels bad now that she fell asleep but
she doesn't realize that the drink was drugged.

She knows that something bad has happened to
her because she is in a dark, cold place and even
though her eyes are open, she can't see anything.

Perhaps she feels her way along the wall and
comes into contact with Breta. Perhaps she comes
into contact with her by calling out quietly, not
by running into her. Perhaps she and Breta have a
conversation, which Breta starts. Breta is the
part of her that knows what's what, the part of
her that can admit to the worst about her mother.
Breta thinks that her mother may be behind what
happened to her.

Is Breta the spunky part of Charlotte? Or is
Breta the good little girl that Charlotte would
like to be? It seems more likely that Breta is
the spunky one because Charlotte would want to
behave like a nice little girl around her mother
and she would need someone to blame when she
failed to do so.

But Breta needs to be kept realistic; she
needs to speak with a ten-year-old's voice.

So what we get from this section: Charlotte's
situation; a vague notion of her whereabouts (we'll
never know for sure that she's in the country until
her body is found); her background; her mother's
position; a notion of the kind of relationship she
has with Eve and Cito; the existence of Breta; what
happened to her the afternoon she was kidnapped.

Maybe she gets to the stairs in the windmill
when she first hears Breta speak. She thinks she's
in the cellar of a house.

What you see, I hope, is that I try to give myself as much information as possible prior to writing the scene. This allows me to concentrate on the writing itself when I'm doing the scene: the use of language, the structure of sentences, the transitions between paragraphs, and the sense of movement I want the reader to have, going from moment to moment in the novel. In other words, when I'm actually writing the rough draft, I can concentrate on the *art* of writing because I've already done my work in the craft of writing.

All along through the plotting process, I try to keep in mind that credibility is essential for a plot to work. Characters need to act *in* character, so as I'm writing the plot outline, I frequently refresh my memory about the characters I've created, checking their analyses to see that their responses align with their core needs as I've developed them. I make certain that the behavior of the characters is thus rooted not only in who they are but also in what has happened during the scene. They aren't just reacting out of nowhere. They aren't just reacting because I have to throw in something exciting to keep the plot going. There's a consistency and logic to what's happening.

Creating a step outline and then a running plot outline allows me to make sure that every scene either advances the plot, advances one of the subplots, develops character, or addresses theme. I have to be honest with myself during this process. If the scene I'm creating in the outline doesn't do one of those things, I have to toss it out. The benefit of having a step outline first, then, is that I can throw the scene out very early in the process rather than having to do so after I've labored over a rough draft for hours or days.

All along, though, I must make sure that every scene contains within it some degree of that fundamental part of any plot: conflict. Of course, to meet this basic requirement, it's important for me to understand what conflict is.

Sometimes neophyte writers believe that conflict has to be writ large, à la Ayn Rand: John Galt versus Socialism. How's that one for some potential contention? But the truth is that conflict is merely a form of collision, and what collides is—as James Frey tells us in *How to Write a Damn Good Novel*—a character's desires against some sort of resistance to his desires.[1]

That resistance can come from anywhere:

It can come from within the character himself. Let's face it, Macbeth's biggest opponent was his own mind. Macduff was going after him, true. But had he had less of a conscience and less of a brain naturally bent toward obsession, he possibly would have gotten a few more good nights' sleep, which might have gone a long way toward keeping him grounded in reality. And *that* might have made him more capable of thinking things through when he heard that final set of predictions about Birnham Wood on the march and no man of woman born.

Resistance can also come from nature as it does unforgettably in *Jaws*. The shark makes a powerful antagonist against whom the might and wisdom of man must fling themselves to reach a resolution. The eponymous weather conditions in *A Perfect Storm* conquer some of those caught in its grasp while others meet its challenge head on and manage to survive. Mount Everest is the nemesis of the climbers in *Into Thin Air*. Rabies is the bad guy in *Cujo*.

Antagonists from the spirit world or from other dimensions supply the conflict in books like *The Exorcist* and *The Amityville Horror*. Stephen King has expertly used them time and again in books like *The Shining*.

My point is this: Conflict doesn't just have to be the guys in the white hats against the guys in the black hats. It doesn't have to be guys against guys at all. Limit yourself to that and you limit your thinking.

No matter what types of protagonists and antagonists you use, though, keep in mind that conflict is what will bring your characters to life and make them real for the reader. When you describe a character, you give the reader an image of him. But when you put him to the test by putting him into conflict, then he springs to life. He is forced to make a decision and then forced to act upon that decision. This displays the mettle of the character, which allows the reader to get to the essence of who the character is.

Conflict will also add tension to the novel. It will be part of the dramatic questions being asked. Dramatic questions being asked equate to anticipation in the reader. And remember, anticipation in the reader adds to the reader's sense of suspense.

A reader who feels anticipation, excitement, interest, or compassion is a reader who is not going to walk away from the novel till the

entire story is told. If you can inculcate any of these reactions in your reader, you're doing part of your job as a writer.

You have choices to make when you're thinking about conflicts in your plots and your subplots, too. Considering these choices will allow you to consider the kinds of conflict available to you.

The first of these is my favorite: what James Frey calls the crucible.[2] When you choose this sort of conflict, you must create a situation in which your characters are bonded together for one reason or another and thus unable to escape being in conflict with one another. The closed community killing is one example of a crucible of this sort. Agatha Christie employs this in *Ten Little Indians:* Her characters are stuck on an island together and someone among them keeps knocking them off, one at a time. I use the closed community in my novel *Payment in Blood:* Those actors are all snowed in on a Scottish estate when . . . whammo, one of them is murdered. James Clavell uses it in *King Rat* when he writes about the World War II prison camp. In *Kiss of the Spider Woman* the crucible is even smaller: a prison cell. In *The Lords of Discipline* it's a military school. The point is that a crucible works *as* a crucible if the characters either cannot get out or have stronger reasons for staying *in* than they do for escaping. For example, if they are searching for something of equal value to both of them and if they can find it only together, like Harrison Ford and Karen Allen in *Raiders of the Lost Ark*. Or if they are partners forced into the choice of working with each other or losing their jobs. These situations are crucibles. They heat things up between characters. When things heat up, characters are put to the test. Conflict is what ensues.

Keep in mind that no matter what kind of conflict you're choosing, what you should have is a character's will in *collision* with something else: that is, some sort of resistance.[3] This can take the form of another person's will, another person's body, a situation, or the character's own internal functioning. If you're going to use the last one, remember as you plot your book that part of this character's type of conflict should be the indecision and ambivalence that are natural to all people. No matter who the character is, at some time he will suffer what we all suffer from time to time: guilt, fear, doubt, worry. All of these equate to an inner conflict.

A character's inner conflict will show that he is real.

The external conflict he faces will show that there is something at stake.

Both can be equally powerful conflicts to use.

As you plot, however, remember that conflict works best when it is *rising conflict*. This does not thrust the character into the middle of a raging situation. It builds over time, revealing more facets of character as incidents occur. At each different stage of the conflict, the character's reactions differ, perhaps intensifying, perhaps gaining more clarity, perhaps sinking into more confusion. At the climax, however, the character stands before the reader fully revealed.

Thus, when you're plotting, keep rising conflict in mind. You must eliminate story situations that are heated between characters with no foundation laid for that heat. You need to make certain that your characters face obstacles that ratchet up the tension. You must increase the problems that the characters face; consequently, you'll be increasing the pressure that the character is under.

All of this applies to the subplots as well, by the way.

And your book *will* have subplots. One main plot does not a novel make. But before you recoil from the prospect of creating subplots *as well as* plot, let me point out the additional benefit of creating your characters in advance of plotting: Those same characters will tell you what the subplots are. You will see the subplots right there in the analyses and you won't even have to think about them.

But in case you want to . . .

Subplots generally rise out of a novel's theme. As you create your character analyses, you'll begin to make connections between characters. You'll discover the similarities in what they're going through or have gone through. You will see a common element that you wish to write about, and this will be your theme. Your subplots will mirror that theme, like the marriages in *Anna Karenina* that mirror each other. If they don't mirror the theme, they will not fit easily into the world of the novel, and they will go *clunk* each time you're writing them till you finally decide to cut them out altogether. *Pride and Prejudice* is an excellent example of this: Elizabeth and Darcy, Jane and Bingley, Charlotte and Mr. Collins, Lydia and Wickham. Most people would agree that Elizabeth and Darcy's unfolding relationship constitutes the

main plot of Jane Austen's novel. The other three relationships are different wrinkles on the same blanket.

No matter how many of them you decide to feature in a book, however, subplots have the same essential requirements as the main plot: All of them should display rising conflict, a climax, and a resolution. Unless you're writing novels that are deliberate cliffhangers, which I don't recommend lest you want readers to come at you like a lynch mob, you need to end every story you begin.

That's the promise we make to our readers when we offer them a piece of writing, by the way. We offer them the secure knowledge that, in a world where only death and taxes are definite, there is another world in which things play out to a logical and inevitable conclusion.

The Start: Decisions, Decisions

... I'm beginning to have more clarity on the novel. What I haven't seen yet is precisely how or where in the story to begin. It's a question of deciding among at the beginning, before the beginning, or after the beginning. After the beginning has been a choice of mine for a while now. If I do that again, it does provide me the opportunity to attempt a non-linear narrative. There are elements of these people's back stories that I would like to explore and a non-linear narrative gives me that option. But then, so does beginning before the beginning. The only question in doing that is whether I can hold the reader's interest.

Journal of a Novel,
June 7, 2001

All writers would like to get in touch with the cosmos. Is that not, after all, what great writing is? Do not truly great writers sit at the parchment, the legal pad, the spiral notebook, the typewriter, the word processor, hands hovering above the tools of their trade till they feel the Great Spirit of Literature awaken within them?

I suppose they do, more or less. But first, even they have to make some decisions.

The first of these is the decision concerning where to start the story. The way I see it, you have three alternatives. You can begin the story just before the beginning; you can begin it right at the beginning; or you can begin it after the beginning.

Starting just before the beginning, you of necessity have to come up with a scene that illustrates the status quo of the main characters *before* the primary event occurs. For my money, illustrating their emo-

tional status quo is going to have more power than any other form of status quo (financial, physical, etc.) because if you can come up with a dynamic scene that illustrates the character's emotional temperature, you stand a very good chance of hooking the reader into the life of that character in just a few paragraphs.

Consider the opening of Robert Ferrigno's *The Horse Latitudes*.

> IT DIDN'T TAKE MUCH to set him off these days—laughter from the apartment below, a flash of blond hair out of the corner of his eye. Or, late at night, the sound of two car doors slamming in quick succession. Especially that. He imagined them walking to his place or her place, both of them eager but trying not to let it show, holding hands, tentatively at first, then the man slipping his arm around her waist while she smiled and laid her head on his shoulder.
>
> There were nights when Danny missed Lauren so bad that he wanted to take a fat man and throw him through a plate-glass window. Just for the sound of it. Instead, he went swimming in the bay.
>
> The water was cold and dark and empty and he hadn't missed a swim in the four months and ten days since the divorce became final. He was going to drown one of these nights, or he was going to get over her—it was too early to tell which.[1]

Notice that what Ferrigno does is to give us a character not only in emotional *extremis* but in a life situation with which virtually every reader can identify. We have all suffered loss at one time or another. We have all been wounded by love. We have something in common with the main character at once, so we are immediately placed within his experience and his psyche since Ferrigno plunges right into both from the first sentences. Consequently, we have a bond with this character. Either we care about what happens to him or we're curious about what happens to him. But in either case, we continue reading.

If you choose to start your novel right at the beginning, you are making the choice to introduce simultaneously both the characters and

the primary event that gets the ball rolling in the story. This is what P. D. James does in her novel *A Taste for Death*. Take a look at it.

> The bodies were discovered at eight forty-five on the morning of Wednesday 18 September by Miss Emily Wharton, a sixty-five-year-old spinster of the parish of St. Matthew's in Paddington, London, and Darren Wilkes, aged ten, of no particular parish as far as he knew or cared. This unlikely pair of companions had left Miss Wharton's flat in Crowhurst Gardens just before half past eight to walk the half-mile stretch of the Grand Union Canal to St. Matthew's Church. Here Miss Wharton, as was her custom each Wednesday and Friday, would weed out the dead flowers from the vase in front of the statue of the Virgin, scrape the wax and candle stubs from the brass holders, dust the two rows of chairs in the Lady Chapel, which would be adequate for the small congregation expected at that morning's early Mass, and make everything ready for the arrival at nine twenty of Father Barnes.
>
> It was on a similar mission seven months earlier that she had first met Darren. He had been playing alone on the towpath, if anything as purposeless as hurling old beer cans into the canal could be described as playing, and she had paused to say good morning to him. Perhaps he had been surprised to be greeted by an adult who didn't either admonish or cross-examine him. For whatever reason, after his initial expressionless stare, he had attached himself to her, at first dawdling behind, then circling round her, as might a stray dog, and finally trotting at her side. When they had reached St. Matthew's Church he had followed her inside as naturally as if they had set out together that morning.[2]

We know three things immediately: There is more than one body involved in what we're about to read (and since it's a P. D. James novel, we do expect there to be at least one body—and fairly soon—when we pick up one of her books); there are two characters who discover these bodies; there is a church intimately connected to the action and to the

relationship between the two principal characters we've met. We are thrust abruptly into the world of the characters as well as into the events that immediately precede the discovery of the bodies. We are right at the beginning of the story.

Beginning your novel after the beginning of the story means that you are choosing to start *after* the primary event has occurred. The ball, in other words, is already in motion and the reader is plunked down in the middle of the action. This is the choice that I made when I began my first published novel, *A Great Deliverance.*

IT WAS A solecism of the very worst kind. He sneezed loudly, wetly, and quite unforgivably into the woman's face. He'd been holding it back for three-quarters of an hour, fighting it off as if it were Henry Tudor's vanguard in the Battle of Bosworth. But at last he'd surrendered. And after the act, to make matters worse, he immediately began to snuffle.

The woman stared. She was exactly the type whose presence always reduced him to blithering idiocy. At least six feet tall, dressed in that wonderfully insouciant mismatch of clothing so characteristic of the British upper classes, she was ageless, timeless, and she peered at him through razor blue eyes, the sort that must have reduced many a parlourmaid to tears forty years ago. She had to be well over sixty, possibly closer to eighty, but one could never tell. She sat bolt upright in her seat, hands clasped in her lap, a finishing-school posture which made no concessions towards comfort.

And she stared. First at his Roman collar, then at his undeniably dripping nose.

Do forgive, darling. A thousand apologies. Let's not allow a little faux pas like a sneeze to come between such a friendship as ours. He was always so amusing when engaged in mental conversations. It was only aloud that everything became a terrible muddle.[3]

Here we see a priest on a train. We don't know who he is, and we don't really find out who he is during this scene as it continues. We do see him traveling into London; we learn that his business is extremely important, at least to him; ultimately, we learn he is on his way to New

Scotland Yard. He's a fumbling and bumbling sort of man, so the fact that he of all people is going to Scotland Yard suggests that there is more here than meets the eye. But we don't learn that at once. Scotland Yard and all the immediate associations that spring to mind with that place will intrigue the reader, I hope. Intrigued, the reader will not be bothered by the fact that I don't immediately tell him what's going on, to whom, and why.

No matter how you choose to begin your novel, you have to think about creating an opening that either *possesses* or *promises* excitement, intrigue, or high interest for the reader. It should reflect some element of the conflicts to be found in the plot or the subplot, or it should possess—even in metaphorical form—some indication of theme. It should lay out some sort of problem that the character has encountered, or it should foreshadow problems to be encountered. Atmosphere should be set. A place must be established. Characters—not necessarily the main ones—need to be introduced.

Perhaps all this seems like a tall order. But keep this in mind: If you're writing well, you're doing this automatically. If you're trusting your gut reaction to what you're writing (i.e., trusting your body and not listening to the committee in your mind), you'll do fine.

If that's too tall an order for you, though, you can always fall back on another element of craft: the *hook*.

We always need to hook our readers, whether they be people picking up our novels in bookshops, agents picking up our novels from slush piles, or editors agreeing to look at our novels upon the recommendation of an agent. That being the case, we always need to open our stories in a way that's designed to keep a reader reading. This hook, if you will, can be the first sentence of our masterwork. It can also be the first paragraph. Or the first scene or the first chapter. Whichever you choose as your instrument to attach reader to page, your general purpose is twofold: You are stimulating someone's interest in your tale at the same time as you are establishing mood and atmosphere.

What's nice about the hook is that this tool of craft can be wielded in at least eight different ways, nearly all of which can be combined or shuffled or played with as much as you would like. Let me list them first.

1. Name a character in the book.

2. Tell the reader something significant in the plot.

3. Show the reader a personality quirk that one of the characters possesses.

4. Illustrate a character's attitude (and there will be plenty more on this little topic later).

5. Show the way the narrator's mind works.

6. Give a clue or trick in the plot or a foreshadowing of either.

7. Lead the reader into excitement.

8. Render a mysterious or suspenseful occurrence.

Look at how much Edgar Allan Poe juggles in the opening sentence of "The Cask of Amontillado." (One of my literary agents, by the way, once declared this the only famous opening line in literature . . . till I whispered, "Call me Ishmael" to her.) The italics in the opening and those openings that follow are mine.

Poe writes: "The thousand injuries of *Fortunato* I had borne as best I could, but *when he ventured upon insult,* I vowed *revenge.*" In twenty-one words, Poe gives us two characters: Fortunato and the narrator; he illustrates the narrator's state of mind through his use of language: "when he ventured upon insult"; he lays down his plot: revenge.

When Herman Melville writes: "Call me *Ishmael,*" he begins by giving us one of the characters in *Moby-Dick.*

When Daphne du Maurier writes, "Last night I dreamed I went to *Manderley* again," she is laying down a setting that in and of itself is so significant to the plot of *Rebecca.* Had not Maxim de Winter lived only for Manderley—merely an English estate, for heaven's sake (one does wonder about Maxim's priorities for a lot of the novel)—he wouldn't have found himself in the pickle he was in once those divers discovered Rebecca's boat at the bottom of the bay.

Dickens declares, "It was the *best of times,* it was the *worst of times,*" at the opening of *A Tale of Two Cities,* thereby setting up the mood of the novel.

Shakespeare has Richard, Duke of Gloucester, say, "Now is the winter of our discontent/Made glorious summer by this *sun of York*," in the opening of *Richard III*. In doing so, he gives us two characters—Richard, the speaker, as well as his brother, whom he calls the sun of York in a play on the words *son of York*—as well as Richard's attitude toward Edward.

If we expand this opening line to the entire soliloquy that begins the play, we see that Shakespeare is using all sorts of elements to get our attention:

```
SCENE I. [LONDON. A STREET.]
ENTER RICHARD DUKE OF GLOUCESTER SOLUS.
```

> RICH. Now is the winter of our discontent
> Made glorious summer by this sun of York,
> And all the clouds that low'rd upon our house
> In the deep bosom of the ocean buried.
> Now are our brows bound with victorious wreaths,
> Our bruised arms hung up for monuments,
> Our stern alarums chang'd to merry meetings,
> Our dreadful marches to delightful measures.
> Grim-visag'd War hath smooth'd his wrinkled front,
> And now, instead of mounting barbed steeds
> To fright the souls of fearful adversaries,
> He capers nimbly in a lady's chamber
> To the lascivious pleasing of a lute.
> But I, that am not shap'd for sportive tricks
> Nor made to court an amorous looking-glass;
> I, that am rudely stamp'd, and want love's majesty
> To strut before a wanton ambling nymph;
> I, that am curtail'd of this fair proportion,
> Cheated of feature by dissembling Nature,
> Deform'd, unfinish'd, sent before my time
> Into this breathing world, scarce half made up,
> And that so lamely and unfashionable
> That dogs bark at me as I halt by them—
> Why, I, in this weak piping time of peace,

Have no delight to pass away the time,
Unless to see my shadow in the sun
And descant on mine own deformity.
And therefore, since I cannot prove a lover
To entertain these fair well-spoken days,
I am determined to prove a villain
.And hate the idle pleasures of these days.
Plots have I laid, inductions dangerous,
By drunken prophecies, libels, and dreams,
To set my brother Clarence and the King
In deadly hate the one against the other;
And if King Edward be as true and just
As I am subtle, false, and treacherous,
This day should Clarence closely be mew'd up
About a prophecy which says that G
Of Edward's heirs the murderer shall be.
Dive, thoughts, down to my soul! Here Clarence comes.[4]

Notice that Shakespeare gives us not only characters but also their positions: Edward the King, George the Duke of Clarence, Richard the little brother of them both. At the same time, we learn something crucial to the plot of the play: Richard intends to set up a situation in which Edward and George are at each other's throats. Additionally, we are exposed to Richard's attitude toward his brother the king when he mockingly speaks of Edward capering "nimbly in a lady's chamber..." where once he was an impressive and invincible man of war. And last, we learn not only of Richard's deformity but also of what that deformity has done to his ability to relate to other people, particularly women. He is not "shap'd for sportive tricks." Because he cannot play the lover, he will play the villain. Once Shakespeare lays out all this information, George walks onto stage ("Here Clarence comes"), and the ball gets rolling.

Similarly, if we take another, closer look at Robert Ferrigno's *The Horse Latitudes,* we can now see how he, too, is utilizing several elements to hook us into his story.

IT DIDN'T TAKE MUCH to set him off these days—laughter from the apartment below, a flash of blond hair out of the

corner of his eye. Or, late at night, the sound of two car doors slamming in quick succession. Especially that. He imagined them walking to his place or her place, both of them eager but trying not to let it show, holding hands, tentatively at first, then the man slipping his arm around her waist while she smiled and laid her head on his shoulder.

There were nights when Danny missed Lauren so bad that he wanted to take a fat man and throw him through a plate-glass window. Just for the sound of it. Instead, he went swimming in the bay.

The water was cold and dark and empty and he hadn't missed a swim in the four months and ten days since the divorce became final. He was going to drown one of these nights, or he was going to get over her—it was too early to tell which.[5]

He names his characters: Danny and Lauren. We don't know who they are yet, but because of Danny's attitude in the opening moments— that wonderful decision Ferrigno makes to use the image of throwing a fat man through a plate-glass window . . . just for the sound of it—we are intrigued. To those two elements of the hook, the writer adds the quirk of swimming at night in the bay. And then he finishes it off with "He was going to drown . . . or he was going to get over her—it was too early to tell which." We are with him; we are deeply with him through character, attitude, and quirk.

Sometimes, attitude alone can carry an opening. Examine how Ken Follett hooks us in *The Key to Rebecca*.

The last camel collapsed at noon.

It was the five-year-old white bull he had bought in Gialo, the youngest and strongest of the three beasts, and the least ill-tempered: he liked the animal as much as a man could like a camel, which is to say that he hated it only a little.

They climbed the leeward side of a small hill, man and camel planting big clumsy feet in the inconstant sand, and at the top they stopped. They looked ahead, seeing nothing but another hillock to climb, and after that a thousand more, and it

was as if the camel despaired at the thought. Its forelegs folded, then its rear went down, and it couched on top of the hill like a monument, staring across the empty desert with the indifference of the dying.

The man hauled on its nose rope. Its head came forward and its neck stretched out, but it would not get up. The man went behind and kicked its hindquarters as hard as he could, three or four times. Finally he took out a razor-sharp curved Bedouin knife with a narrow point and stabbed the camel's rump. Blood flowed from the wound but the camel did not even look around.

The man understood what was happening. The very tissues of the animal's body, starved of nourishment, had simply stopped working, like a machine that has run out of fuel. He had seen camels collapse like this on the outskirts of an oasis, surrounded by life-giving foliage which they ignored, lacking the energy to eat.

There were two more tricks he might have tried. One was to pour water into its nostrils until it began to drown; the other to light a fire under its hindquarters. He could not spare the water for one nor the firewood for the other, and besides neither method had a great chance of success.[6]

Follett deliberately keeps us in the dark with regard to the identity of the character involved in this scene. Doing that, he develops a fine sense of mystery and intrigue. Through the character's attitude toward the camel we become more involved because we're struck by his total indifference to the animal's suffering and by the extremes he's been willing to go to in order to get the camel up and moving once again. So Follett creates a terrific opening. He writes a first sentence that no reader is going to walk away from and then he moves forward, consistently drawing us into the world he's creating.

You can go further and make your entire first chapter the hook, ending it on a high point of action. But even if you do this, you'll also be attempting to create opening moments within that first chapter that in and of themselves serve to draw the reader into your story. Thus your decision—the first one you make in the process of creating

your rough draft—is how you're going to hook your reader. Will it be with a single sentence? With a paragraph or two? With an entire scene? With a chapter?

To make that decision, think about *where* you want your opening to occur. Ask yourself if you need to include a *specific detail* in that place that will add to its verisimilitude: A smashed jack-o'-lantern on the street can indicate time of year more effectively than your saying it directly; Christmas lights drooping from a porch can illustrate not only time of year but also atmosphere, mood, and tone. Look at your characters and decide which among them will best serve the purposes of your opening. Which among them, for instance, will best work to illuminate theme or plot or place? If there's dialogue in your opening, you'll need to think about *what* they're talking about and how this relates to the primary event that has set the action in motion. Is there a THAD that can illustrate character in a concise fashion, and can you use it in your opening? What are the agendas of the characters in your hook?

Your running plot outline should give you some of the answers to these questions. You'll derive even more answers from the decisions you are going to make about voice and point of view.

As There Is Viewpoint, So Is There Voice

I read the first prologue to my students last night, and as I read I could tell it wasn't right. I couldn't put my finger on why. It seemed too glitzy and commercial, which is what I said when I was done. But Mimsie put her finger on what was wrong, and she did it in her usual incisive fashion. She pointed out that Virginia Elliott was one-dimensional. And I had to confess that, although she's the POV character in the scene, I'd violated my first rule of writing out of sheer laziness and I'd not done a character analysis on her although I'd done analyses for the two other characters in the scene.

Journal of a Novel,
August 14, 1997

For some reason, these two concepts tend to be the most difficult for neophyte writers to grasp. I had a student once at the Maui Writers Retreat whom I finally had to refer in despair to another instructor because no matter how many ways I came up with to explain point of view and voice to him, he simply couldn't understand them.

Let me see if I can do a little better with you. I'll start with point of view.

To put this most simply, point of view is merely a decision the writer makes that will determine through whose eyes the story is going to be told. Bernays and Painter use the example of an automobile accident to illustrate point of view,[1] and I'll expand on that. If an accident occurs and the police show up to take reports on it, the telling of the

accident will differ slightly depending on whose point of view is being expressed. The person behind the steering wheel of the car that's demolished by the drunk driver will have a different "take" on the story than his passenger who wasn't wearing her seat belt and who went through the windshield as a result. The drunk driver will have yet another point of view. Those people on the street who witnessed the wreck will have another point of view. So will the paramedics who come upon the woman who went through the windshield. So will the firefighters who have to use the Jaws of Life to get the innocent driver out of his car.

In other words, as James Frey points out, point of view just refers to where the narrator stands in relation to the other characters and to the events in the story.[2] Is this person an unseen eyewitness who acts just like a journalist, giving "just the facts, ma'am"? Is this person an all-knowing power who can reveal the thoughts and feelings of the characters as the action plays out? Or is this person another character in the story? Come to think of it, does the point of view come from a *person* at all?

You have to have a point of view in the novel, and wise is the writer who makes her decision about point of view early in the process. This one element of the craft is crucial because it's part of how a writer dramatizes events.[3] It also is critical to how the story is structured (as you will see, I hope), and often it's part of the entire artistic idea behind the novel. Point of view will allow your readers to suspend their disbelief if it's used with consistency throughout the book. It also will establish something of an authority figure so that the story can become more believable, even if it's the most imaginative and outlandish piece of fiction ever written.

Since I'm suggesting that you choose your viewpoint early in the process, it would probably help you to know how to go about this. But first, you need to know what your choices actually are.

The first is the *objective viewpoint*. When a writer chooses this, she decides to remain outside the characters at all times. She's making a decision to write journalistically, like a reporter. Using this viewpoint, the writer gives us only the facts. What she doesn't give us are the thoughts and feelings of the characters. She doesn't give us their atti-

tudes, their concerns, their obsessions, their desires, or their plans. Indeed, anything that's part of a character's internal working is removed from the narration altogether.

This viewpoint is a tough one to carry off well. First of all, it's difficult to pare stories down to their essentials because in doing this, the writer has to trust the reader absolutely. She also has to trust her ability to affect the reader solely through an often terse depiction of events. She has to rely on the reader's imagination and on the reader's ability to empathize. She has to give up a portion of control over the reader as well as all attempts to manipulate him.

Consider these opening paragraphs from Ernest Hemingway's "Indian Camp."

AT the lake shore there was another rowboat drawn up. The two Indians stood waiting.

Nick and his father got in the stern of the boat and the Indians shoved it off and one of them got in to row. Uncle George sat in the stern of the camp rowboat. The young Indian shoved the camp boat off and got in to row Uncle George.

The two boats started off in the dark. Nick heard the oarlocks of the other boat quite a way ahead of them in the mist. The Indians rowed with quick choppy strokes. Nick lay back with his father's arm around him. It was cold on the water. The Indian who was rowing them was working very hard, but the other boat moved further ahead in the mist all the time.

"Where are we going, Dad?" Nick asked.

"Over to the Indian camp. There is an Indian lady very sick."

"Oh," said Nick.

Across the bay they found the other boat beached. Uncle George was smoking a cigar in the dark. The young Indian pulled the boat way up on the beach. Uncle George gave both the Indians cigars.

They walked up from the beach through a meadow that was soaking wet with dew, following the young Indian who carried a lantern. Then they went into the woods and followed

a trail that led to the logging road that ran back into the hills. It was much lighter on the logging road as the timber was cut away on both sides. The young Indian stopped and blew out his lantern and they all walked on along the road.

They came around a bend and a dog came out barking. Ahead were the lights of the shanties where the Indian bark-peelers lived. More dogs rushed out at them. The two Indians sent them back to the shanties. In the shanty nearest the road there was a light in the window. An old woman stood in the doorway holding a lamp.

Inside on a wooden bunk lay a young Indian woman. She had been trying to have her baby for two days. All the old women in the camp had been helping her. The men had moved off up the road to sit in the dark and smoke out of range of the noise she made. She screamed just as Nick and the two Indians followed his father and Uncle George into the shanty. She lay in the lower bunk, very big under a quilt. Her head was turned to one side. In the upper bunk was her husband. He had cut his foot very badly with an ax three days before. He was smoking a pipe. The room smelled very bad.

Nick's father ordered some water to be put on the stove, and while it was heating he spoke to Nick.

"This lady is going to have a baby, Nick," he said.

"I know," said Nick.

"You don't know," said his father. "Listen to me. What she is going through is called being in labor. The baby wants to be born and she wants it to be born. All her muscles are trying to get the baby born. That is what is happening when she screams."

"I see," Nick said.

Just then the woman cried out.

"Oh, Daddy, can't you give her something to make her stop screaming?" asked Nick.

"No. I haven't any anæsthetic," his father said. "But her screams are not important. I don't hear them because they are not important."

The husband in the upper bunk rolled over against the wall.[4]

We are closest to Nick, true. But we are not in his head. Instead, we remain at a distance from him while the objective narrator reports on the events as they occur. There is no editorializing. There is no delving into a character's psyche. There is just what happens. Because what happens in the story is ultimately so dreadful, the horror of it ends up being intensified by the very lack of internal reaction on the part of the characters. That, obviously, was Hemingway's point. These were, after all, "only Indians."

When the writer wishes to create an aura of intrigue about a character or a situation, she also can make a choice to use objective narration. Stephen King does just that in *The Dead Zone* with the mysterious Mr. Smith.

At 2:30 P.M. on December 26, 1978, Bud Prescott waited on a tall and rather haggard-looking young man with graying hair and badly bloodshot eyes. Bud was one of three clerks working in the 4th Street Phoenix Sporting Goods Store on the day after Christmas, and most of the business was exchanges—but this fellow was a paying customer.

He said he wanted to buy a good rifle, light-weight, bolt-action. Bud showed him several. The day after Christmas was a slow one on the gun-counter; when men got guns for Christmas, very few of them wanted to exchange them for something else.

This fellow looked them all over carefully and finally settled on a Remington 700, .243 caliber, a very nice gun with a light kick and a flat trajectory. He signed the gunbook John Smith and Bud thought, *If I never saw me an alias before in my life, there's one there.* "John Smith" paid cash—took the twenties right out of a wallet that was bulging with them. Took the rifle right over the counter. Bud, thinking to poke him a little, told him he could have his initials burned into the stock, no extra charge. "John Smith" merely shook his head.

When "Smith" left the store, Bud noticed that he was

limping noticeably. Would never be any problem identifying that guy again, he thought, not with that limp and those scars running up and down his neck.

At 10:30 A.M. on December 27, a thin man who walked with a limp came into Phoenix Office Supply, Inc., and approached Dean Clay, a salesman there. Clay said later that he noticed what his mother had always called a "fire-spot" in one of the man's eyes. The customer said he wanted to buy a large attaché case, and eventually picked out a handsome cowhide item, top of the line, priced at $149.95. And the man with the limp qualified for the cash discount by paying with new twenties. The whole transaction, from looking to paying, took no more than ten minutes. The fellow walked out of the store, and turned right toward the downtown area, and Dean Clay never saw him again until he saw his picture in the Phoenix *Sun*.

Late that same afternoon a tall man with graying hair approached Bonita Alvarez's window in the Phoenix Amtrak terminal and inquired about traveling from Phoenix to New York by train. Bonita showed him the connections. He followed them with his finger and then carefully jotted them all down. He asked Bonnie Alvarez if she could ticket him to depart on January 3. Bonnie danced her fingers over her computer console and said that she could.

"Then why don't you . . ." the tall man began, and then faltered. He put one hand up to his head.

"Are you all right, sir?"

"Fireworks," the tall man said. She told the police later on that she was quite sure that was what he said. *Fireworks*.

"Sir? Are you all right?"

"Headache," he said. "Excuse me." He tried to smile, but the effort did not improve his drawn, young-old face much.

"Would you like some aspirin? I have some."

"No, thanks. It'll pass."

She wrote the tickets and told him he would arrive at New York's Grand Central Station on January 6, at midafternoon.

"How much is that?"

She told him and added: "Will that be cash or charge, Mr. Smith?"

"Cash," he said, and pulled it right out of his wallet—a whole handful of twenties and tens.

She counted it, gave him his change, his receipt, his tickets. "Your train leaves at 10:30 A.M., Mr. Smith," she said. "Please be here and ready to entrain at 10:10."

"All right," he said. "Thank you."

Bonnie gave him the big professional smile, but Mr. Smith was already turning away. His face was very pale, and to Bonnie he looked like a man who was in a great deal of pain.

She was very sure that he had said *fireworks.*[5]

You're quite correct if you noticed that King veers slightly out of objective narration in the first section when he goes briefly into Bud's head for his thoughts. But that's the only moment in an otherwise objectively observed group of scenes.

What's important to keep in mind about this viewpoint is that it's going to offer the reader the least degree of intimacy. Its purpose is to keep readers at a distance from the story, to make them critical observers of events. If you want to hook them into the hearts and souls of your characters, this obviously would not be the viewpoint to use.

Omniscient viewpoint might work to do this, but of all the viewpoints this requires the most adept hand to keep the viewpoint *truly* omniscient and not just an excuse for an undisciplined sliding in and out of different characters' points of view. If you select this viewpoint, your narrator is a kind of god who speaks with godlike authority. The narrator knows, sees, and hears all. Doing this, the narrator enters into the mind of every character. The narrator has the freedom to explore everything and anything that supports the novel's theme, furthers the plot, or reveals character. If the writer has a strong literary style and—more important—something to say about characters, theme, setting, plot, period of time, etc., then omniscient might be just the ticket.

However, omniscient contains a little something that makes it extremely challenging. Done skillfully and done correctly, the omniscient narrator is *not* necessarily the viewpoint of the author. It's the

viewpoint of an all-knowing narrator who is brought on board *by* the author to relate or to render the events of the story. Hence, that omniscient narrator has to possess the single most important quality that the other viewpoints—save objective—possess. Voice. Along with that go tone and attitude. But we will get to that.

First let's take a look at a fine example of omniscient narration from the opening of Alice Hoffman's book *Second Nature*.

BY APRIL most people had already forgotten about him, except for some of the nurses on the floor, who crossed themselves when they walked past his room. The guard stationed outside his door, who had little to do but read magazines and drink coffee for more than three months, bragged to his friends that on nights when there was a full moon he needed a whip and a chair just to set a dinner tray on the other side of the door. But in fact, the guard had never even dared to look around the room, where the metal bed was made up with clean white sheets every week, though it had not once been slept in.

The man who occupied the room had no name. He refused to look anyone in the eye or, even after months of work with the speech therapists, to make any sound whatsoever, at least not in the presence of others. Officially he was listed as patient 3119, but among themselves the staff called him the Wolf Man, although they were expressly forbidden to do so. He was underweight and had a long scar along the inside of one thigh that had healed years before but still turned purple on cold or rainy days. For two months he'd needed to wear a cast on his reconstructed foot; otherwise he was in surprisingly good health. Since he had no birthday, the staff at Kelvin Medical Center had assigned him one. They'd chipped in to buy him a sweater, blue wool, on sale at Bloomingdale's, and one of the cooks had baked and frosted an angel food cake. But that was back in January, after he learned to use a fork and dress himself, and they'd still had hope for him. Now, they left him alone, and when he sat motionless, and sunlight came through the bars on his window, some of the nurses swore that his eyes turned yellow.

The evening before his transfer upstate, the barber was sent to his room. There would be no need to sweep the floor after his shave and haircut; the raven that had been perching on the window ledge was waiting to dart through the bars and gather up the hair to wind into its nest. One lab technician, who had been brave enough to look through the glass window in the door, had once seen the raven eating right out of his plate while the Wolf Man calmly continued with his dinner. Now, the raven watched as the attendants strapped the Wolf Man into a metal chair and held his head back. The barber wanted no chances taken; a human bite was the most dangerous of all. In the interest of speed, he used a razor rather than scissors, and while he worked he quickly recited a blessing.

The following morning, two attendants helped the Wolf Man into a black overcoat, which would be taken away once he settled into the State Hospital, since he'd never need it again and another patient could make use of it. The cook who had baked the angel food cake for his birthday wept. She insisted he had smiled when she lit the candles on the cake, but no one believed her, except the guard stationed at his door, who had been made so anxious by this bit of news that he took to biting his fingernails, close enough to the skin to draw blood.

The cook had discovered that the Wolf Man would not eat meat unless it was raw. He liked his potatoes unbaked as well, and would not touch a salad or a pudding. For his last meal, an early breakfast, she had simply passed a hamburger patty over a flame for a moment. So what if uncooked meat was bad for you, and most of the patients liked cereal and toast, she wanted him to have what he liked. She had an impulse to hide a knife or a screwdriver inside the folded napkin, because she knew that as soon as he'd eaten his breakfast, he would be handcuffed, then released into the custody of a social worker from the State Hospital for the ride along the Hudson. By afternoon he would be signed into a ward from which no one was ever released. But she didn't follow her impulse, and after the Wolf Man had his meal, the attendants dressed him and

helped him into the black overcoat, then clasped the handcuffs on him, quickly, from behind, before he could fight back.

Outside the door, the guard turned his Walkman up to the highest volume, and he slipped his sunglasses on, though the April sky threatened to storm. His friends liked to hear stories about the Wolf Man—how he crouched and circled three times before he curled up to sleep with his back against the wall, that five strong men were needed to hold him down each time they drew blood or inoculated him against measles and tetanus—and the guard was always happy to oblige. But what he never mentioned, as he drank cold beer with his friends, was that on nights when there was thunder he often heard a whimpering behind the door, a sound so pitiful it turned his bones cold and his heart inside out.[6]

What you should notice is that the omniscient narrator sounds like a storyteller. He or she relates events in a fashion similar to the objective narrator. But unlike the objective narrator, the omniscient gives us a sense of the history behind these characters at the same time as she reveals something of their hearts and minds. As you read, you have a definite sense of sinking into a story, of the tale enfolding you just as it might have done had you heard it while sitting around a campfire. A lot is explored in just a few pages because the omniscient narrator is not confined to the time or the place of an individual scene that's in the process of being rendered by a strong viewpoint character.

And that's the next group of viewpoints: the *character viewpoints.*

What this term means is that you're deciding to tell the story through the eyes of one or more characters who are generally taking an active part in it. When you use this point of view, then you make a promise to the reader that you will limit yourself to revealing *only* what your chosen viewpoint character would see, know, think, or feel in each scene in which that character is participating.

When it comes down to the character viewpoints, there are a gaggle of them, and they all stem from two sources: the single-character viewpoints and the multiple-character viewpoints. We'll take the single-character viewpoints first.

Most people are familiar with *first person*. Using this viewpoint, the writer creates a novel whose story is told by the main character. The operative word is *I*. Quite a few beginning writers employ this viewpoint because superficially it appears to be the easiest. That's not the reality, but we'll get to that in a moment. First, let's make sure we're all on the same page in our understanding of first person.

When a writer uses this, she stays with one narrator throughout the novel. She's in that character's head and no one else's, and that is the character who tells the reader the story. Doing this, she gives the reader a fine opportunity to identify strongly with the character.

The advantage here is that putting the reader in the skin and the psyche of someone intimately involved with the events that will unfold creates a terrific sense of intimacy and adds to the authenticity of the work. The lead character can explain his motives and his actions. He can make both credible. Consequently, he can make the entire story credible.

However, this viewpoint has its disadvantages, the most notable of which is the difficulty that can arise with plotting. A first-person narrator is on the stage at all times. This being the case, the step outline needs to indicate loudly, clearly, and in advance what the causal relationships are between scenes. Additionally, the reader can only see, hear, and know, what the narrator sees, hears, and knows. And finally, unless you're writing an autobiography, the first-person narrator's voice is *not* your voice. How could it be unless you're a character in your own novel?

If you love first person, definitely use it. Just remember that each time you write another novel in first person, you must develop a new voice for your narrator, providing you aren't writing a series in which the first-person narrator is always the same, like Kinsey Milhone in Sue Grafton's novels.

Look at the strong first-person viewpoint in the following by Susan Isaacs, from her novel *Shining Through*.

> In 1940, when I was thirty-one and an old maid, while the
> whole world waited for war, I fell in love with John Berringer.
> An office crush. Big deal. Since the invention of the steno pad,
> a day hasn't gone by without some secretary glancing up from
> her Pitman squiggles and suddenly realizing that the man who

was mumbling "... and therefore, pursuant to the above ..." was the one man in her life who could ever bring her joy.

So there I was, a cliché with a number 2 yellow pencil: a working girl from Queens who'd lost her heart to the pride of the Ivy League.

And to make matters worse, John Berringer bore absolutely no resemblance to the typical Wall Street international lawyer, the kind whose gray face was two shades paler than his suit. Sure, a girl could wind up losing her heart to one of those dreary men. There's nothing quieter than an old maid's bedroom, and in that black stillness it's so easy to create magic: A lawyer with the profile of a toad—Abracadabra!—is transformed into an Adonis, pulsating with passion under his pinstripes.[7]

Do you see how her narrator has a distinct personality? Do you see how she has a tone? Remember that. We'll be looking more closely at it when we turn to the topic of voice.

The other single-character viewpoint is *third person*. When you make the decision to use this narrative style, you tell the story through the eyes of a single character in the third person—*he* or *she*—and all the events in the novel are filtered through this single character's consciousness. You write *about* the character. Other than capturing his tone, you do not adopt his persona or walk in his skin.

The advantages to using this viewpoint are fairly similar to the advantages of first person. You are inviting your reader to become intimate with one character whose motivations can be thoroughly explored. You can render his individual experiences vividly for the reader. You need develop only one narrative voice.

The disadvantages are also the same, however. Once again, you submit yourself to the challenges of plotting since this one character will be in every scene, even if he isn't central to every scene. He has to emerge strongly in your work because he is your main if not your only chance to create a bond with the reader. If the reader is going to identify with any of the characters, it's likely to be the viewpoint character.

In the opening of *Havana Bay*, Martin Cruz Smith puts us firmly into the viewpoint of Arkady Renko.

A police boat directed a light toward tar-covered pilings
and water, turning a black scene white. Havana was invisible
across the bay, except for a single line of lamps along the sea-
wall. Stars rode high, anchor lights rode low, otherwise the
harbor was a still pool in the night.

Soda cans, crab pots, fishing floats, mattresses, Styrofoam
bearded with algae shifted as an investigation team of the
Policía Nacional de la Revolución took flash shots. Arkady
waited in a cashmere overcoat with a Captain Arcos, a barrel-
chested little man who looked ironed into military fatigues,
and his Sergeant Luna, large, black and angular. Detective
Osorio was a small brown woman in PNR blue; she gave
Arkady a studied glare.

A Cuban named Rufo was the interpreter from the
Russian embassy. "It's very simple," he translated the captain's
words. "You see the body, identify the body and then go
home."

"Sounds simple." Arkady tried to be agreeable, although
Arcos walked off as if any contact with Russians was contami-
nation.

Osorio combined the sharp features of an ingenue with
the grave expression of a hangman. She spoke and Rufo
explained, "The detective says this is the Cuban method, not
the Russian method or the German method. The Cuban
method. You will see."

Arkady had seen little so far. He had just arrived at the air-
port in the dark when he was whisked away by Rufo. They
were headed by taxi to the city when Rufo received a call on a
cellular phone that diverted them to the bay. Already Arkady
had a sense that he was unwelcome and unpopular.

Rufo wore a loose Hawaiian shirt and a faint resemblance
to the older, softer Muhammad Ali. "The detective says she
hopes you don't mind learning the Cuban method."

"I'm looking forward to it." Arkady was nothing if not a
good guest. "Could you ask her when the body was discov-
ered?"

"Two hours ago by the boat."

"The embassy sent me a message yesterday that Pribluda was in trouble. Why did they say that before you found a body?"

"She says ask the embassy. She was certainly not expecting an investigator."

Professional honor seemed to be at stake and Arkady felt badly outclassed on that score. Like Columbus on deck, Captain Arcos scanned the dark impatiently, Luna his hulking shadow. Osorio had sawhorses erected and stretched a tape that read NO PASEO. When a motorcycle policeman in a white helmet and spurs on his boots arrived, she chased him with a shout that could have scored steel. Somehow men in T-shirts appeared along the tape as soon as it was unrolled—what was it about violent death that was better than dreams? Arkady wondered. Most of the onlookers were black; Havana was far more African than Arkady had expected, although the logos on their shirts were American.

Someone along the tape carried a radio that sang, "*La fiesta no es para los feos. Qué feo es, señor. Super feo, amigo mío. No puedes pasar aquí, amigo. La fiesta no es para los feos.*"

"What does that mean?" Arkady asked Rufo.

"The song? It says, 'This party is not for ugly people. Sorry, my friend, you can't come.' "

Yet here I am, Arkady thought.[8]

Note that we experience Havana, Cuba, as Arkady himself experiences it. Because it's new and exotic to the character, Martin Cruz Smith has the freedom to paint the place intimately and even flamboyantly for us, seeing it as a stranger would see it, as he himself no doubt saw it when he went there to do his research.

For some writers, however, a single-character viewpoint is too limiting. They want the luxury of dwelling in many minds, so they choose one of the multiple character viewpoints, the first of which is *shifting first person*.

This sounds like someone with multiple personality disorder. In

reality it's a style of narrative in which each section of a novel or alternating chapters of a novel are told by a different first-person narrator. Some of the same events may be seen through different eyes as the story moves forward; frequently with this style of narration, a lot of time is covered in the course of the book.

The main challenge in choosing this style of narrative viewpoint comes from the fact that each *I* must be utterly distinct from the *I* that preceded it. Additionally, every time that *I* appears in the narrative, it must be consistent with its previous appearances in the novel. It must have a distinct tone, a distinct style, and a distinct syntax, and you must depend on your skill as a creator of character to make each *I* someone for whom the reader has some feeling.

Barbara Kingsolver does just that in *The Poisonwood Bible*. Here are three of her main narrators: Leah, Ruth May, and Rachel Price, sisters who are taken off to Africa on their father's mission to convert the natives.

First we hear from Leah.

WE CAME FROM BETHLEHEM, Georgia, bearing Betty Crocker cake mixes into the jungle. My sisters and I were all counting on having one birthday apiece during our twelve-month mission. "And heaven knows," our mother predicted, "they won't have Betty Crocker in the Congo."

"Where we are headed, there will *be* no buyers and sellers at all," my father corrected. His tone implied that Mother failed to grasp our mission, and that her concern with Betty Crocker confederated her with the coin-jingling sinners who vexed Jesus till he pitched a fit and threw them out of church. "Where we are headed," he said, to make things perfectly clear, "not so much as a Piggly Wiggly." Evidently Father saw this as a point in the Congo's favor. I got the most spectacular chills, just from trying to imagine.[9]

Her section is rich with both details and tone. We get a sense of a young girl fully aware of the irony of what she's telling us. We see her intelligence, and we get a feeling for her wit and her liveliness.

Then we hear from Ruth May.

GOD SAYS THE AFRICANS are the Tribes of Ham. Ham was the worst one of Noah's three boys: Shem, Ham, and Japheth. Everybody comes down on their family tree from just those three, because God made a big flood and drowneded out the sinners. But Shem, Ham, and Japheth got on the boat so they were A-okay.

Ham was the youngest one, like me, and he was bad. Sometimes I am bad, too. After they all got off the ark and let the animals go is when it happened. Ham found his father Noah laying around pig-naked drunk one day and he thought that was funny as all get-out. The other two brothers covered Noah up with a blanket, but Ham busted his britches laughing. When Noah woke up he got to hear the whole story from the tattletale brothers. So Noah cursed all Ham's children to be slaves for ever and ever. That's how come them to turn out dark.[10]

This narrator emerges as a completely different person from the other. Her tale is filled with indications of her innocence. She is exuberant and completely unprepared for what is to befall the family when they get to the Congo.

Then we hear from Rachel.

MAN OH MAN, are we in for it now, was my thinking about the Congo from the instant we first set foot. We are supposed to be calling the shots here, but it doesn't look to me like we're in charge of a thing, not even our own selves. Father had planned a big old prayer meeting as a welcome ceremony, to prove that God had ensued us here and aimed to settle in. But when we stepped off the airplane and staggered out into the field with our bags, the Congolese people surrounded us— *Lordy!*—in a chanting broil. Charmed, I'm sure. We got fumigated with the odor of perspirating bodies. What I should have stuffed in my purse was those five-day deodorant pads.

I looked around for my sisters to tell them, "Hey, Ade, Leah, aren't you glad you use Dial? Don't you wish everybody did?" I couldn't find either one of the twins but did catch sight

of Ruth May fixing to executrate her second swoon of the day. Her eyes were rolled back with mostly the whites showing. Whatever was pulling her under, I knew she was opposing it with all her might. Ruth May is surprisingly stubborn for a child of five and unwilling to miss out on any kind of a spree.[11]

If you notice Kingsolver's choice of language in the first paragraph alone, you can see how she creates in Rachel a character completely unlike Leah: "Man oh man" and "are we in for it now" and "big old prayer meeting" and "in a chanting broil." Leah's use of language is formal; Rachel's is casual. Add to this her occasional malapropism—"God had *ensued* us here" (italics are mine)—and the reader can visualize Rachel popping her chewing gum as she relates her story.

Kingsolver's challenge was to maintain the voices of the different narrators throughout the novel. She succeeded.

Shifting third person is the other multiple-character viewpoint. When a writer uses this, she is telling the story in the third person from the point of view of several characters: either scene by scene, chapter by chapter, or section by section. There is no viewpoint shift within a scene unless the writer can manage it seamlessly.

I love this viewpoint. It's the one I've so far used in all of my novels save two (in those I combined this viewpoint with first person). What I like about it is that I can show my readers what everyone is up to whenever it suits my purpose. Because I can go anywhere I like and into the head of any character at any time, I can build up the suspense, add to the tension, and heighten interest and excitement by leaving a character hanging at the end of a scene or a chapter and switching in the next scene or chapter to another character entirely.

The down side of using shifting third person, however, is that every time I create a different point of view, I have to create a slightly different tone and voice. And it has to be a subtle difference, rather than one that is broadly drawn. The differences between Leah, Rachel, and Ruth May, for example, are less subtle than you have to be when you're creating shifting third person.

Additionally, I have to be careful about how I pace the novel because too many narrators will slow it down. I also have to decide in advance which character is going to be the point-of-view character for

every scene. But these are small disadvantages as far as I'm concerned. The sheer fun and freedom afforded by shifting third person make them insignificant by comparison.

Here are a couple of examples of shifting third person from my novel *A Traitor to Memory.* The first is from the point of view of Ted Wiley, a retired military man who has just spied upon the woman he loves.

> IT WAS THE knowledge of a touch—reserved for him but given to another—that drove Ted Wiley out into the night. He'd seen it from his window, not intending to spy but spying all the same. The time: just past one in the morning. The place: Friday Street, Henley-on-Thames, a mere sixty yards from the river, and in front of her house from which they'd departed only moments before, both of them having to duck their heads to avoid a lintel put into a building in centuries past when men and women were shorter and when their lives were more clearly defined.
>
> Ted Wiley liked that: the definition of roles. She did not. And if he hadn't understood before now that Eugenie would not be easily identified as his woman and placed into a convenient category in his life, Ted had certainly reached that conclusion when he saw the two of them—Eugenie and that broomstick stranger—out on the pavement and in each other's arms.
>
> Flagrant, he'd thought. She *wants* me to see this. She wants me to see the way she's embracing him, then curving her palm to describe the shape of his cheek as he steps away. God damn the woman. She *wants* me to see this.[12]

Contrast that narration with the one that follows, told from the point of view of J. W. Pitchley, another character in the same novel.

> J. W. PITCHLEY, AKA TongueMan, had experienced an excellent evening. He'd broken Rule One—*never* suggest meeting *anyone* with whom one has engaged in cybersex—but it had all worked out, proving to him yet again that his instincts for

picking fruit past its prime but all the juicier for having hung
disregarded on the tree so long were as finely honed as a surgi-
cal tool.

Humility and honesty forced him to admit that it hadn't
been that much of a risk, however. Any woman who called her-
self CreamPants was as good as advertising what she wanted,
and if he'd had any doubts about that, five meetings on-line
that had had him coming into his Calvin Klein jockeys without
the slightest handshake of the organ on his part should have
set his mind at rest. Unlike his four other current cyber-
lovers—whose spelling skill was, alas, often as limited as their
imaginations—CreamPants had a capacity for fantasy that
cooked his brain and a natural ability to express that fantasy
that stiffened his cock like a divining rod the moment she
logged on the net.

Creamy here, she would write. *R U rdy 4 it, Tongue?*

Oh my. Oh yes. He always was.

So he'd taken the metaphorical plunge himself this time
instead of waiting for his cyberspondent to do so. This was
wildly out of character for him. Usually, he played along coop-
eratively, always there at the other end of on-line encounters
when one of his lovers wanted action but never venturing into
the arena of embodiment unless or until his partner suggested
it. Following this pattern, he'd successfully transformed exactly
twenty-seven Super Highway encounters into twenty-seven
intensely satisfying trysts at the Comfort Inn on Cromwell
Road—a wise and cautious distance from his own neighbour-
hood and night-clerked by an Asian gentleman whose memory
for faces took a far back seat to his abiding passion for videos
of old BBC costume dramas. Thus, only once had he found
himself the victim of a practical cyberjoke, agreeing to meet a
lover called DoMeHard and discovering two spotty-faced
twelve-year-olds dressed like the Kray brothers waiting for
him instead. No matter, though. He'd sorted them out quick
enough and he was fairly certain they'd not be trying *that* little
caper on-line again.[13]

What you should see is that despite being in third person, there is a distinct difference between the two narrative voices. Each has a different tone. Each reflects an entirely different way of viewing the world in general and women in particular.

When shifting third person is done well, the reader should be able to tell in whose point of view a scene is being written, even if the author never says the character's name.

The final viewpoint is *narrator as observer.* This wears the guise of first person because a secondary character tells the story. But unlike first person or shifting first person, this character is generally outside the main action. He may be on the fringe of the action, but he never directs the course of the action or affects it in any substantial way. What he knows he knows because he's been told or because he's witnessed it.

The best example of this is Dr. Watson from the Sherlock Holmes stories. He plays a part in the stories as Holmes's friend and compatriot. But when Holmes tells him that "the game's afoot," the reader may rest assured that Watson is going to be on the sidelines, cheering the detective on and not getting himself particularly muddy in the scramble.

Sometimes this style of narration is used if a character has a vested interest in telling the story. In *Oscar and Lucinda,* for example, Peter Carey gives us a narrator who is telling the story of his great-grandparents. He himself is never once in the book.

So. How do you decide which of the viewpoints to use?

Essentially, you make an informed decision that's based both on your personal preference and your level of skill. Beyond that, you start out by asking yourself which of the characters that you've designed can tell the story best. If you know that one of them can do it, you've settled on a single-character point of view. On the other hand, if you examine what you're intending to write (hence the importance of the expanded story idea and the step outline) and you see that there are many scenes with many characters, you may be heading for one of the multiple-character viewpoints. In this case, you will always begin the running plot outline of a scene by asking yourself which character can

best serve the interests of that scene. Finally, you ask yourself if you have a strong literary style and a lot to say about the idea of the book, the theme, the twists and turns of plot, the place, and the characters. If the answer is yes and if you have the firepower to create a strong narrative storyteller's voice, perhaps omniscient is the way for you to go.

Keep in mind, though, that no matter which of the points of view you choose, each of them can be further refined. Within first person, you can create a narrator who is completely reliable, committed to the truth like Jean Louise Finch in *To Kill a Mockingbird,* or one who is a devilishly clever liar like Dr. Sheppard in Agatha Christie's controversial *The Murder of Roger Ackroyd.* Additionally, this narrator can be likable or unlikable. And aside from laying out the story in a normal narrative fashion, first person can employ letters or journals as well.

Within third person, you can keep the reader close to the point-of-view character (this is what I like to do) or you can keep the reader at a distance from the character. Closeness implies an examination of the workings of the character's mind. Distance implies an observation of his actions.

Ultimately, the choice is yours. But here's the most important consideration about point of view: Written, it needs to reflect narrative voice. And it is *narrative voice* that's crucial to the success of your viewpoint choice, not the choice itself.

Voice: You Gotta Have 'Tude

Yesterday's writing was turgid. I realized ultimately that it was because it wasn't in Barbara's voice. I'd created an omniscient narrator's voice, and that narrator was using some of the most tortuous constructions in the English language. There was simply no way that I could conceive of to make it simple. Finally, I gave up at 11:00 last night, having written more than five pages, certainly, but also having to throw them all away. I realized as I lay in bed that the problem was that Barbara's voice was missing from the scene.

Journal of a Novel,
October 28, 1997

The critical element to point of view is something called *voice*. You've already seen examples of it in the previous chapter, and I've been alluding to it. Now let me define it.

Simply put, the narrative voice of your novel is the point-of-view character's defining way of speaking and thinking. Mind you, I'm not referring to the point-of-view character's style of *dialogue*, however. I'm referring to the tone that comes through the narrative itself when that point-of-view character is on stage, rendering a scene for the reader. If you've selected one of the single-character viewpoints, then the voice is going to be the same throughout the novel. If you've selected one of the multiple-character viewpoints, the voice will alter as each different point-of-view character renders a scene.

Perhaps the single most important thing to remember is that the voice of the point-of-view character is not *your* voice unless you are the character. So the voice of the point-of-view character is not your way of speaking and it's not your way of thinking. If it is, you're falling

down on the job as an artist, rather like Constable painting by numbers.

The logical question, then, is where does voice come from if it's not your own voice? And the answer: It comes from the character analysis you've created. If you've done your preliminary work assiduously, if you've designed a set of characters who spring to life for you as you read over their analyses, then as you highlight the most salient aspects of their personalities, their voices will emerge.

A character's voice comes from his background. It takes form from his education or lack thereof, from his position in society, from his personal and familial history, from his prejudices and biases, and from his inclinations and desires. It's molded by his belief system, by what he wants for his life, by his agenda in an individual scene, by his throughline—by which I mean his purpose, his goal—for the entire novel, and by his core need.

The nice part about voice is that you don't have to wander around in the dark as you attempt to create it. You have the character analysis to fall back on to gain a basic understanding of your character and then you have some specific ingredients that together make a voice come to life.

The first of these is a character's distinctive use of language. By this I mean how the character puts sentences together. Remember, I'm not talking about how he puts sentences together when he's speaking. Rather, I mean how he puts them together when he's thinking or writing.

Next, there is the character's vocabulary and his use of idioms. Within his point of view, a character has to use language that would be appropriate to his background and his circumstances. Check out the first page of *The Adventures of Huckleberry Finn* to get an idea of what I'm talking about.

Then there is the character's tone. The choice of words you use will develop the tone. It's exactly like the tone of someone's voice.

Finally and most important—and if you forget everything else, you must remember this—there is the character's *attitude*. More than anything that you can do to illustrate voice for your reader, the character's attitude will differentiate one character from another.

Consider the following example from my novel *Payment in Blood*.

HER NAME was Lynette. But as she sprawled beneath him, writhing hotly and moaning appreciatively at his every thrust, Robert Gabriel had to school himself to remember that, had to discipline himself not to call her something else. After all, there had been so many over the past few months. Who could possibly be expected to keep them all straight? But at the appropriate moment, he recalled who she was: the Agincourt's nineteen-year-old apprentice set designer whose skin-tight jeans and thin yellow jersey now lay in the darkness on the floor of his dressing room. He had discovered soon enough—and with considerable joy—that she wore absolutely nothing beneath them.

He felt her fingernails clawing at his back and made a sound of delight although he would have vastly preferred some other method of her signalling her mounting pleasure. Still, he continued to ride her in the manner she seemed to prefer— roughly—and tried his best not to breathe in the heavy perfume she wore or the vaguely oleaginous odour that emanated from her hair. He murmured subtle encouragement, keeping his mind occupied with other things until she had taken satisfaction and he might then seek his own. He liked to think he was considerate that way, better at it than most men, more willing to show women a good time.

"Ohhhh, don't stop! I can't stand it! I *can't!*" Lynette moaned.

Nor can I, Gabriel thought as her nails danced abrasively down his spine. He was three-quarters of the way through a mental recitation of Hamlet's third soliloquy when her ecstatic sobbing reached its crescendo. Her body arched. She shrieked wildly. Her nails sank into his buttocks. And Gabriel made a mental note to avoid teenagers henceforth.[1]

What you should notice is how Robert Gabriel's voice reflects his belief system, his narcissism, and his attitude toward women in general, among other characteristics. You should also notice that I achieve this, in part, by using particular words or phrases that reveal aspects of his character that are completely unlike those of, say, Thomas Lynley,

who's one of my main continuing characters. We're inside his head, living the scene through him, and because of this we need to relate to the situation as he relates to it. Consequently, we see him use term "ride her" in reference to the sex act when another character with a different attitude toward the woman with whom he was having intercourse might have used the term "make love" and yet another might have used "do it to her" and another might have used "fuck her." In each case, the act remains the same, but it becomes a prism that we turn each time we're examining a different character through it.

Contrast that encounter between Robert Gabriel and Lynnette with this one from *For the Sake of Elena* between Thomas Lynley and Lady Helen Clyde.

He felt her tremble slightly. He saw her throat work. He felt his heart open.

"Helen." He drew her into his arms. He took strength from knowing each gentle curve of her, from feeling the rise and fall of her chest, from the feathering touch of her hair against his face, from the slender hand that caught at his jacket. "Darling Helen," he whispered and ran his hand along the length of her hair. When she looked up, he kissed her. Her arms slipped round him. Her lips softened and opened beneath his. She smelled of perfume and Troughton's cigarette smoke. She tasted of brandy.

"Do you understand?" she whispered.

In reply, he drew her mouth back to his, giving himself over to nothing more than the separate sensations attendant to kissing her: the soft warmth of her lips and her tongue, the faint sound of her breathing, the heady pleasure of her breasts. Desire built in him, slowly obliterating everything but the knowledge that he had to have her. Now. Tonight. He wasn't prepared to wait another hour. He would take her to bed and to hell with the consequences. He wanted to taste her, to touch her, to know her completely. He wanted to take every lovely part of her body and to make her body his. He wanted to lower himself between her upraised thighs and hear her gasp and cry out when he sank inside her and . . .

I wanted to feel young resilient flesh I wanted to kiss breasts that were full and firm I wanted unveined legs and feet without callosity and IwantedIwantedIwanted . . .

He released her. "Good Christ," he whispered.

He felt her hand touch his cheek. Her skin was so cool. His own, he knew, was probably burning.

He stood. He felt shaken. He said, "I ought to get you back to Pen's."

"What is it?" she asked.

He shook his head blindly. It was, after all, so easy to construct lofty, intellectual, self-denigrating comparisons between himself and Victor Troughton, especially when he felt relatively sure that her response would be a loving and generous reassurance that he was not like other men. It was far more difficult to look at the matter when his own behaviour—his desires and his intentions—delineated the truth. He felt as if he'd spent the last few hours earnestly gathering the seeds of understanding, all of which he'd just flung mindlessly into the wind.[2]

See the difference? Lynley views Helen from a position of equals. He treasures her, and his attitude throughout the moment reflects this. He wants to possess her, yes. But it's a possession born of the desire to unite whereas Gabriel's is born of a desire to use.

Crucially, attitude reveals character just as it does in life itself. Look at how Lady Ursula's thoughts about a letter of condolence that she's received in P. D. James's *A Taste for Death* illustrates in a single paragraph the depth of her snobbery.

He must have written it as soon as Barbara had telephoned the news and had sent it round by one of his nurses who, in a hurry to get home after night duty, hadn't even stopped to hand it in but had slipped it through the letter box. He had used all the obvious adjectives. He hadn't needed a thesaurus to decide on the appropriate response. Murder, after all, was appalling, terrible, horrific, unbelievable, an outrage. But the letter, a social obligation too promptly performed, had lacked

conviction. And he should have known better than to have his secretary type it. But that, she thought, was typical. Scrape away the carefully acquired patina of professional success, prestige, orthodox good manners, and the real man was there: ambitious, a little vulgar, sensitive only when sensitivity paid. But much of this, she knew, was prejudice, and prejudice was dangerous. She must be careful to betray it as little as possible if the interview was to go the way she wanted. And it was hardly fair to criticize the letter. Dictating condolences to the mother of a murdered husband whom you've been busily cuckolding for the last three years would take more than his limited social vocabulary.[3]

Lady Ursula's son has been brutally murdered—his throat slit in the vestry of a church—and there she is, hardly in extremis about the matter, evaluating the lack of taste of the letter's author. The reader learns volumes about her in this paragraph, at the same time as learning something about the sender of the letter and his relationship to the deceased. It's all very economically done. No words are wasted.

What attitude does is to give the reader yet another way to connect to the characters and hence to the novel. Sometimes this happens because the reader shares a life experience with the character, one of those I've-been-there-too moments that cause a spark of recognition to flash between people. Sometimes it happens because the character couldn't be any less like the reader and consequently the reader's curiosity is piqued. In either case, attitude done well in a novel is pure delight, as is the case in *The Crown of Columbus,* where writers Michael Dorris and Louise Erdrich pit two utterly different narrative voices against each other. Here's one of them, Roger. He's a college professor, a type-A personality.

I despise a clutch that slips. A vehicle is the extension of oneself, the four-wheeled face one presents to the world, the ectoskeleton upon which one depends both for attracting others and for protection, if necessary, from them. A car announces its occupants. The medium is the message, the means that justifies

the end. When air travel deprives me of my vintage Saab—understated, elegant, secure—I don't begrudge the extra money spent for a quality rental. Nothing flashy, of course, nothing with a movable roof or that must be entered from a crouched position. I ask for midsize and hope to be bumped to full. I actually like leasing, the variety of exploring the gadgets of each new model: cruise control, electric mirrors, the random-scan button on the radio.

When Sydney Clock had quoted the steep fee he charged for one of his "Island Getaway" fleet, I hadn't blanched. Anything for mobility, for an air-conditioned refuge with a door that closed. Or so I had thought, not counting on the corrosive powers of salt air, on the results of casual maintenance, on the fact that when the winds of change, of catalytic converters and gasoline conservation, had swept the landmass of North America, a detritus of enormous, Detroit-made clunkers had been blown to the islands off shore.

Late on the afternoon of our arrival, Clock had presented me, in exchange for my substantial check, with a twin of the car in which I had ridden to my girlfriend's public high school senior prom. It was vaguely Chevrolet, tan and broad, with treadless tires as smooth and inflated as inner tubes. The upholstery of the bench front seat—odd how antique phraseology lay in wait at the back of one's mind—told tales of melodrama and passion, of passengers carrying sharp objects in their back pockets and drivers who ignored the ashtray when they smoked. The glove compartment was closed with a complicated twist of coat hanger, and the odometer read an incredible ninety-seven thousand miles.[4]

With the car as their tool, Dorris and Erdrich paint a compelling and amusing portrait of one of their two lead characters. The language and the syntax Roger uses are character specific, highly appropriate to his position as a university professor stuck on himself. You can almost hear his voice.

Vivian is the other lead character from the same novel. She could not be less like Roger, something that comes across loud and clear in her narration.

Nothing seems important when you're waiting for labor to start. Certainly not research. Shoving my way into the library, I spun the revolving door with such force that I ejected a surprised freshman in my wake. She stumbled outside, onto the lush, late summer grass with a small cry of outrage. I stopped just inside the door to marshal my temper. In my ninth month of pregnancy, I had grown strange in my moods, in turn belligerent and stupefied.

By day I was Assistant Professor Twostar, hotshot lecturer in anthropology, an authority, a professional woman as well as the decent, responsible mother of a provoking and eccentric sixteen-year-old son. Most evenings I was simply Vivian, sitting at home with the grandmother who raised and now lives with me, grading uninspired papers on the sun dance or "Custer's Last Stand: A New Perspective." Near my left hand I kept a bowl of cheese popcorn, near my right the controls to the satellite dish I had trained on the Nostalgia Channel. I would glance up from time to time at the black-and-white movies while Grandma grimly stitched together a baby quilt.

Today had been especially taxing, so I tried a relaxation technique I had learned from my midwife, Sara Thompson. I held my breath, let it out slowly. *Flow,* I told myself. *Lower your pulse rate and remember that your heart is beating for the baby, for the two of you.* Everything passes through the placenta, from beer to rage. Sara's words. At my first prenatal visit she had also demanded that I hand over my cigarettes. She had thrown them into her office sink and turned on the tap full force.

So now I was disgustingly healthy, and mad as hell.

Why mad? It was the fault of Christopher Columbus. Five months ago I had been asked—no, *ordered*—to submit a professional article on Mr. Navigator, and I hadn't made much headway.

Despite my heritage, a mixed bag of New and Old Worlds, I have other interests in life, and besides, I had seen the quincentennial of the discovery coming from a long way off. My primary urge, the same as every other sensible person of full or

partial American Indian descent, was to duck it. I was also pissed off because the only thing that fit me anymore was a denim jumper as big as a pup tent. I was mad because I was just . . . mad.[5]

Here we have the same two skilled writers at work, and an entirely different character with an entirely different voice emerging. Can you imagine the first narrator—our university professor, Roger—eating cheese popcorn, watching the Nostalgia Channel, or ever using the word *mad* in place of the correct word *angry*? No. Vivian is as unique in her voice as he is in his. Both are rich with feeling and attitude.

So if your story is good and your writing is competent but you still aren't setting the world of publishing on fire, check the voices in which your characters render the scenes they appear in. More important, check to see if each of the voices reveals 'tude.

Dialogue: Speak the Speech, If You Will

I received such an outstanding review for Deception on His Mind *yesterday that it made me really nervous. Several reviewers have talked about the fact that they can't wait to read my novels and that they're a little scared before they read them that I won't be able to maintain the quality I've had in them so far. Gee. They should be on this end of things if they're feeling scared. . . . How can I continue to maintain the quality? It seems to me that the only way I can do it is to take my time, to approach things thoughtfully.*

Journal of a Novel,
August 26, 1997

Everyone knows what dialogue is. Unless you've spent your life in a cave and only now are emerging, determined to become a writer, you will know that dialogue exists when two or more characters talk to each other on the printed page. It's as simple as that. Scene opens. Characters talk. Characters act. Characters do both simultaneously. Scene ends. In the most basic kinds of writing, dialogue serves the interests of moving the story forward. Characters reveal information, admit to knowledge, incite other characters to act, make accusations, lie about something, defend themselves or others, assert themselves, avoid confrontation, engage in confrontation, argue their points, distract their listeners, and deny important facts. In more complex and satisfying writing, however, when a character speaks, he also reveals himself. What he says and how he says it tell us as much about who he is as do his actions.

But even then, a writer using dialogue only to convey the story or to reveal the character isn't using dialogue to its fullest. Wielded by someone with skill, dialogue can serve all sorts of functions in a novel.

For example, it can act as a means of foreshadowing, foretelling events that may not occur for hundreds of pages. Or less, as is the case in Poe's "The Cask of Amontillado" when Fortunato tells Montressor, "I shall not die of a cough," and Montressor replies, "True—true," knowing full well that he's leading Fortunato to his death, ready to wall him up in the wine cellar.

Dialogue makes those events more vivid when they do occur. Fortunato's anguished "For the love of God, Montressor!" as the narrator is putting the last brick in place echoes not only in the story but also in the mind of the reader, especially this particular reader who's never forgotten either that terrible moment or Montressor's reply, "Yes. For the love of God!" I still get chills when I read those lines.

Relationships take on life through dialogue. They become more real than they could ever be just through narrative. This is because dialogue adds to the narrative's force. No longer are people being written *about*. They are now coming to life, actually taking part in a drama. When they come to life, so do the relationships between them.

Look at the dialogue in this moment between two of my main characters, DI Thomas Lynley and DS Barbara Havers in *For the Sake of Elena*. Lynley has been in Cambridge working on a case. Barbara has just joined him. Note how the nature of their dialogue illustrates the nature of their relationship even as it advances the plot.

> Sergeant Havers emerged from the buttery and descended the stairs from the terrace only moments after Lynley emerged from the library passage which connected Middle Court to North Court. She flipped her cigarette into a bed of asters and sank both hands into the pockets of her coat. Pea-soup green, it hung open to reveal navy trousers going baggy at the knees, a purple pullover, and two scarves—one brown and one pink.
>
> "You're a vision, Havers," Lynley said when she joined him. "Is this the rainbow effect? You know the sort of thing. Rather like the greenhouse effect but more immediately apparent?"

She rummaged in her bag for a packet of Players. She shook one out, lit it, and reflectively blew smoke in his face. He did his best not to lap up the aroma. Ten months without smoking and he still felt the urge to rip the cigarette from his sergeant's hand and smoke it to the nub.

"I thought I ought to blend in with the environment," Havers said. "You don't like it? Why? Don't I look academic?"

"You do. Certainly. By someone's definition."

"What could I hope to expect from a bloke who spent his formative years at Eton?" Havers asked the sky. "If I'd shown up in a top hat, striped trousers, and cutaway, would I have passed muster with you?"

"Only if you had Ginger Rogers on your arm."

Havers laughed. "Sod you."

"Sentiments returned." He watched her flick a bit of ash to the ground. "Did you get your mother settled at Hawthorn Lodge?"

Two girls passed them, holding a muted conversation, their heads together over a piece of paper. Lynley saw that it was the same hand-out which had been posted in front of the police station. His eyes went back to Havers, who kept her own on the two girls until they disappeared round the herbaceous border that marked the entrance to New Court.

"Havers?"

She waved him off, puffing on her cigarette. "I changed my mind. It didn't work out."

"What have you done about her?"

"Carrying on with Mrs. Gustafson for a bit. I'll see how it goes." She brushed her hand aimlessly over the top of her head, ruffling her short hair. The cold air made it crackle. "So. What d'we have here?"

For the moment, he submitted himself to her desire for privacy and gave her what facts he had gleaned from Sheehan. When he was finished telling her what he knew so far, she said:

"Weapons?"

"For beating her, they don't know yet. Nothing was left at

the scene, and they're still working on possible trace evidence on the body."

"So we've got the ubiquitous unidentified blunt object," Havers said. "And the strangulation?"

"The tie from the hood of her jacket."

"The killer knew what she would wear?"

"Possibly."

"Photos?"

He handed her the folder. She put her cigarette between her lips, opened the folder, and squinted through the smoke at the pictures that lay on top of the report. "Have you ever been to Brompton Oratory, Havers?"

She looked up. The cigarette bobbed as she spoke. "No. Why? Are you getting some of that old-time religion?"

"There's a sculpture there. The martyred St. Cecilia. I couldn't quite put my finger on what it was about this body when I first saw the pictures, but on the way back here it came to me. It's the sculpture of St. Cecilia." Over her shoulder, he fingered through the pictures to find the one he wanted. "It's the way her hair sweeps forward, the position of her arms, even the ligature round her neck."

"St. Cecilia was strangled?" Havers asked. "I thought martyrdom was more your basic lion-attack in front of a crowd of cheering, down-thumbing Romans."

"In this case—if I recall it correctly—her head was half-severed and she waited two days to die. But the sculpture only shows the cut itself, which looks like a ligature."

"Jesus. No wonder she got into heaven." Havers dropped her cigarette to the ground and crushed it out. "So what's your point, Inspector? Do we have a killer hot after duplicating all the sculptures in Brompton Oratory? If that's what's going on, when he gets to the crucifixion, I hope I'm off the case. *Is* there a crucifixion sculpture in the Oratory, by the way?"

"I can't remember. But all the Apostles are there."

"Eleven of them martyrs," she said reflectively. "We've got big trouble. Unless the killer's only looking for females."

"It doesn't matter. I doubt anyone would buy the Oratory theory," he said and guided her in the direction of New Court. As they walked, he listed the points of information he had gathered from Terence Cuff, the Weavers, and Miranda Webberly.

"The Penford Chair, blighted love, a good dose of jealousy, and an evil stepmother," Havers commented when he was done. She looked at her watch. "All that in only sixteen hours by yourself on the case. Are you sure you need me, Inspector?"

"No doubt of that. You pass for an undergraduate better than I. I think it's the clothes." He opened the door to L staircase for her. "Two flights up," he said and took the key from his pocket.[1]

Despite their patterns of speech (more on that in a moment), their interchange reveals the nature of their partnership. Here are a man and a woman who are comfortable with each other, who care for and about each other, who are familiar enough with each other to tease, who know what pushes each other's buttons. Their relationship is illustrated, and the plot moves forward. Simultaneously.

Beyond illustrating relationships, however, the dialogue in a novel can cause revelations to occur that will, in and of themselves, also propel the plot forward. Dialogue can also precipitate the climax of the novel as well as individual crises that lead up to that climax. In doing any of these things, it will probably also be delineating conflict.[2] And as you will no doubt recall, conflict is the key element of plot.

In his novel *Mystic River,* Dennis Lehane establishes his conflict up front through three young boys who will later become the three adult men in conflict with each other: a cop, a kidnap victim years after the kidnapping, and an ex-con hoodlum. In this scene, the three boys are contemplating stealing a car for a joyride. Notice how Lehane foreshadows his future conflict with this present one.

"How about this one?" Jimmy put his hand on Mr. Carlton's Bel Air, and his voice was loud in the dry breeze.

"Hey, Jimmy?" Sean walked toward him. "Maybe some other time. Right?"

Jimmy's face went all saggy and narrow. "What do you mean? We'll do it. It'll be fun. Fucking cool. Remember?"

"Fucking cool," Dave said.

"We can't even see over the dashboard."

"Phone books." Jimmy smiled in the sunlight. "We'll get 'em from your house."

"Phone books," Dave said. "Yeah!"

Sean held out his arms. "No. Come on."

Jimmy's smile died. He looked at Sean's arms as if he wanted to cut them off at the elbows. "Why won't you just do something for fun. Huh?" He tugged on the handle of the Bel Air, but it was locked. For a second, Jimmy's cheeks jiggled and his lower lip trembled, and then he looked in Sean's face with a wild loneliness that Sean pitied.

Dave looked at Jimmy and then at Sean. His arm shot out awkwardly and hit Sean's shoulder. "Yeah, how come you don't want to do fun things?"

Sean couldn't believe Dave had just hit him. Dave.

He punched Dave in the chest, and Dave sat down.

Jimmy pushed Sean. "What the hell you doing?"

"He hit me," Sean said.

"He didn't hit you," Jimmy said.

Sean's eyes widened in disbelief and Jimmy's mimicked them. "He hit me."

"He hit me," Jimmy said in a girl's voice, and pushed Sean again. "He's my fucking friend."

"So am I," Sean said.

"So am I," Jimmy said. "So am I, so am I, so am I."

Dave Boyle stood up and laughed.

Sean said, "Cut it out."

"Cut it out, cut it out, cut it out." Jimmy pushed Sean again, the heels of his hands digging into Sean's ribs. "Make me. You wanna make me?"

"You wanna make him?" And now Dave shoved Sean.

Sean had no idea how this had happened. He couldn't even remember what had made Jimmy mad anymore or why Dave had been stupid enough to hit him in the first place. One

second they were standing by the car. Now they were in the middle of the street and Jimmy was pushing him, his face screwed up and stunted, his eyes black and small, Dave starting to join in.

"Come on. Make me."

"I don't—"

Another shove. "Come on, little girl."

"Jimmy, can we just—?"

"No, we can't. You a little pussy, Sean? Huh?"

He went to shove him again but stopped, and that wild (and tired, Sean could see that, too, suddenly) aloneness pummeled his features as he looked past Sean at something coming up the street.

It was a dark brown car, square and long like the kind police detectives drove, a Plymouth or something, and its bumper stopped by their legs and the two cops looked out through the windshield at them, their faces watery in the reflected trees that swam across the glass.

Sean felt a sudden lurch in the morning, a shifting in the softness of it.[3]

What Lehane does in this brief section is what every writer aims to do with dialogue and what you must attempt to do with dialogue: Lehane gives it the look and the sound of natural speech even while he knows he cannot make it a *reproduction* of natural speech.

Think about it. Natural speech isn't fluid. It starts and stops. It wanders. Phrases are rethought halfway through and substituted with other phrases that are themselves rethought. If you were to write dialogue like that, it would be virtually unreadable and would come out looking like . . . well, like transcriptions of the Watergate tapes.

People of a certain age will remember those transcriptions quite well, day after day on the front page of their local newspapers. The Watergate tapes, with expletives carefully deleted, were printed verbatim in the newspaper, and because the transcription offered a *word for word* account of the conversations that went on in Richard M. Nixon's Oval Office—with all the starts, stops, *uhmms, wells,* and *expletive deleteds* —it looked as if the country were being run by numbskulls who

couldn't put together a coherent thought if a smoking gun were held to their collective heads. Of course, that turned out to be the case, but that's not the point. The point is that dialogue in a novel is not supposed to look like Watergate dialogue unless that character in the novel has a speech impediment, low-wattage brain power, synapses misfiring, or psychological problems, and the dialogue is being used to define his natural limitations.

Yet . . . dialogue needs to *seem* natural and real even when it can't *be* natural and real. So how does a writer achieve this?

First of all, it helps to develop an ear for people's speech patterns so that you can duplicate these patterns in your writing. Then keep in mind that the syntax you use will reveal volumes about character. Pedantic speech, for example, is unlike casual speech, which is itself unlike uneducated speech. Yet all three types of speech—and more— exist in real life and are available for you to use. To do so, though, you must begin by schooling yourself to *hear* these differences when people are speaking and then to remember them.

Additionally, use your imagination to bring appropriate idioms into a character's speech and to coin phrases that are peculiar to that character alone. In Craig Lesley's *The Sky Fisherman,* the narrator's uncle Jake—flamboyant and charismatic owner of a small-town sporting goods store—has a signature word he uses throughout the novel: *negatory,* In John Irving's *The Cider House Rules,* Dr. Wilbur Larch always refers to his collection of orphaned boys as "Princes of Maine, Kings of New England." Think of actor Wallace Shawn in *The Princess Bride* crying out "Inconc*ei*vable!" whenever his plan is foiled. In each of these cases, the expression used becomes a believable and unforgettable part of who the character is.

Having doubts about your ability to do any of this? Consider how the following affirmative statements could be used to make dialogue natural at the same time as they can be used to differentiate between characters. And all you're doing is changing the idioms:

Yes.

Yep.

Yeah.

Sure.

Whatever.

Surely.
I think you're right.
That's exactly spot on.
That notion is utterly splendid.

All of these are declarations of agreement; all of these represent the way people might actually speak in one station of life or another. Depending upon which you use in dialogue, you'd be revealing information about the character, but more important, you'd be giving the flavor of natural speech.

Sometimes speech patterns and idioms are broad. Sometimes they are obvious. If you're writing about characters from a region of the country known for its vernacular, this will be particularly true. William Faulkner, some might claim, had it easy. Writing about the deep South, he had copious examples of the common man's lingo upon which he could draw, as he does in this section from *Light in August.*

They enter the kitchen together, though Mrs. Armstid is in front. She goes straight to the stove. Lena stands just within the door. Her head is uncovered now, her hair combed smooth. Even the blue garment looks freshened and rested. She looks on while Mrs. Armstid at the stove clashes the metal lids and handles the sticks of wood with the abrupt savageness of a man. "I would like to help," Lena says.

Mrs. Armstid does not look around. She clashes the stove savagely. "You stay where you are. You keep off your feet now, and you'll keep off your back a while longer maybe."

"It would be a beholden kindness to let me help."

"You stay where you are. I been doing this three times a day for thirty years now. The time when I needed help with it is done passed." She is busy at the stove, not backlooking. "Armstid says your name is Burch."

"Yes," the other says. Her voice is quite grave now, quite quiet. She sits quite still, her hands motionless upon her lap. And Mrs. Armstid does not look around either. She is still busy at the stove. It appears to require an amount of attention out of all proportion to the savage finality with which she built

the fire. It appears to engage as much of her attention as if it were an expensive watch.

"Is your name Burch yet?" Mrs. Armstid says.

The young woman does not answer at once. Mrs. Armstid does not rattle the stove now, though her back is still toward the younger woman. Then she turns. They look at one another, suddenly naked, watching one another: the young woman in the chair, with her neat hair and her inert hands upon her lap, and the older one beside the stove, turning, motionless too, with a savage screw of grey hair at the base of her skull and a face that might have been carved in sandstone. Then the younger one speaks.

"I told you false. My name is not Burch yet. It's Lena Grove."

They look at one another. Mrs. Armstid's voice is neither cold nor warm. It is not anything at all. "And so you want to catch up with him so your name will be Burch in time. Is that it?"

Lena is looking down now, as though watching her hands upon her lap. Her voice is quiet, dogged. Yet it is serene. "I don't reckon I need any promise from Lucas. It just happened unfortunate so, that he had to go away. His plans just never worked out right for him to come back for me like he aimed to. I reckon me and him didn't need to make word promises. When he found that night that he would have to go, he— "

"Found out what night? The night you told him about that chap?"[4]

The speech of these two southern women is distinct and broadly depicted. We can tell something about their background and level of education from their choice of words and we can also tell generally where they're from because of the idioms and the syntax Faulkner uses in crafting their dialogue. When you have characters from a region known for a particular style of speaking, you have an easier time depicting natural dialogue that's also character specific.

Sometimes, however, you have to rely on more subtle ways to make dialogue crisp and distinct.

Look at this moment of confrontation between DI Thomas Lynley and DS Barbara Havers from my novel *In the Presence of the Enemy*.

Lynley powered the Bentley in the direction of the Thames. He gripped the steering wheel hard. He didn't know what to think about what he'd just learned, and he was trying like the devil to keep from reacting. Just get there, he told himself reasonably. Get there in one piece and ask your questions so you can understand.

Havers had followed him as he strode across the underground car park. She'd said, "Sir, listen to me," and had finally hooked on to his arm when he'd continued on his way without reply, deep in thought. She hadn't been able to stop him, however, so she had resorted to planting her chunky body in his path. She'd said, "Listen. You'd better not go over there now. Cool off first. Talk to Eve Bowen. Get the story from her."

He'd gazed at the sergeant, nonplussed by her behaviour. He'd said, "I'm perfectly cool, Havers. Head out to Wiltshire. Do your part. Let me do mine."

She said, "Perfectly cool? What bullshit. You're about to go off at half-cock, and you know it. If Bowen hired him to look for her daughter—and Webberly *said* not fifteen minutes ago that she did—then Simon's activities from that moment on were professional activities."

"Agreed. So, I'd like to gather the facts from him. It seems a logical place to begin."

"Stop lying to yourself. You're not after facts. You're after vengeance. It's written all over you."

Clearly, Lynley realised, the woman was mad. He said, "Don't be absurd. Vengeance for what?"

"You know what. You ought to have seen your face when Webberly said what everyone's been up to since Wednesday. You went white to the lips and you haven't recovered."

"Nonsense."

"Is it? Look. I know Simon. So do you. What do you think he was doing? Do you imagine he sat on his thumbs just wait-

ing for this girl to be found dead in the countryside? Is that what you think happened?"

"What happened," he said reasonably, "is the death of a child. And I think you'll agree that death might have been prevented had Simon, not to mention Helen, had the foresight to involve the police from the first."

Havers settled her hips. Her expression said *Gotcha*. Her words were, "And that's it, isn't it? That's at the root of what's bothering you."

"Bothering me?"

"It's Helen. Not Simon. Not even this death. Helen was into things up to her eighteen-carat-gold earrings and you didn't know. Right? Well? Am I right, Inspector? And *that's* why you're heading to Simon's house."

"Havers," Lynley said, "I've got things to do. Please get out of my way. Because if you don't remove yourself from my path immediately, you're going to find yourself assigned to another case."

"Fine," she said. "Lie to yourself. And while you're at it, pull rank and have done with it."

"I believe I just have done. And since this is your first opportunity to be at the head of at least one arm of an investigation, I suggest you consider your options wisely before you force my hand."

Her upper lip curled. She shook her head. "Holy hell," she said. "You can be a real prick." She turned on the heel of her high-top trainer and set off for her own car, slinging the strap of her canvas bag to her shoulder.[5]

We have no broad regional dialect here. But we do have distinct ways of speaking that, I can only hope, sound natural at the same time as they sound different from each other. Lynley's speech reflects his upper-class background, his level of education (Eton and Oxford), his position in society. So does Havers's. They each have a distinctive way of *using* language and neither of them uses language in the way I personally use language when I'm talking to someone.

If you still have doubts about what you can do with dialogue, then take one last look at the following example. Three different ways of asking for a glass of water:

Could I have some water, please?

Jay swaff, as they say in Paree.

Gimme some water.

Each request serves the same purpose—asking for water. But each reveals something completely different about the person who says it. This is character-specific dialogue, which is what all dialogue should aspire to be.

It would be nice if that's all dialogue ever had to do in a novel: be natural and highlight distinctions between characters. The frustrating fact is that it has to do much more. Besides seeming natural, besides revealing character, dialogue also must serve the interests of the plot by moving it relentlessly forward. In an individual scene it must also serve the action of that scene. It should pass along important information to the reader, and at all times it should be relevant to the plot, the conflict, the theme, the subplot, or the development of character. It needs to add to the growing tension in the story and it needs to keep moving. No sixty-three-page speeches from John Galt, please.

The trickiest bit about dialogue, though, is that it must do everything at once: every single thing I mentioned in this chapter. For that reason, it's the most difficult part of the process for a good many writers, including me.

Additionally, dialogue needs to be concise, avoiding either preaching or dealing with too many ideas at one time. While it can be used to give information, it should never be obviously expository. The line "You ought to see your goddamn face. Boy, you are as white as new undershorts and your lips look like liver" actually gives information about the listener at the same time as, through its language, it reveals something about the speaker. But the line "Listen to me. You're ten years older than your wife, Steve," is not an effective use of dialogue because, in telling the listener in the scene what he already knows, it acts as *obvious* exposition.

You may argue that that second example is the sort of thing people say all the time, and you'd be right. But remember: Dialogue is not supposed to be the sort of thing people say all the time. Think Watergate tapes, okay?

Tricks of the Dialogue Trade

I have a love-hate relationship with the writing life. I wouldn't wish to have
any other kind of life . . . and on the other hand, I wish it were easier. And it
never is. The reward comes sentence by sentence. The reward comes in the
unexpected inspiration. The reward comes from creating a character who lives
and breathes and is perfectly real. But such effort it takes to attain the reward!
I would never have believed it would take such effort.

Journal of a Novel,
December 15, 1997

It's good to remember that dialogue is yet another tool in the craft of
writing. A novelist can develop it with flair or breezily bounce through
it without realizing how much it can do to support every element of an
overall story.

There's so much *to* it: That's the beauty of dialogue.

Take the issue of subtext as a case in point. Subtext is what the
characters are really talking about beneath what they appear to be talk-
ing about in a scene. It comes from a writer's acute knowledge of who
her characters are and what their individual issues are. A character
with a core need of doing his duty, for example, is going to say things
possessing an entirely different subtext than a character with a core
need for constant excitement.

To understand subtext, let me show you two scenes. The first is
direct. A man and a woman on their honeymoon. The underpinning of
the scene is their love for each other. What they say is to the point.
They express themselves in a straightforward fashion with no attempt

to avoid the subject at hand through any means that one might use to avoid a subject: humor, distraction, outright denial, displacement, etc.

> Deborah rested her head against St. James' knee. His long, thin fingers moved gently through her hair, smoothing the curly mass back from her face. She looked up at him.
> "I'm afraid, Simon. I didn't think I would be, not once this last year, but I am." She saw in his eyes that he understood. Of *course* he did. Had she ever truly doubted that he would?
> "So am I," he replied. "Every moment today I felt just a little bit mad with terror. I never wanted to lose myself, not to you, not to anyone in fact. But there it is. It happened." He smiled. "You invaded my heart with a little Cromwellian force of your own that I couldn't resist, Deborah, and I find now that rather than lose myself, the true terror is that I might somehow lose you." He touched the pendant he'd given her that morning, nestling in the hollow of her throat. It was a small gold swan, so long between them a symbol of commitment: choosing once, choosing for life. His eyes moved from it back to her own. "Don't be afraid," he whispered gently.
> "Make love to me then."
> "With great pleasure."[1]

Here we have St. James and Deborah, two of my main continuing characters, on their wedding night as they speak of their mutual fears. The tone is quiet and reflective. The subject is directly addressed. Their conversation is mutually vulnerable as they get to the heart of the matter. If there is any subtext it all, it's that these two people love and trust each other.

If every section of dialogue in a novel were written that way, though, the book would begin to feel repetitive and tedious to the reader. It would lack balance, and it would have to fight to maintain the reader's interest in the characters. To offset the direct nature of dialogue having minimum subtext, then, you need to have scenes in which the dialogue is rich with subtext.

Consider the other romantic entanglement that I write about in my novels: the friendship, affair, and later marriage of DI Thomas

Lynley and Helen Clyde. Their relationship couldn't be less like the relationship between Deborah and St. James. They rarely talk to each other directly. At least, Helen rarely talks to her husband directly. Thus, much of the time they speak at cross purposes, something that arises from the subtext of their conversation, something that also heightens their occasional conflicts.

"Oh." The word was small. She went to the room's old Georgian dressing table and sat tentatively on the edge of its stool. She watched him gravely, a shadow playing across her cheek where her hair shielded her face from a shaft of sunlight that streamed in through the window. She looked so much like a schoolgirl waiting to be disciplined that Lynley found himself reassessing what he'd believed were his rational grievances against her.

He said, "I'm sorry about the row, Helen. You were giving your opinion. That's more than your right. I jumped all over you because I wanted you on my side. She's my wife, I thought, and this is my work and these are the decisions that I'm forced to take in the course of my work. I want her behind me, not in front of me blocking my way. I didn't think of you as an individual in that moment, just as an extension of me. So when you questioned my decision about Barbara, I saw red. My temper got away from me. And I'm sorry for it."

Her gaze lowered. She ran her fingers along the edge of the stool and examined their route. "I didn't leave the house because you lost your temper. God knows I've seen you lose it before."

"I know why you left. And I shouldn't have said it."

"Said . . . ?"

"That remark. The tautology bit. It was thoughtless and cruel. I'd like to have your forgiveness for having said it."

She looked up at him. "They were only words, Tommy. You don't need to ask forgiveness for your words."

"I ask nonetheless."

"No. What I mean is that you're already forgiven. You were forgiven at once if it comes to that. Words aren't reality,

you know. They're only expressions of what people see." She
bent and took up one of the wallpaper samples, holding it the
length of her arm and evaluating it for some moments. His
apology, it seemed, had been accepted. But he had the distinct
feeling that the subject itself was miles away from being put at
rest between them.

Still, following her lead, he said helpfully in reference to
the wallpaper, "That looks like a good choice."

"Do you think so?" Helen let it fall to the floor. "Choices
are what defeat me. Having to make them in the first place.
And having to live with them afterwards."

Warning flares shot up in Lynley's consciousness. His wife
hadn't come into their marriage the most eager of brides.
Indeed, it had taken some time to persuade her that marriage
was in her interests at all. The youngest of five sisters who'd
married in every possible circumstance, from into the Italian
aristocracy to on the land to a Montana cattleman, she'd been a
witness to the vicissitudes and vagaries that were the offspring
of any permanent attachment. And she'd never prevaricated
about her reluctance to become a party to what might take
from her more than it could ever give. But she'd also never
been a woman to let momentary discord prevail over her com-
mon sense. They'd exchanged a few harsh words, that was all.
Words didn't necessarily presage anything.

Still, he said to counter the implication in her statements,
"When I first knew that I loved you—have I ever told you
this?—I couldn't understand how I'd managed to go so long
blind to the fact. There you were, a part of my life for years,
but you'd always been at the safe distance of a friend. And
when I actually *knew* that I loved you, risking having more than
your friendship seemed like risking it all."

"It was risking it all," she said. "There's no going back after
a certain point with someone, is there? But I don't regret the
risk for a moment. Do you, Tommy?"

He felt a rush of relief. "Then we're at peace."

"Were we anything else?"

"It seemed—" He hesitated, uncertain how to describe the

sea change he was experiencing between them. He said, "We've got to expect a period of adjustment, haven't we? We aren't children. We had lives that were independent of each other before we married, so it's going to take some time to adjust to lives that include each other all the time."

"Had we." She said it as a statement, reflectively. She looked up from the wallpaper samples, to him.

"Had we what?"

"Independent lives. Oh, I see that you did. Who would ever argue with that? But as to the other half of the equation . . ." She made an aimless gesture at the samples. "I would have chosen flowers without a moment's hesitation. But flowers, I'm told by Charlie, are twee. You know, I never actually considered myself hopeless in the arena of interior design. Perhaps I've been kidding myself about that."

Lynley hadn't known her for more than fifteen years to fail in understanding her meaning now. "Helen, I was angry. Angry, I'm the first to climb on the highest horse I can find. But as you pointed out, what I said was words. There's no more truth in them than there's truth in suggesting I'm the soul of sensitivity. Which, as you know, I'm not. Full stop."

As he spoke, she'd begun setting the floral samples to one side. As he finished, she paused. She looked at him, head cocked, face gentle. "You don't really understand what I'm talking about, do you? But then, how could you? In your position I wouldn't understand what I was talking about either."

"I do understand. I corrected your language. I was angry because you weren't taking my side, so I responded as I believed you'd responded: to the form instead of to the substance beneath it. In the process, I hurt you. And I'm sorry for that."

She got to her feet, sheets of wallpaper held to her chest. "Tommy, you described me as I am," she said simply. "I left the house because I didn't want to listen to a truth I've avoided for years."[2]

A lot is going on between those two characters in that scene, and much of it is not expressed. The subtext—that which they are not

directly saying to each other—colors the scene at the same time as it grounds it in reality. People don't always say what they really mean. They don't always state their thoughts and their feelings directly. They sometimes talk around a topic instead of addressing themselves to it straightforwardly. When that's happening within a scene, you have subtext: what's *really* going on both inside and between two individuals.

If subtext enriches dialogue, tag lines and their accompanying modifiers identify dialogue. These are the words that precede, interrupt, or follow the dialogue, indicating who the speaker is.

Sometimes a writer just starting out thinks that she needs to be especially creative with her tag lines, believing that the repetition of *said* lacks snap and personality. Actually, *said* is a little miracle word that no one should abandon. What happens when a writer uses *said* in a tag line is that the reader's eye skips right over it. The brain takes in the name of the speaker, while the accompanying verb—providing it's the verb *said*—simply gets discarded. To a large extent, so do *asked, answered,* and *replied.*

But this isn't the case of all those fancier tag lines: *snarl, moan, snap, hiss, wail, whine, whimper, shout, groan, sneer, growl,* and all the rest of them. These call attention to themselves, and while you might use them judiciously—although, frankly, I discourage you from using them at all—and only when they suit the drama and the content of the scene you're writing, you must use them with the realization that they will leap out at the reader. The situation is this: When the writing (and of course by that I mean the writ*er*) is *really* doing its job, the reader will be aware that someone is shouting, snarling, thundering, moaning, or groaning. The scene will build up to it, so the writer doesn't have to use any obvious words to indicate the manner in which the speaker is speaking.

Sometimes adverbs can help you out, but just like the intense tags listed in the previous paragraph, adverbs are something a writer needs to be careful with. An adverb can add a degree of precision to a tag, such as *said numbly.* But if you're using adverbs, you need to keep in mind that the reader's attention will then be drawn to *how* the line of dialogue is said rather than to *what* is said. I call the editor of my first twelve Lynley novels the queen of adverbs, by the way. She put them in; I took them back out.

Let me stress that I'm not advocating the complete renunciation of precise tags or of adverbs. I'm just recommending that you use both of these sparingly, remembering the effect that they're going to have on the scene you're creating. If your dialogue is distinct enough for each character, you can run an entire scene without tag lines at all. This is risky writing, but when it works, it *works*.

Be careful about junk words, too. Delete them from your dialogue. In real life, people begin sentences all the time by saying the word *well*. they do it without thinking, and their listeners just filter the word out. But in written dialogue in a novel, words like that are going to clutter up a page and become an irritant to the reader. Use those words if they're idiomatic (such as a Valley girl using the words *like* or *so* as in, "She was, like, so not there, wasn't she?"). Use them if they illustrate character. Otherwise, don't use them at all.

Which brings us to dialect, doesn't it? Here we have much the same consideration as we have when we're considering *said* versus another tag that looks more precise. If the dialect you're creating uses phonetic spelling and misspelled words, it's going to draw attention to itself. If that's your intent, then do it. Otherwise, give the flavor of dialect by making a careful choice of words peculiar to the region where our story takes place and recognizable to the reader at the same time.

I reckon.

Aye.

Give him over to the rozzers.

Can't taste no worse.

Get outa here, bud.

Yo! How's doing?

Suggest dialect rather than go for full dialect. The reader will get it and you'll save yourself a lot of headaches about two hundred pages into your rough draft.

Foreign speech, however, is different from dialect, and there are probably as many ways of doing it as there are ways of writing and people to do the writing. In James Clavell's *Shogun* in which a lot of dialogue is in Japanese, the author generally wrote an immediate translation in English after the line of dialogue. This worked because the lines

were short enough to accommodate the technique, and once Clavell assumed that the reader had probably caught on to specific phrases, he stopped translating them in the text.

It's less awkward to employ a device that allows for a translation from context. That's what occurs in the following example.

"Frijoles, señor?" *the woman said. She extended the plate to him.*

He ate. The beans were cold, and a puddle of congealed cheese lay inertly on top of them like something disgorged from the belly of a cat.

The action that follows her line of dialogue identifies exactly what *frijoles* are, should the reader not know.

No matter what kind of dialogue you're creating, though, what's important is to sustain the reader's interest and to avoid occasions in which you might lose the reader's interest, occasions like long speeches during which the reader simply checks out of the hotel.

But sometimes a long speech is called for. There's a tale to be told, and to tell it in rapid-fire, high-interest dialogue between two characters is not going to work. If that's the case, then you have a few options to consider to keep your reader with you.

You can show that what's about to be said is important by beginning it in an important way: "Those bastards! Those *bastards!* You hear what they did to old Tom Watkins?" Now you have the reader's attention.

You can maintain that attention by recording the other characters' reactions to the speech: the gesture, the significant start, the ill-considered remark. You can also interrupt the speech with a moment of thematically related action: the cat slinking along with a dead rat in his jaws, the sound of voices outside the room in which the story is being told, the wind against the windowpane, the song on the radio overheard as a car passes. All of these work to maintain the reader's interest, which is job one for the writer at all times.

Keep in mind, though, that dialogue isn't always appropriate and it isn't always necessary even if the information contained in the dialogue is. Just for purposes of abbreviating a scene or changing the pace of it or giving the reader a breather from dialogue, a writer can choose to put what would otherwise be spoken words into indirect dialogue. This is merely a summarized form of dialogue told in narrative style. Look at this example from E. M. Forster's *A Passage to India*.

To drag in everyone was precisely the barrister's aim. He then suggested that the lawyer in charge of the case would be a Hindu; the defence would then make a wider appeal. He mentioned one or two names—men from a distance who would not be intimidated by local conditions—and said he should prefer Amritrao, a Calcutta barrister, who had a high reputation professionally and personally, but who was notoriously anti-British.

Fielding demurred; this seemed to him going to the other extreme. Aziz must be cleared, but with a minimum of racial hatred. Amritrao was loathed at the club. His retention would be regarded as a political challenge.

"Oh no, we must hit with all our strength. When I saw my friend's private papers carried in just now in the arms of a dirty policeman, I said to myself, 'Amritrao is the man to clear up this.'"

There was a lugubrious pause. The temple bell continued to jangle harshly. The interminable and disastrous day had scarcely reached its afternoon. Continuing their work, the wheels of Dominion now propelled a messenger on a horse from the Superintendent to the Magistrate with an official report of arrest. "Don't complicate, let the cards play themselves," entreated Fielding, as he watched the man disappear into dust. "We're bound to win, there's nothing else we can do. She will never be able to substantiate the charge."[3]

Here, in the middle of a long scene in which the characters discuss various options for the defense of Aziz, an Indian accused of raping an Englishwoman, Forster allows part of the dialogue to be indirect. What this does is alter the pacing of the scene, but it also allows what would otherwise be a fairly large section of dialogue to be concentrated into a few paragraphs. It's an economical way to move the scene forward while still allowing the reader to understand that a lengthy discussion is ensuing. The content of the immediate discussion isn't as important as the outcome of it, which is why indirect works well at this juncture in the scene. (I hope you also noticed the thematically related interruption in the scene: the jangling of the temple bell.)

What the writer can do with indirect, then, is to condense speech and alter pace. But indirect can still reveal a character's attitude even as it also can emphasize important parts of the dialogue.[4]

When you've managed to get your dialogue all written for a scene, then you're ready to evaluate it, which is actually the easiest part of the whole crafting process. Read it through and look specifically to see if it adds tension to the scene you're writing and if it demonstrates part of the conflict between characters. Make sure that each character speaking sounds only like himself and not like any other character. Then ask yourself if it's free from clichés, unless the character in question is supposed to speak in clichés like Polonius to Laertes. Determine whether the dialogue is also revealing some aspect of the character speaking or the character listening. Finally, look at the scene in its entirety and decide if any of the dialogue would be better expressed as indirect rather than direct.

Be critical of but not brutal with your writing. If something isn't essential, get rid of it. Remember that good dialogue can serve a whole passel of purposes in your novel, and to overlook one of them is to overlook one of the tools of the craft. Like hitting a nail with a screwdriver, if you know what I mean.

The Scene: Okay, So It *Is* Rocket Science

In reading Annie Dillard today, I realized that what makes her an excellent writer is that she's outside of herself. She not only observes keenly, but she also appreciates greatly. She applies this observation to nature and then uses nature as a metaphor for the writing process. In my case, I'm perhaps (make that likely) too grounded in the self. You have to be able to get out of your own way when you're writing, to do it unselfconsciously, to swim in it as if it were a river and the words are just carrying you along like the current. In fact, you aren't swimming at all if you're writing well. You're being carried. Swimming implies a lack of freedom from the restrictions of self. You no longer battle until you're weary-armed. You just are.

Journal of a Novel,
January 14, 1998

All that I've shared with you so far begs the real question: How do you *write* it? It being the book. "One word at a time" is the coy answer (like the incredibly helpful response I heard a writer give a student asking how to write good dialogue: "Open a vein." Now *that* was really useful.). The answer I prefer to give is this: If you see your novel as a collection of causally related scenes, you just write the book one scene at a time.

You begin this process by deciding whether you need a scene at all, given where you might be in the novel. You might not need a scene. You might do well with simple dramatic narration for the place you are in the book.

Using this latter form of storytelling, you're crafting a section of

the novel in which a narrator *relates* actions rather than *renders* them. This can be done in summary fashion, in which case you have something we call summary narration. Or it can be done in lengthy fashion in which characters grow and develop, in which conflicts brew (both inner and outer), and in which other tools of the craft—such as figurative language—are employed. Consider this example from Jim Harrison's novella "Revenge."

You could not tell if you were a bird descending (and there was a bird descending, a vulture) if the naked man was dead or alive. The man didn't know himself and the bird was tentative when he reached the ground and made a croaking sideward approach, askance and looking off down the chaparral in the arroyo as if expecting company from the coyotes. Carrion was shared not by the sharer's design but by a pattern set before anyone knew there were patterns. The vulture had just eaten a rattler run over by a truck outside of Nacozari de Garcia, a little town well off the tourist run about a hundred miles from Nogales. The coyotes would follow the vulture's descent out of curiosity whether or not they were hungry from the night's hunt. As the morning thermals developed more vultures would arrive until the man's dying would have an audience.

As the dawn deepened into midmorning and the heat dried and caked the blood on the man's face, the blood lost most of its fresh coppery odor. The man was dying fitfully now, more from the heat and dehydration than from his injuries: an arm twisted askew, chest a massive blue bruise, one cheekbone crushed in with a hematoma rising like a purple sun, his testicles inflated from a groining. And a head wound that darkened the sand and pebbles and drew him down into his near fatal sleep of coma. Still, he kept breathing, and the hot air whistled past a broken tooth and when the whistle was especially loud the vultures were disturbed. A female coyote and her recently weaned pups stopped by but only for a moment: she snapped at the pups saying this pitiful beast is normally dangerous. She nodded in passing to a very large, old male coyote who watched with intense curiosity from the

shadow of a boulder. He watched, then dozed, even in sleep owning an alertness unknown to us. His belly was full of javelina and watching this dying man was simply the most interesting thing to happen his way in a long time. It was all curiosity though: when the man died the coyote would simply walk away and leave it to the vultures. And it had been a long vigil for him, having been close by when the naked man had been thrown from the car the night before.

In the first comparative coolness of the evening a Mexican peasant (*peóne* in Mexican slang) and his daughter walked along the road making short forays into the brush for stray pieces of mesquite firewood. Rather, the man walked doggedly under his light load of wood and the daughter pranced, hopping from one foot to another, skipping, running then waiting for her father. She was his only child and he wouldn't let her pick up firewood for fear she would be bitten by a scorpion, or a *corallo,* a coral snake which unlike the rattlesnake gave no warning though it was shy and retiring and meant no harm. It simply bit when cornered or provoked, then slid away and calmed its nerves under another log or stone. The daughter carried a bible. She helped in the kitchen of the Mennonite mission where her father had long been the custodian.

The daughter began to sing and that flushed the vultures still another hundred yards down the road. They were about to leave anyway for the safety of their mountain rookery before evening deepened. The coyote withdrew a little farther into the gathering shadows. He recognized the voices of the man and his daughter and knew from the seven years of his life that they weren't dangerous to him. He had watched them on their way to the mission countless times but they had never seen him. The great birds flushing in the evening sun aroused the curiosity of the father and he quickened his pace. He had a hunter's inquisitiveness, not unlike the coyote's, and he remembered the time when he had found a large deer freshly fallen from an escarpment by following a descending gyre of vultures. He told his daughter to wait at a distance and he cautiously entered the

dense chaparral along the road. He heard a rush of breath and a faint whistle and quickly opened a long pearl-handled knife. He crept noiselessly toward the whistling, smelling a trace of blood amidst the vulture dung. Then he saw the man and whistled himself, kneeling to feel the pulse. At odd times he had accompanied the missionary who was also a doctor on his treks into the mountains and he had learned the elements of first aid. Now he stood, whistled again in unison with the dying man, and looked at the sky. He was mostly Indian and his first thought was to simply walk away and avoid any contact with the Federales. But then the doctor was friends with the Federales and the man remembered the parable of the good Samaritan and looked back down at the body somewhat fatalistically, as if to say, I'll help but I think it's too late.

He came out of the brush and sent his daughter running to the mission a half mile down the valley. He squatted in the roadway and rolled pebbles back and forth with the blade of his knife. The sight of someone so gravely injured had quickened his heartbeat but he coolly rehearsed his story of finding the body. In his youth, in addition to being a hunter, he had been a small-time bandit and he understood that when speaking to authorities it was best to keep things simple.[1]

This is dramatic narration. The omniscient narrator gives us the facts of what occurred. There is no dialogue. An entire short story could have come from the discovery of the dying man's body instead of just the opening of the novella itself.

Contrast that with this next example, which is still dramatic narration but which is instead *summary* narration from *A Passage to India*.

So the cavalcade ended, partly pleasant, partly not; the Brahman cook was picked up, the train arrived, pushing its burning throat over the plain, and the twentieth century took over the sixteenth. Mrs. Moore entered her carriage, the three men went to theirs, adjusted the shutters, turned on the electric fan and tried to get some sleep. In the twilight, all resembled corpses, and the train itself seemed dead though it

moved—a coffin from the scientific north which troubled the scenery four times a day. As it left the Marabars, their nasty little cosmos disappeared, and gave place to the Marabars seen from a distance; finite and rather romantic. The train halted once under a pump, to drench the stock of coal in its tender. Then it caught sight of the main line in the distance, took courage, and bumped forward, rounded the civil station, surmounted the level-crossing (the rails were scorching now), and clanked to a standstill. Chandrapore, Chandrapore! The expedition was over.

And as it ended, as they sat up in the gloom and prepared to enter ordinary life, suddenly the long drawn strangeness of the morning snapped. Mr. Haq, the Inspector of Police, flung open the door of their carriage and said in shrill tones: "Dr. Aziz, it is my highly painful duty to arrest you."[2]

E. M. Forster ends his characters' fateful visit to the Marabar caves. He moves them from the caves to the train and on the train to their destination. He does this quickly and economically, with no fully explored scene. The mood is somber—hardly anything else being possible when the cars of the train are compared to coffins!—and the story plunges into more complications with the arrest of the good Dr. Aziz at the end of the narrative section. This works very well for Forster's purposes. There was need to get the characters from the caves to their homes, but there was no need to dwell on what happened on the way. Dramatic narration was called for. *Summary* narration did the trick.

More often, however, you're going to want to create a scene in which the point-of-view character or the omniscient narrator renders actions as they occur, allowing the reader to be a witness to the activities of the characters, an eavesdropper on their conversations. A scene fully played out can be long or, as in the following example, it can be quite concise.

Melvin Johns hadn't intended to make love. He had met Tracy at their usual place, the gate leading to the towpath, and they had walked together, her arm tucked under his, her thin body hugging against his until they came to their secret place,

the patch of flattened grass behind the thick elderberries, the straight, dead stump of tree. And it had happened, as he knew it would. The brief, unsatisfactory spasm and what went before were no different than they had always been. The potent smell of loam and dead leaves, the soft earth under his feet, her eager body straining under his, the smell of her armpits, her fingers scratching at his scalp, the scrape of the bark of the tree against his cheek, the gleam of the canal seen through a thicket of leaves. All over. But afterwards the depression that always followed was worse than he had ever known. He wanted to sink into the earth and groan aloud. She whispered:

"Darling, we have to go to the police. We must tell them what we saw."

"It wasn't anything. Just a car parked outside the church."

"Outside the vestry door. Outside where it happened. The same night. And we know the time, about seven o'clock. It could be the murderer's car."

"It isn't likely he'd be driving a black Rover, and it isn't as if we noticed the number, even."

"But we have to tell. If they never find who did it, if he kills again, we'd never forgive ourselves."

The note of unctuous self-righteousness nauseated him. How was it, he wondered, that he'd never noticed before that perpetual whine in her voice. He said hopelessly:

"You said your dad would kill us if he knew we'd been meeting. The lies, telling him you were at evening classes. You said he'd kill us."

"But, darling, it's different now. He'll understand that. And we can get engaged. We'll tell them all that we were engaged."

Of course, he thought, suddenly enlightened. Dad, that respectable lay preacher, wouldn't mind as long as there was no scandal. Dad would enjoy the publicity, the sense of importance. They would have to marry. Dad, Mum, Tracy herself, would ensure that. It was as if his life were suddenly revealed to him in a slow unwinding reel of hopelessness, picture suc-

ceeding picture down the inescapable years. Moving into her parents' small house; where else could they afford to live? Waiting for a council flat. The first baby crying in the night. Her whining, accusing voice. The slow death, even of desire. A man was dead, an ex-Minister, a man he had never known, never seen, whose life and his had never until this moment touched. Someone, his murderer or an innocent motorist, had parked his Rover outside the church. The police would catch the killer, if there was a killer, and he would go to prison for life and in ten years he would be let out, free again. But *he* was only twenty-one and *his* life sentence would end only with his death. And what had he done to deserve his punishment? Such a little sin compared with murder. He almost groaned aloud with the injustice of it.

"All right," he said with dull resignation. "We'll go to the Harrow Road police station. We'll tell them about the car."[3]

Here in two brief pages, P. D. James plays out an entire scene in *A Taste for Death*. She places us firmly inside her point-of-view character's head, and the scene contains not only the conflict he faces but also the resolution to the conflict. Interestingly, this is the only time these two characters appear in the novel, serving the function of passing along valuable information to the police. But rather than just having one of the investigators report that an unnamed couple saw a car parked in front of the church on the night of the murder, the author instead allows us to see these characters *in situ*. As a result, she adds to the verisimilitude of the work.

There are also times, however, when a fully rendered scene isn't necessary. These times generally arise with omniscient narration since the narrator can bounce around, in and out of people's heads, in and out of settings, in and out of time periods if she feels like it. That's what John Irving does in the following selection from *Cider House Rules*.

He was nothing (Homer Wells) if not of use. His sense of usefulness appears to predate Dr. Larch's instructions. His first foster parents returned him to St. Cloud's; they thought there was something wrong with him—he never cried. The foster

parents complained that they would wake to the same silence that had prompted them to adopt a child in the first place. They'd wake up alarmed that the baby hadn't woken them, they'd rush into the baby's room, expecting to find him dead, but Homer Wells would be toothlessly biting his lip, perhaps grimacing, but not protesting that he was unfed and unattended. Homer's foster parents always suspected that he'd been awake, quietly suffering, for hours. They thought this wasn't normal.

Dr. Larch explained to them that the babies of St. Cloud's were used to lying in their beds unattended. Nurse Angela and Nurse Edna, dearly devoted though they were, could not be rushing to each and every baby the second it cried; crying was not of much use at St. Cloud's (though in his heart of hearts Dr. Larch knew very well that Homer's capacity for withholding tears was unusual even for an orphan).

It was Dr. Larch's experience that foster parents who could so easily be deterred from wanting a baby were not the best parents for an orphan. Homer's first foster parents were so quick to assume they'd been given a wrong one—retarded, a lemon, brain-damaged—that Dr. Larch didn't extend himself to assure them that Homer was a very fit baby, bound to have a courageous long haul in the life ahead.

His second foster family responded differently to Homer's lack of sound—his stiff-upper-lip and bite-the-bullet-while-just-lying-there placidity. His second foster family beat the baby so regularly that they managed to get some appropriately babylike noise out of him. Homer's crying saved him.

If he'd proven himself to be stalwart at resisting tears, now when he saw that tears and howls and shrieks seemed to be what his foster family most desired of him, he tried to be of use and gave, with his whole heart, the lustiest wails he could deliver. He had been such a creature of contentment, Dr. Larch was surprised to learn that the new baby from St. Cloud's was disturbing the peace in the fortunately small and nearby town of Three Mile Falls. It's fortunate that Three Mile Falls was small, because the stories of Homer's cries were the center of

the area's gossip for several weeks; and it's fortunate that Three Mile Falls was nearby, because the stories found their way to St. Cloud's and to Nurse Angela and Nurse Edna, who had cornered the gossip market in all those river, wood, and paper towns. When they heard the tales of how their Homer Wells was keeping Three Mile Falls awake until the small hours, and how he would wake up the town before it was light, the nurses' good memories did not forsake them; they went straight to St. Larch.

"That's not *my* Homer!" Nurse Angela cried.

"He's not a *natural* at crying, Wilbur," Nurse Edna said—taking every opportunity she had to pronounce that name so dear to her heart: Wilbur! It always made Nurse Angela cross with her (whenever Nurse Edna indulged her desire to call Dr. Larch a *Wilbur* to his face).

"*Doctor* Larch," Nurse Angela said, with pointed and excessive formality, "if Homer Wells is waking up Three Mile Falls, that family you let have him must be burning that boy with their cigarettes."

They weren't *that* kind of family. That was a favorite fantasy of Nurse Angela's—she hated smoking; just the look of a cigarette dangling from anyone's mouth made her remember a French-speaking Indian who'd come to see her father about digging a well and had stuck his cigarette in one of her cats' faces, burning its nose!—the cat, an especially friendly spayed female, had jumped up in the Indian's lap. That cat had been named Bandit—she'd had the classic masked face of a raccoon. Nurse Angela had restrained herself from naming any of the orphans after Bandit—she thought of Bandit as a girl's name.

But the family from Three Mile Falls were not sadists of a very known kind. An older man and his younger wife lived with his grown-up children of a previous marriage; the young wife wanted a child of her own, but she couldn't get pregnant. Everyone in the family thought it would be nice for the young wife to have her own baby. What no one mentioned was that one of the grown-up children from the previous marriage had had a baby, illegitimately, and she hadn't cared for it very well,

and the baby had cried and cried and cried. Everyone complained about the baby crying, night and day, and one morning the grown-up daughter had simply taken her baby and gone. She left only this note behind:

I'M SICK OF HEARING FROM ALL OF YOU ABOUT HOW MUCH MY BABY CRIES. I GUESS IF I GO YOU WON'T MISS THE CRYING OR ME EITHER.

But they *did* miss the crying—everyone missed that wonderful, bawling baby and the dear, dim-witted daughter who had taken it away.

"Be sure nice to have a baby crying around here again," someone in the family had remarked, and so they went and got themselves a baby from St. Cloud's.

They were the wrong family to be given a baby who wouldn't cry. Homer's silence was such a disappointment to them that they took it as a kind of affront and challenged each other to discover who among them could make the baby cry first; after first they progressed to loudest, after loudest came longest.

They first made him cry by not feeding him, but they made him cry loudest by hurting him; this usually meant pinching him or punching him, but there was ample evidence that the baby had been bitten, too. They made him cry longest by frightening him; they discovered that startling babies was the best way to frighten them. They must have been very accomplished at achieving the loudest and longest in order to have made Homer Wells's crying a legend in Three Mile Falls. It was especially hard to hear anything in Three Mile Falls—not to mention how hard it was to make a legend out of anything there.[4]

Covering Homer Wells's adoption history in a few pages, Irving uses both summary narration and partial scenes to lay out his information for the reader. Note that the partial scene contains dialogue, and

once it has been touched upon, the summary narration takes over once again. So what we have is narration, a pause for dialogue within an unspecified scene, then a return to narration. You should also note that this is an omniscient narrator: John Irving utilizing a storyteller's voice.

Thus, you have three different types of narration to consider when you're constructing your novel: dramatic narration (summary narration or otherwise), the full scene, or the partial scene interrupting dramatic narration.

If your choice is the scene, you have further considerations, things to ponder before or during your creation of the scene. You'll need to make sure you're constructing your scene in such a way that, whatever behavior it depicts on the part of the characters, that behavior either advances the plot or illustrates something about the character engaged in it. Scenes are for drama, so make sure the events you render are dramatically depicted. Make sure the scene creates dramatic questions in the mind of the reader. Be careful that the scene adds something necessary to the story's development: information, revelation, discovery, sudden change. If the scene you're creating doesn't do any of this, then what you have is something that doesn't need to go into a scene in the first place. Instead, it can be handled as part of dramatic narration (again, summary or otherwise) and indirect dialogue within that dramatic narration.

But if you're doing a scene, then shape what you're doing to *make* it a scene. That means there must be conflict, even if the conflict is not the same as the Big Conflict of the main story. There may be a conflict from a subplot that you can exploit during your scene. Well and good. Do it. And make that conflict *rise*, as all good conflict should. Don't jump into it with people yelling, screaming, shooting, and having swords drawn.

Think of a scene as you would a complete story, and shape it like a story. It should begin at a low point. During the course of the scene, the tension should rise as the conflict brews. At the height of the conflict you should have the climax and what follows should be a form of resolution which propels the entire novel forward.

Here's an example from my novel *Payment in Blood.*

BARBARA HAVERS closed her notebook. It was a studied movement, one that bought her time while she thought. Across from her, Lynley felt in the breast pocket of his jacket. Although colour still splodged his face where Lady Helen had struck him, his hands were quite steady. He brought out his cigarette case and lighter, used them both and handed them over. Barbara did likewise although after inhaling once, she grimaced and crushed out the cigarette.

Not a woman who ever spent a great deal of time analysing her emotions, Barbara did so now, realising with some confusion that she had wanted to intervene in what had just occurred. All Lynley's questions had, of course, been fairly standard police procedure, but the manner in which he had asked them and the nasty insinuations carried in his tone had made Barbara want to throw herself into the fray as Lady Helen's champion. She couldn't understand why. So she thought about it in the aftermath of Lady Helen's departure, and she found her answer in the myriad ways that the young woman had shown kindness to her in the months since Barbara had been assigned to work with Lynley.

"I think, Inspector," Barbara ran her thumb back and forth on a crease in the cover of her notebook, "that you were more than a bit out of line just now."

"This isn't the time for a row about procedure," Lynley replied. His voice was dispassionate enough, but Barbara could hear its taut control.

"It has nothing to do with procedure, does it? It has to do with decency. You treated Helen like a scrubber, Inspector, and if you're about to answer that she acted like a scrubber, I might suggest you take a good look at one or two items in your own chequered past and ask yourself how well they'd appear in a scrutiny the likes of which you just forced her to endure."

Lynley drew on his cigarette, but, as if he found the taste unpleasant, he stubbed it out in the ashtray. As he did so, a jerk of his hand spilled ashes across the cuff of his shirt. Both of them stared at the resulting contrast of black grime against white.

"Helen had the misfortune of being in the wrong place at the wrong time," Lynley replied. "There was no way to get round it, Havers. I can't give her special treatment because she's my friend."

"Is that right?" Barbara asked. "Well, I'll be fascinated to see how that line plays out when we have the two old boys together for a confidential little chat."

"What are you talking about?"

"Lords Asherton and Stinhurst sitting down for a chew. I can hardly wait for the chance to see you treat Stuart Rintoul with the same iron glove that you used on Helen Clyde. Peer to peer, chap to chap, Etonian to Etonian. Isn't that how it plays? But as you've said, none of that will get in the way of Lord Stinhurst's unfortunate placement of himself at the wrong place at the wrong time." She knew him well enough to see his quick rise to anger.

"And what is it exactly that you would have me do, Sergeant? Ignore the facts?" Coolly, Lynley began to tick them off. "Joy Sinclair's hall door is locked. The master keys are, for all intents and purposes, unavailable. Davies-Jones' prints are on the key to the only other door that gives access to the room. We have a period of time that is unaccounted for because Helen was asleep. All that, and we haven't even begun to consider where Davies-Jones was until one in the morning when he showed up at Helen's door, or why Helen, of all people, was put into this room in the first place. Convenient, isn't it, when you consider that we have a man coincidentally coming here in the middle of the night to seduce Helen while his cousin is being murdered in the very next room?"

"And that's the rub, isn't it?" Barbara pointed out. "*Seduction,* not murder."

Lynley picked up the cigarette case and lighter, slipped them back in his pocket, and got to his feet. He didn't respond. But Barbara did not require him to do so. A response was pointless when she knew very well that his stiff-upper-lip breeding had a propensity towards deserting him in moments of personal crisis. And the truth of the matter was that the

instant she had seen Lady Helen in the library, had seen Lynley's face when Lady Helen crossed the room to him with that ridiculous greatcoat hanging forlornly to her heels, Barbara had known that, for Lynley, the situation had the potential of developing into a personal crisis of some considerable proportions.

Inspector Macaskin appeared at the bedroom door. Fury played on his features. His face was flushed, his eyes snapped, his skin looked tight. "Not one script in the house, Inspector," he announced. "It appears our good Lord Stinhurst has burnt every last one."

"Well, la-de-da-da," Barbara murmured to the ceiling.[5]

In this scene, the lowest point of the drama is at the beginning when Barbara Havers closes the book. The tension increases during her conversation with Lynley over the manner in which he dealt with Helen Clyde during his questioning of her regarding the night of the murder. The scene reaches its climax on the word *seduction*. The resolution occurs when Macaskin appears on the scene to relay the information that part of the evidence has been deliberately destroyed. Obviously, that new fact must propel the story forward. The police can hardly ignore the situation when a suspect burns up evidence.

Don't mistake what I'm saying here about the shape of scene, however. Don't think that every scene must be formed identically, because that isn't what I mean to imply. Indeed, sometimes a scene might start with the climax, back off from it and explain how we got to that point, and then continue. But even if it does that, it will still contain rising conflict and resolution as well, just in a different order. And the order in which these elements appear is determined by your choice of scenic construction.

More choices? Indeed. That's the thing about craft. The more tools you have, the more choices available. The more choices available, the better the writing can be.

There are as many ways to construct scenes as there are people with imaginations. If the basic rule of writing is "Whatever works," then the

more the merrier as far as I'm concerned. I'm going to give you just a few examples of ways to consider structuring your scenes.

I call the first one the *motion picture technique*. If you think about the most common way a scene is set in a film, the camera begins with an establishing shot. Then it dollies in to the character or characters. Then the dialogue begins. Or, put in abbreviated form: Set the scene, move to a narration of action, hit the dialogue. Here's what that looks like in writing, from my novel *For the Sake of Elena*.

Cambridge police headquarters faced Parker's Piece, a vast green crisscrossed by intersecting paths. Joggers ran here, their breaths gusting out in fibrous clouds, while on the grass two dalmatians—tongues flapping happily—chased after an orange Frisbee thrown by a whip-thin bearded man whose bald head shone in the morning sun. All of them seemed to be rejoicing in the disappearance of the fog. Even pedestrians rushing by on the pavement held up their faces to let the sunlight strike them for the first time in days. Although the temperature was no higher than it had been on the previous morning, and a brisk wind made the chill cut close, the fact that the sky was blue and the day was bright served to make the cold stimulating instead of insufferable.

Lynley paused outside the dun brick-and-concrete structure that housed the main offices of the local police. A glass-enclosed notice board stood in front of the doors, on which were fastened posters about child safety in cars, drinking and driving, and an organisation called Crimestoppers. Over this last had been taped a hand-out giving the superficial details of Elena Weaver's death and asking for information from anyone who might have seen her yesterday morning or Sunday night. It was a hastily composed document with a grainy, photocopied picture of the dead girl upon it. And it had not been generated by the police. *DeaStu* and a telephone number were printed prominently at the bottom of the page. Lynley sighed when he saw this. The deaf students were launching their own investigation. That wouldn't make his job any less complicated.

A blast of warm air hit him when he opened the doors and entered the lobby where a young man garbed in black leather was arguing with a uniformed receptionist about a traffic ticket. On one of the chairs, his companion waited, a girl in moccasins and what appeared to be an Indian bedspread. She kept murmuring, "Come on, Ron. Cripes. Come *on*," with her feet drumming impatiently on the black tile floor.

The constable working reception cast a thankful look in Lynley's direction, perhaps appreciative of the diversion. He broke into the young man's "You listen here, mate. I bloody don't intend to—" with "Sit down, lad. You're getting in a twist over nothing," after which he nodded to Lynley, saying, "CID? Scotland Yard?"

"It's that obvious, then?"

"Colour of the skin. Police pallor, we call it. But I'll have a glance at your ID all the same."[6]

We start out with the "camera" at a distance, and through the lens we see the Cambridge police station. Then Lynley arrives and observes the place. When he goes inside, the action and dialogue begin. Thus, with each "camera movement," the reader gets closer to the character involved in the drama.

Sometimes, however, I like to start off with more of a bang. When that's the case, I use what I call *sound versus sight*. Doing this, I begin immediately with dialogue. Then I back off to set the scene. Then I return to dialogue and move the scene forward. Here's what that looks like, from the opening of chapter six in *In the Presence of the Enemy*.

"So what have we got on for tomorrow?" Dennis Luxford pointed a finger at Sarah Happleshort, his news editor. She tongued her chewing gum to the side of her mouth and picked up her notes.

Round the table in Luxford's office, the rest of the news meeting waited for the conclusion to their daily conference. This was the gathering to determine the contents of tomorrow's *Source,* to decide how stories would be spun, and to hear Luxford's decision on what would run on the front page.

Sports had been arguing for heightened coverage of the selection of the England cricket team, a suggestion that had been greeted with hoots of derision despite the recent death of England's best batsman. In comparison to the rent boy rumba, the asphyxiation of an eminent cricketer was minuscule potatoes no matter who had been arrested and charged with orchestrating said asphyxiation. Besides, that was old news and it didn't carry the amusement value of the Tories' attempts at damage control faced with Sinclair Larnsey, the rent boy he was caught with, and the steamy-windowed Citroën—"The slime-ball doesn't even buy British," Sarah Happleshort said, her dudgeon high—in which the pair were purportedly "discussing the dangers of solicitation" when abruptly interrupted by the local police.

Sarah used a pencil to point to items on her list. "Larnsey's met with his constituency committee. No precise word yet, but we've got a reliable source telling us he's going to be asked to stand down. East Norfolk is willing to put up with the occasional dalliance, it seems. All pardonable in the light of let's-practise Christian-forgiveness and let-him-without-sin-proceed-with-the-stone-toss. But they appear to draw the line at human weaknesses involving married men, teenaged boys, closed automobiles and an exchange of body fluids and cash. The crucial question among the committee appears to be whether they want to force a by-election while the PM's popularity is on the wane. If they don't, they look like they don't care about the Recommitment to Basic British Values. If they do, they're going to lose the seat to Labour and they know it."

"Politics as usual," the sports editor complained.

Rodney Aronson added, "The story's getting tired."[7]

Using sound versus sight, I jump in with Dennis Luxford speaking. The reader doesn't know where he is until the next paragraph in which I explain where he is and what's going on. Only *after* I've explained that do I have the character to whom he's speaking answer him. That's how sound versus sight works.

Similarly, a technique that I call *present-past-present* begins a scene

and then appears to back off from it. Unlike the previous example, however, when you use this construction, you start the scene in real time, stop the scene, and go back to previous action to bring the reader up to date, then return to present time. Here's an example from a novel I wrote called *A Suitable Vengeance*.

The day's fair weather had begun to change by the time Lynley touched the plane down onto the tarmac at Land's End. Heavy grey clouds were scuttling in from the southwest and what had been a mild breeze back in London was here gathering force as a rain-laden wind. This transformation in the weather was, Lynley thought bleakly, a particularly apt metaphor for the alteration that his mood and his circumstances had undergone. For he had begun the morning with a spirit uplifted by hope, but within mere hours of his having decided that the future held the promise of peace in every corner of his life, that hope had been swiftly overshadowed by a sick apprehension which he believed he had put behind him.

Unlike the anxiety of the past few days, this current uneasiness had nothing to do with his brother. Instead, from his meetings with Peter throughout the night had grown a sense of both renewal and rebirth. And although, during his lengthy visit to New Scotland Yard, the family's solicitor had depicted Peter's danger with transparent simplicity unless the death of Mick Cambrey could be unassailably pinned upon Justin Brooke, Lynley and his brother had moved from a discussion of the legal ramifications of his position to a fragile communion in which each of them took the first tentative steps towards understanding the other's past behaviour, a necessary prelude to forgiving past sins. From the hours Lynley had spent talking to his brother had come the realisation that understanding and forgiveness go hand-in-hand. To call upon one is to experience the other. And if understanding and forgiveness were to be seen as virtues—strengths of character, not illustrations of personal weakness—surely it was time he accepted the fact that they could bring harmony to the single relationship in his life where harmony was most needed. He

wasn't certain what he would say to her, but he knew he was ready to speak to his mother.

This intention—a resolution which lightened his steps and lifted his shoulders—began to disintegrate upon his arrival in Chelsea. Lynley dashed up the front steps, rapped on the door, and came face to face with his most irrational fear.

St. James answered the door. He was pleasant enough with his offer of a coffee before they left, and confident enough with his presentation of his theory about Justin Brooke's culpability in Sasha Nifford's death. Under any other circumstances the information about Brooke would have filled Lynley with the surge of excitement that always came with the knowledge that he was heading towards the conclusion of a case. Under these circumstances, however, he barely heard St. James' words, let alone understood how far they went to explain everything that had happened in Cornwall and London over the past five days. Instead, he noted that his friend's face was etiolated as if from an illness; he saw the deepening of the lines on his brow; he heard the tension beneath St. James' exposition of motive, means, and opportunity; and he felt a chill through his skin and settle in every vital organ of his body. His confidence and his will—both flagships of the day—lost a quick battle with his growing dismay.

He knew there could be only one source of the change that had come over St. James, and she walked down the stairs not three minutes after his arrival, adjusting the leather strap of a shoulder bag. When she reached the hallway and Lynley saw her face, he read the truth and was sick at heart. He wanted to give sway to the anger and jealousy that he felt in that instant. But instead, generations of good breeding rose to commandeer his behaviour. The demand for an explanation became meaningless social chitchat designed to get them through the moment without so much as a hair of feeling out of place.

"Working hard on your photos, darling?" he asked her and added, because even good breeding had its limits, "You look as if you haven't had a moment's rest. Were you up all night? Are you finished with them?"

Deborah didn't look at St. James, who went into the study where he began rooting in his desk. "Nearly." She came to Lynley's side, slipped her arms round him, lifted her mouth to kiss him, and said in a whisper against his lips, "Good morning, darling Tommy. I missed you last night."

He kissed her, feeling the immediacy of her response to him and wondering if everything else he had seen was merely the product of pathetic insecurity. He told himself that this was the case. Nonetheless he still said, "If you've more work to do, you don't need to go with us."

"I want to go. The photographs can wait." And, with a smile, she kissed him again.

All the time with Deborah in his arms, Lynley was acutely aware of St. James. During the journey to Cornwall, he was aware of them both. He studied every nuance in their behavior towards him, in their behavior towards each other. He examined each word, each gesture, and remark under the unforgiving microscope of his own suspicion. If Deborah said St. James' name, it became in his mind a veiled avowal of her love. If St. James looked in Deborah's direction, it was an open declaration of commitment and desire. By the time Lynley taxied the plane to a halt on the Land's End airstrip, he felt tension coiling like a spring in the back of his neck. The resulting pain was only a secondary consideration, however. It was nothing compared to his self-disgust.

His roiling emotions had prevented him from engaging in anything other than the most superficial of conversations during the drive to Surrey and the flight that followed it. And since not one of them was gifted with Lady Helen's capacity for smoothing over difficult moments with amusing chatter, their talk had ground itself down to nothing in very short order so that when they finally arrived in Cornwall, the atmosphere among them was thick with unspoken words. Lynley knew he was not the only one to sigh with relief when they stepped out of the plane and saw Jasper waiting with the car next to the tarmac.[8]

Notice how we begin in real time: Lynley is just touching the plane down at Land's End in Cornwall. But his mood is bleak and this requires explanation. So I back away from present time at Land's End airfield and bring the reader up to date, going back to the previous night and his conversations with his brother and running through the morning's events and what they've done to his peace of mind. When that ground is covered, I hop back to the present. You can see, I hope, that using this structure allowed me to summarize the events of the previous night instead of playing them out. The key, however, is that the action of the previous night contained within the section of the past *must* be action that moves the present story forward.

Sometimes, it's simplest to begin a scene just by giving the time of day or by telling how much time has passed since the last time we were with the point of view character. For example, in *A Taste for Death,* P. D. James begins a chapter by writing, "Ten minutes after Kate got back to her office, Massingham came in." Bang. We know where we are and who's there. The scene just goes from there.

Other times, we want our footwork to be fancier. In *For the Sake of Elena,* for example, I end a chapter with an artist moving away from her *plein air* drawing to evaluate it, only to step on an arm. The exact words are: "The object wasn't a branch, but a human arm." The next chapter immediately begins.

Mercifully, the arm was attached to a body. In his twenty-nine years with the Cambridge Constabulary, Superintendent Daniel Sheehan had never had a dismemberment occur upon his patch, and he didn't want that dubious investigatory distinction now.

Upon receiving the telephone call from the station house at twenty past seven, he'd come barrelling down from Arbury with lights flashing and siren sounding, grateful for an excuse to leave the breakfast table where the tenth straight day of grapefruit wedges, one boiled egg, and one thin slice of unbuttered toast provoked him into snarling at his teenaged son and daughter about their clothing and their hair, as if they were not both wearing school uniforms, as if their heads were not well-

groomed and tidy. Stephen glanced at his mother, Linda did the same. And the three of them tucked into their own breakfasts with the martyred air of a family too long exposed to the unexpected mood-swings of the chronic dieter.

Traffic had been locked at the Newnham Road roundabout, and only by driving half on the pavement was Sheehan able to reach the bridge of Fen Causeway at something other than the hedgehog speed at which the rest of the cars were moving. He could envision the clogged mess which every southern artery into the city had probably become by now, and when he braked his car behind the constabulary's scenes-of-crime van and heaved himself into the damp, cold air, he told the constable stationed on the bridge to radio the dispatcher for more men to help move traffic along. He hated rubberneckers and thrill seekers equally. Accidents and murders brought out the worst in people.[9]

What I've used here is a narrative explanation of events. I'm essentially explaining how we got to this particular point in the drama. I'm creating a lead into Sheehan's appearance on the scene of the crime because I think it's more interesting to consider the investigators as people who have lives outside the crime novel I'm writing, who've had those lives before the novel was written, and who will continue to have those lives when the novel ends. Hence, the image of Sheehan at the breakfast table with his family, driving them all to distraction because he's on a diet.

Plunging immediately into the action is another way to begin a scene, which is what the next example does from *For the Sake of Elena*. In this scene, we are with Melinda Powell, doing what she's doing as she does it. Notice that this doesn't use any of the other scene constructions. When the character is introduced, the action starts. We stay with that character as the action continues. Where there is setting, it's described so as to make it part of the action.

Melinda Powell was about to wheel her bicycle from Queens' Lane into Old Court when a panda car pulled up less than half a block away. A uniformed policeman got out of it, as

did the President of Queens' College along with the senior tutor. The three of them stood talking in the cold, arms folded across their chests, breath clouding the air, faces grave and grim. The policeman nodded at something the President was saying to the senior tutor, and as they moved apart from one another, preparatory to the policeman's taking his leave, a noisy Mini rumbled into the lane from Silver Street and parked behind them.

Two people emerged, a tall, blond man wearing a cashmere overcoat and a squat, square woman swathed in scarves and wool. They joined the others, the blond man producing some sort of identification and the President of the College following up by offering his hand. There was a great deal of earnest conversation, a gesture from the President towards the side entrance to the college, and what appeared to be some sort of direction given by the blond to the uniformed policeman. He nodded and came trotting back to where Melinda stood with her mittened hands curved round the handlebars of her bike, feeling the cold from the metal seeping through the knit wool like strips of damp. He said, "Sorry, miss," as he scooted past her and stepped through the gateway into the college.

Melinda followed him. She'd been gone most of the morning, struggling with an essay she was rewriting for the fourth time in an effort to make her points clear prior to showing it to her supervisor, who would, with his usual bent for academic sadism, no doubt tear it to shreds. It was nearly noon. And although it was typical to see the occasional member of college strolling through Old Court at this time of day, when Melinda emerged from the turreted passage that led to Queens' Lane, she found numerous small clumps of students having hushed conversations on the path between the two rectangles of lawn while a larger group gathered at the staircase door to the left of the north turret.

It was through this door that the policeman disappeared after he stopped for a moment to answer a question. Melinda faltered when she saw this. Her bicycle felt heavy, as if a rusting chain made it difficult to push, and she lifted her eyes to the

top floor of the building where she tried to see through the windows of that misshapen room tucked under the eaves.

"What's going on?" she asked a boy who was passing. He wore a sky blue anorak and matching knit cap with the words *Ski Bulgaria* blazed onto it in red.

"Some runner," he said. "Got bagged this morning."

"Who?"

"Another bird from Hare and Hounds, they said."

Melinda felt dizzy. She heard him ask, "You all right?" but she didn't respond. Instead, with every sense numbed, she pushed her bicycle towards the door of Rosalyn Simpson's staircase.[10]

You'll probably also recognize that the scene you've just read is constructed so that it begins *in media res* just as some novels begin: in the middle of the action. But you can also begin a scene within the head of a character. That's what's going on in this next scene from *Payment in Blood*. We have a brief bow to setting in the first paragraph, but you should notice that we're *immediately* with Barbara Havers, unlike the camera construction of the motion picture technique where we got a description of the setting before we knew that Lynley was going to be the character involved in the scene.

BARBARA HAVERS paused on the wide drive before going back into the house. Snow had fallen again during the night, but it was a light fall, insufficient to close roads but enough to make walking on the estate grounds wet, cold, and unpleasant. Nonetheless, after a foully sleepless night, she had risen shortly after dawn and had set out through the snow, determined to rid herself of the turmoil of mixed loyalties that were plaguing her.

Logic told Barbara that her primary responsibility was to New Scotland Yard. Adherence right now to procedures, to judges' rules, to Force regulations would add to the likelihood of her receiving a promotion the next time an inspector's position came open. After all, she had taken the examination only last month—she could swear for certain that she'd passed it this time—and the last four courses at the training centre had

earned her the highest possible marks. So the time was right for advancement, or as nearly right as it was ever going to be, if she only played this entire affair wisely.

Thomas Lynley was what made everything so difficult. Barbara had spent practically every working hour over the last fifteen months in Lynley's presence, so she was not at all oblivious of the qualities that had made him a superb member of the Force, a man who had risen from constable to sergeant to detective inspector in his first five years. He was quick-witted and intuitive, gifted with both compassion and humour, a man liked by his colleagues and well trusted by Superintendent Webberly. Barbara knew how lucky she was to be working with Lynley, knew how deserving he was of her absolute faith. He put up with her moods, stoically listened to her ravings even when her most virulent attacks were directed against him, still encouraged her to think freely, to offer her own opinions, to disagree openly. He was unlike any other officer she had ever known, and she owed him personal debts that went far beyond her having been returned to CID from her demotion to uniformed patrol fifteen months back.

So now she had to decide where her true loyalties lay, to Lynley or to advancement in her career. For in her forced hike through the woods this morning, she had inadvertently come upon a piece of information that bore the unmistakable stamp of being part of the puzzle. And she had to decide what to do with it. More, no matter what she decided, she had to understand exactly what it meant.

The air was stinging in its icy purity. Barbara felt its sharp stab in her nose and throat, in her ears and against her eyes. Yet she breathed it in deeply five or six times, squinting against the brilliant purity of sunlit snow, before she trudged across the drive, stamped her feet roughly against the stone steps, and walked into the great hall of Westerbrae.

It was nearly eight. There was movement in the house, footsteps in the upper corridor and the sound of keys turning in locks upstairs. A smell of bacon and the rich perfume of coffee gave normality to the morning—as if the events of the past

thirty-two hours had only been part of an extended night-
mare—and the low murmur of pleasant voices came from the
drawing room. Barbara walked in to find Lady Helen and St.
James sitting in a soft pool of sunlight at the east end of the
room, sharing coffee and conversation. They were alone. As
Barbara watched them together, St. James shook his head,
reached out and rested his hand for a moment upon Lady
Helen's shoulder. It was a gesture of infinite gentleness, of
understanding, the wordless binding of a friendship that made
the two of them together stronger and more viable than either
one could ever be alone.

Seeing them, Barbara was struck by the thought of how
easy it was to make a decision when she considered it in the
light of friendship. Indeed, between Lynley and her career
there was no choice at all. She had no real career without him.
She crossed the room to join them."

So we have in this scene the bow to setting, a sojourn in Barbara's
mind, and then the action starts.

What's important to remember here is that there are scores of
ways to begin scenes. The only limit is that of your imagination. If
there's any rule at all, it's that whatever works, works. Beyond that, it's
all about rising conflict (either outer or inner), climax, and resolution.

PART III

TECHNIQUE

Knowledge Is Power, Technique Is Glory

Writing continues to be a scary proposition for me, as I don't see myself as
particularly talented and I wonder how much longer I'll be able to massage
novels out of my meager storehouse of gifts. Daily, I show up at the computer,
and I hope for the best. But when I'm reading someone's stunning first
novel—like Cold Mountain *or* Ingenious Pain, *a British first novel*
that I'm reading—I think, What am I doing? My God, I am so insignificant
a storyteller in comparison with these guys. But then I tell myself that all I
can do is my best, telling the story as well as I can, leaving the rest up to God.

Journal of a Novel,
February 24, 1998

Sometimes people think that they know how to write by virtue of the fact
that they know how to speak. Others think that they know how to write
because they know how to read. Still others think it's a case of anyone-
can-do-it, and once they get their hands on a word processor, they start
banging away to prove—or in many cases fail to prove—their point.

But the fact is that good writing comes down to an understanding
of craft. An understanding of craft comes first from knowing what the
tools are and second from knowing how to use them. In the case of
writing, using the tools skillfully depends upon one's facility for lan-
guage. And that facility for language grows from innate talent, expo-
sure to good language, and a basic comprehension of how words are
strung together correctly and for maximum effect.

I like to suggest that my students become conversant with some

basics of our language before they throw themselves into writing a novel. So I'd like to review what you probably learned in elementary school but may very well have not thought about since.

In English our primary unit of expression is a sentence. (This excludes exclamations, expletives, and other single-word expressions, which convey emotional content.) The sentence comprises a subject, a predicate (otherwise called a verb), and a complete thought. This sentence can be dressed up or dressed down by making it:

Simple: *The water tower burst into flames at two* A.M.

Compound: *The water tower burst into flames at two* A.M., *and the arsonist ran from the scene.*

Complex: *When the water tower burst into flames, the arsonist experienced a form of heady and intense sexual gratification.*

Complex-Compound: *When the water tower burst into flames, the arsonist experienced heady sexual gratification, and the fire blazed furiously against the night sky.*

Deliberately Fragmented: *If only the flames would take the tower.*

Deliberately Run-on (and sometimes called a Comma-Splice): *The flames ate at the tower, the arsonist watched, his palms sweated, the fire soared.*

Knowing how each of these sentence types is constructed allows you to manipulate language to alter the mood of what you're writing. Using them skillfully means you're able to move the reader through the narrative itself. All of this equates to power. Your power. Through your prose. (Those are two deliberate fragments, by the way.)

All of this also equates to wisdom because finding a copy editor who knows one kind of sentence from the other these days is becoming nothing short of miraculous. More than once I've had a copy editor who's created an error in one of my novels out of blissful ignorance.

The question is: Can you write an entire novel without being able to identify the kind of sentences you're using? Of course you can. People do it all the time. My point is that the more you know about your tools, the better you'll be able to use them.

These primary units of expression we use to build paragraphs: a collection of sentences unified by one prevailing topic that's either stated or implied. Let's take a look at an example of each.

The reef enclosed more than one side of the island, lying perhaps a mile out and parallel to what they now thought of as

their beach. The coral was scribbled in the sea as though a giant had bent down to reproduce the shape of the island in a flowing chalk line but tired before he had finished. Inside was peacock water, rocks and weed showing as in an aquarium; outside was the dark blue of the sea. The tide was running so that long streaks of foam tailed away from the reef and for a moment they felt that the boat was moving steadily astern.[1]

In this paragraph from *Lord of the Flies*, William Golding's topic is the reef. He states this directly and right up front. All the sentences he creates within his paragraph are unified, then, around that topic.

In contrast, Golding paints the aftermath of his character Simon's death in the same novel by using the change that comes over the island once the storm during which Simon is killed has abated. But the topic of change is not specifically mentioned. Instead, it is only implied.

Toward midnight the rain ceased and the clouds drifted away, so that the sky was scattered once more with the incredible lamps of stars. Then the breeze died too and there was no noise save the drip and trickle of water that ran out of clefts and spilled down, leaf by leaf, to the brown earth of the island. The air was cool, moist, and clear; and presently even the sound of the water was still. The beast lay huddled on the pale beach and the stains spread, inch by inch.[1]

Unlike the first example in which everything in the paragraph relates back to the reef that's mentioned in the opening of it, all the information in this paragraph relates to a topic that is itself not stated. In both cases, however, each paragraph possesses the crucial element of unity. Thus, every sentence in every paragraph you write either should be an amplification of the sentence that precedes it or should address itself to a prevailing albeit implied topic in some way. If the sentence you're writing does neither, get rid of it. It doesn't belong there and it will end up impeding the natural flow of your narrative.

Once you have the hang of writing paragraphs that are cohesive, you're ready to think about how to link them together so as to create a seamless narrative. This is a large part of what will propel a reader

through your story, and you effect this propulsion by bridging together paragraphs, scenes, events, or actions. Bridging through the creation of transitions maintains the narrative's smooth flow.

Examine these paragraphs from my novel *Deception on His Mind*. They come from a scene in which the principal character, Detective Sergeant Barbara Havers, has arrived in the town where the murder has occurred.

> She turned on her heel and headed towards the kitchen. Barbara called, "My lemonade?" as the door swung shut behind her.
>
> Alone again, Barbara read the rest of the article unimpeded. The dead man, she saw, had been the production manager at a local business called Malik's Mustards & Assorted Accompaniments. This concern was owned by one Akram Malik who, according to the article, was also a member of the town council. At the time of his death—which the local CID had declared took place on Friday night, nearly forty-eight hours before Barbara's arrival in Balford—Mr. Querashi had been eight days away from marrying the Malik daughter. It was his future brother-in-law and local political activist Muhannad Malik who, upon the discovery of Querashi's body, had spearheaded the local cry for a CID investigation. And although the enquiry had been handed over to CID immediately, no cause of death had as yet been announced. As a result of this, Muhannad Malik promised that other prominent members of the Asian community would be joining him to dog the investigators. "We would be foolish to pretend we are not aware of what 'getting to the truth' means when it's applied to an Asian," Malik was quoted as saying on Saturday afternoon.
>
> Barbara laid the newspaper to one side as Suzi returned with her glass of lemonade in which a single piece of ice bobbed with hopeful intentions. Barbara nodded her thanks and ducked her head back to the paper to forestall any additional commentary. She needed to think.
>
> She had little doubt that Taymullah Azhar was the "prom-

inent member of the Asian community" whom Muhannad Malik had promised to produce. Azhar's departure from London had followed too closely on the heels of this story for the situation to be otherwise. He had come here, and Barbara knew it was only a matter of time until she stumbled upon him.

She could only imagine how he would greet her intention to run interference between him and the local police. For the first time, she realised how presumptuous she was being, concluding that Azhar would need her intercession. He was an intelligent man—good God, he was a university professor—so he had to know what he was getting into. Hadn't he?

Barbara ran her finger down the moisture on the side of her lemonade glass and considered her own question. What she knew about Taymullah Azhar she knew from conversations with his daughter. From Hadiyyah's remark "Dad's got a late class tonight," she had initially concluded that he was a student. This conclusion wasn't based so much on preconception as it was based on the man's apparent age. He *looked* like a student, and when Barbara had discovered that he was a professor of microbiology, her amazement had been associated more with learning his age than with not having had a racial stereotype affirmed. At thirty-five, he was two years older than Barbara herself. Which was rather maddening since he looked ten years younger.

But age aside, Barbara knew there was a certain naïveté that accompanied Azhar's profession. The ivory tower aspect of his career protected him from the realities of day-to-day living. His concerns would revolve round laboratories, experiments, lectures, and impenetrable articles written for scientific journals. The delicate dance of policework would be as foreign to him as nameless bacteria viewed beneath a microscope would be alien to her. The politics of university life—which Barbara had come to know at a distance from working a case in Cambridge the previous autumn—were nothing like the politics of policing. An impressive list of publications, appearances at conferences, and university degrees didn't have the same

cachet as experience on the job and a mind for murder. Azhar would no doubt discover this fact the first moment he spoke to the officer in charge, if that indeed was his intention.

The thought of that officer sent Barbara back to the newspaper again. If she was going to muscle in with warrant card at the ready in the hope of buffering Taymullah Azhar's presence on the scene, it would help to know who was running the show.[3]

What you'll notice upon a close inspection is that the paragraphs are linked together through a simple means. The last sentence in one paragraph either is directly related to the first sentence in the paragraph that follows or acts as a prompt that sets up the next paragraph. Consequently, "She needed to think," introduces *what* she's going to think about in the next paragraph: the probability that Taymullah Azhar is the person who was identified as a prominent member of the Asian community. When that paragraph ends with "until she stumbled upon him," the next paragraph is automatically set up since it goes on with her speculation about how he would *react* when she stumbled upon him. That paragraph ends with a question, which is answered in the paragraph that follows it. And that paragraph ends with "he looked ten years younger," which is connected to "But age aside . . ." which begins the following paragraph. Do you see how it works?

When you write with an awareness of bridges and transitions, you create an experience for the reader that is seductive and mysterious. By this I mean that despite the fact that the novel may not have breakneck pace (my editor once said to me, "E, no one will ever accuse you of writing a fast-paced novel"), the reader feels compelled to continue reading . . . and doesn't actually know why. This, for me, is the great fun of writing: to seduce the reader to continue the story purely with the force and the grace of the prose.

If that ain't creative writing, I don't know what is.

Finally, the wise writer keeps in mind that unity is important in any novel and that most novels are unified around their theme. This— the theme—is the basic truth about which you are writing, the idea you're playing with in the novel, or the point you are attempting to make. Generally, the conflicts that your characters engage in and the difficulties they face are reflections of the theme.

Most of the time, I know the theme that I wish to write about in advance of creating the rough draft of a novel. I knew *A Great Deliverance,* for example, was going to be about letting go of the past. It was clear to me that *Payment in Blood* dealt with betrayal: of friend, of spouse, of lover, of country. On the other hand, I'd thought *For the Sake of Elena* was going to examine the effect obsession has on creativity, only to discover midway through the book that I was actually writing about the decisions women are faced with and how those decisions ricochet through their lives. And when I wrote *Missing Joseph,* it wasn't until Polly Yarkin's final scene with Brendan Powers that I saw in her comment "Don't we all need something," that I'd been writing about those wants that we all have, which are doomed to go unfulfilled.

My point is this: You may not know the theme in advance, but it will emerge. Knowing it in advance is an advantage, however, because that allows you to plan your subplots accordingly since they need to reflect the theme so they fit into the overall novel rather than clunk and groan along.

Sometimes an author creates a scene to address the theme directly. P. D. James does that in *A Taste for Death.*

Massingham had hung about at the Yard longer than was strictly necessary and it was a minute to midnight by the time he drove up to the villa in St. Petersburgh Place. But the downstairs light was still on; his father hadn't yet gone up to bed. He turned the key in the lock as quietly as possible and pushed open the door as stealthily as if he were making an illegal entrance. But it was no good. His father must have been waiting for the noise of the car. Almost at once the door of the small front sitting room opened and Lord Dungannon shuffled out. The words "slippered pantaloon" fell into Massingham's mind, bringing with them the familiar dragging weight of pity, irritation and guilt.

His father said:

"Oh, here you are then, my dear boy. Purves has just brought in the grog tray. Would you care to join me?"

His father never used to call him my dear boy. The words sounded false, over-rehearsed, ridiculous. And his answering voice struck the same note of embarrassed insincerity.

"No thank you, Father. I'd better get up. It's been a tiring day. We're working on the Berowne case."

"Of course. Berowne. She was Lady Ursula Stollard before she married. Your Aunt Margaret was presented in the same year. But she must be over eighty. It can't have been unexpected."

"It's not Lady Ursula who's dead, Father. It's her son."

"But I thought Hugo Berowne was killed in Northern Ireland."

"Not Hugo, Father. Paul."

"Paul." His father seemed to contemplate the word, then said:

"Then I must, of course, write to Lady Ursula. Poor woman. If you're sure you won't come in . . ." His voice, which since April had become the quaver of an old man, broke off. But Massingham was already bounding up the stairs. Halfway along the landing he paused and glanced down over the banisters expecting to see his father shuffling back into the sitting room to his solitude and his whisky. But the old man was still there, gazing up at him with what seemed almost indecent longing. In the strong light from the hall lamp he saw clearly what the last five months had done to the craggy Massingham features. The flesh seemed to have slipped from the bones so that the beaked nose cleft the skin sharp as a knife edge while the jowls hung in slack, mottled pouches like the flesh of a plucked fowl. The flaming Massingham hair was bleached and faded now to the colour and texture of straw. He thought: He looks as archaic as a Rowlandson drawing. Old age makes caricatures of us all. No wonder we dread it.

Mounting the short flight of stairs to his flat, he was caught in the same old muddle. It really was becoming intolerable. He had to get away and soon. But how? Apart from a brief spell in the Section House, he had lived in his separate rooms in his parents' house ever since he had joined the police. While his mother had been alive, the arrangement had suited him admirably. His parents, absorbed in each other as they had been ever since his father's late marriage in his mid-forties,

had left him alone, hardly noticing whether he was in or out. The shared front door had been an inconvenience but nothing more. He had lived comfortably, paid a nominal rent, saved money, told himself that he would buy his own flat when he was ready. He had even found it possible to conduct his love affairs in privacy, while at the same time being able to call on his mother's depleted staff if he wanted a meal cooked, his clothes washed, his rooms cleaned, his parcels taken in.

But with his mother's death in April, all that had changed. While the House of Lords was sitting his father managed to get through his days, padding out with his bus pass to catch the number 12 or the 88 to Westminster, lunching at the House, occasionally sleeping through the evening debates. But at the weekends, even more in the parliamentary recess, he had become as clinging as a possessive woman, watching his son's comings and goings with almost obsessive interest, listening for his key in the lock, making his quiet but desperate pleas for companionship. Massingham's two youngest brothers were still at school and escaped from their father's grief during the holidays by staying with friends. His only sister was married to a diplomat and lived in Rome. His younger brother was at Sandhurst. The burden fell almost entirely on him. And now he knew that even the rent he paid had become a necessary contribution, almost as important to his father's dwindling resources as the daily attendance payment at the Lords.

Suddenly repentant, he thought: I could have spared him ten minutes. Ten minutes of embarrassing non-communication, of small talk about his job, which, until now, his father had never thought worthy of interest. Ten minutes of boredom only partly alleviated by alcohol and setting a precedent for nights of boredom to come.

Closing the door of his flat behind him, he thought of Kate Miskin, less than a couple of miles to the west, relaxing in her flat, pouring herself a drink, free of responsibility, free of guilt, and felt a surge of envy and irrational resentment so

strong that he could almost persuade himself that it was all her fault.[4]

Here, in DI Massingham's arrival home, the author puts us in touch with the character's guilt over how he treats his father, and that guilt he feels bleeds over into his attitude toward his fellow officer Kate Miskin. With this brief scene, James demonstrates for the reader what the entire novel is about: the corrosive nature of guilt.

On the other hand and as I previously mentioned, when the theme isn't addressed directly, the unification of the subplots around that theme will drive it home to the reader. The trick is to create subplots that illustrate the same theme but through different situations.

The beauty of theme is that sometimes it can comprise the entire arc of a story. In *Absalom! Absalom!*, for example, William Faulkner writes about the great irony of racial prejudice. He creates the wildly prejudiced Colonel Sutpen, a man more concerned with the possibility of miscegenation in the proposed marriage of his daughter than with the incest such a marriage would bring about. Sutpen alienates everyone in his life and ends up with a single descendant: a blackly black man called Jim Bond. Thus the arc of the entire novel expresses Faulkner's theme. Colonel Sutpen ends up with what he hated most.

Beyond unifying a novel around its theme, though, the writer needs to make sure that other unities are adhered to. To do this, she needs to analyze every scene she writes or proposes to write, making sure that each advances either the plot or one of the subplots. Once assured of that, she must look at each paragraph within each scene, deciding if it advances the scene and revolves around a central idea. Finally, she needs to weigh each sentence within each paragraph and decide whether that sentence addresses a point (i.e., a topic) that is either implied or placed directly into the paragraph itself. When you've got all that going for yourself, you have unity.

When you have unity, you also have a sense of a story that knows where it's been and where it's going.

14

Loose Ends

Yesterday the most extraordinary thing happened. I was writing the last scene in the current section of the plot outline when all of a sudden in the middle of the scene, I had the most amazing moment of inspiration. Using a piece of information that had always been in the character analysis of the killer, I succeeded in twisting the story one final time. The reader will probably know who the killer is at this point, but there is no way the reader will know how he did it or why he did it. . . . Could this book be a keeper?

Journal of a Novel,
July 3, 1998

Before we move on to the next part—process—let's tie up a few loose ends about craft, the first of which is suspense.

Personally, I consider suspense one of the most misunderstood elements of fiction writing, right up there with point of view and voice. This is because most people think of suspense in terms of cliff-hanging action, bombs ticking, and damsels hanging by their fingernails from the ledges of tall buildings. But when it comes to suspense, what I think of is everything the writer does—or has at her disposal to do—to keep the reader turning the pages of her book. That's it.

A painter friend of mine once told me that an artist has less than thirty seconds to capture someone's interest in his canvas: the time, more or less, that it takes someone to stroll slowly by it in a gallery. If the painter cannot snare the collector in that time, then he considers the work less than successful.

This isn't unlike the writer's objective in keeping the reader reading, although the writer's job is infinitely more challenging since she

has just a few pages—sometimes only one—in which to hook the reader. Yet hooking alone isn't enough. Maintaining the reader's interest and attention to the end of the story is also part of the writer's job. Hence, suspense needs to be created.

Suspense helps maintain reader interest simply because suspense initiates *wants* in the reader. Involved in a skillfully written book, the reader *wants* to know what's going to happen on three different fronts: (1) to the characters, (2) to the situation in which these characters happen to find themselves, and (3) to the plot. Additionally, the reader is going to *want* to know how these things are going to happen. And the only way the reader is going to get any of that information— hence, the only way the reader's *wants* are going to be satisfied—is by turning the pages. In other words, a great deal of what is suspense in a novel is simply the art of creating one large *don't want* so that the reader with the book in his hands thinks, "I don't want to put this damn book down."

The reality is that a writer achieves suspense simply by making the reader care about something. When we care, we are invested. In the world of literature, that translates to *When we care, we continue to read.* The opportunities to care are as varied as the tools of the writer's trade: those fundamentals of fiction that the writer learns to wield. One of them is, obviously, character. If you can create a character who possesses some element of personality or experience that the reader can identify with, the result will be that the reader will be more intrigued with the story you're telling. These elements of identification come from the idea of commonality: We relate to people who have emotional experiences that resonate within our own lives; we understand people who have backgrounds similar to ours or who live in situations that draw empathy from us; we admire characters who face and prevail over situations we ourselves have experienced; we admire the honesty of characters who unflinchingly examine themselves and their motives, who learn from their mistakes, and who meet challenges with courage. All of this amounts to our caring about a character. Caring about him, we will not abandon him to his fate . . . certainly not without knowing what that fate is, which is what the story itself will reveal to us.

Keeping this in mind, take a final look at the opening from Robert Ferrigno's *Horse Latitudes.*

IT DIDN'T TAKE MUCH to set him off these days—laughter from the apartment below, a flash of blond hair out of the corner of his eye. Or, late at night, the sound of two car doors slamming in quick succession. Especially that. He imagined them walking to his place or her place, both of them eager but trying not to let it show, holding hands, tentatively at first, then the man slipping his arm around her waist while she smiled and laid her head on his shoulder.

There were nights when Danny missed Lauren so bad that he wanted to take a fat man and throw him through a plate-glass window. Just for the sound of it. Instead, he went swimming in the bay.

The water was cold and dark and empty and he hadn't missed a swim in the four months and ten days since the divorce became final. He was going to drown one of these nights, or he was going to get over her—it was too early to tell which.[1]

What Ferrigno does so well in this opening is to give us a character who has been grievously wounded by love. In doing this, he strikes a chord of common experience with virtually every reader he has. The reason is simple: Who in his life has never been hurt by loving someone, whether it be by loving the wrong person, by losing a love through death, by betrayal at the hands of the loved one, or by any of the other variations of what can happen when two people join together in ardor and tenderness? Feeling a sense of empathy for Danny, the reader is going to continue with the story because he *wants* to know what's going to happen to this man.

Plot, however, can also be what the reader cares about. If a plot is essentially believable—even if it's something as imaginative and improbable as cloning dinosaurs—then the reader will stick with the story through that little click in the brain called suspension of disbelief. Although some kinds of fiction more obviously require suspension of disbelief from a reader—fantasy and science fiction, for example—the truth is that every story being created from the mind of a writer also requires this of the reader.

Beyond plot and characters, there are also some devices that you can use to create suspense, although wise is the writer who uses them sparingly because they can smack so decidedly of device. Anything you do in your writing that *smacks* of device is something that's going to make your story clunky. *Anything* that attracts attention to itself within your writing is something that's going to take the reader out of the story. Remember: Your objective is to do everything possible to keep the reader *in* the story. But you have to do it without calling attention to it. A tricky business.

Thus, if the plot structure allows for it—in other words, if you've established a causal relationship up front—then you can put a character at risk, which heightens suspense. If you choose a character about whom the reader knows and for whom the reader cares, then the reader will be invested in the situation in which the character finds himself. Putting a character at risk, however, isn't just sending him to the edge of a cliff with fifteen rabid hounds snapping at his heels. Risk also can mean creating a scene of confrontation for that character: face-to-face with another character, with his greatest fears, with the most compelling decision he ever has to make, etc. Putting him in the eye of a metaphorical storm also works in placing a character at risk because he's in the position of waiting for the next onslaught to occur. Physical attacks work well, too, but so does psychological or emotional jeopardy.

More traditional types of suspense come from the idea of chasing: the villain chases the hero; the villain chases someone at risk; the hero chases the villain; the hero chases the villain who is himself chasing the character at risk who does not know he is at risk.

Violence also serves as an element of suspense. If someone is murdered on the page—in an opening scene or at a plot point—then you have suspense. And please don't think that murders are the province of detective or crime fiction only. Alice Hoffman uses murders effectively in several of her novels (*Turtle Moon* and *Second Nature* come immediately to mind), and the last place they would be put in a bookstore is among the crime novels. Indeed, William Faulkner uses murder, Charles Dickens uses murder, Wilkie Collins uses murder, Thomas Hardy uses murder ... and no one would accuse William Shakespeare of shying away from occasional bloodshed in the cause of a gripping tale.

But if murder is too much for you, then fighting might be the ticket. If you create a scene in which there is physical violence or a great verbal onslaught, you've heightened tension. That equates to suspense.

So does a scene in which a momentous discovery is made. If your plot point reveals a piece of information or a situation by which the story is consequently propelled forward, you have just created suspense.

Characters working against time—usually in thrillers—are a natural source of suspense. When in Frederick Forsyth's *The Fourth Protocol,* the hero is on the trail of a Soviet spy in possession of a nuclear bomb...you've got suspense. The same applies to Dean Koontz's *Twilight Eyes:* Get out of the cave before the bomb goes off. And in *Jurassic Park,* it's crucial for the characters to get the communication system back in order before the supply ship arrives in the mainland.

If time isn't of the essence, then a MacGuffin can work for purposes of suspense. This is an object that everyone in a novel is seeking. Sometimes it turns out to be something that's inherently worthless; other times it's something of value. In either case, it's the race itself—the race to possess the MacGuffin in advance of the other characters—that creates the suspense. Like the eponymous Maltese falcon.

Finally and for my money most importantly, making long-term promises to the reader through foreshadowing and through the careful placement of dramatic questions transports suspense from the mundane to the sublime. In the first instance, the gun that's introduced in the beginning of the novel—or the poison, or the envelope that lies unopened on the table, or the message disregarded on the answering machine—must play a part in the story at a later date, and the reader anticipates that coming moment. In the second instance, those unspoken questions about a character that are implied by his actions, reactions, thoughts, and spoken words all must be answered in future scenes once they've been asked. They, too, encourage the reader to stick with the story. The story is, indeed, the only source of truth.

But perhaps the most critical part of maintaining suspense—and consequently reader interest—is to be aware continually of how you're structuring your novel. Know that your story is not a complete story without plot points: critical moments when events change, informa-

tion is amassed, an important discovery is made, an agreement is reached, a decision is taken. These points propel the story forward, frequently necessitating a change of scene.

Keep in mind at all times that you must develop your instincts for storytelling. I advise my students to trust their bodies when they're writing because their bodies will never lie to them about the story, the pacing, the characters, or anything else. Their minds, on the other hand, will lie to them all the time, telling them something is good when that sinking feeling in their guts (note: in their *bodies*) tells them irrefutably that that something is bad. Or vice versa. I tell them to write with their minds but evaluate with their bodies. Above all, I tell them to ignore the committee in their heads that chatters on and on about how they don't know what they're doing, couldn't write their way out of a paper bag, wouldn't know a good story if it came up to them and introduced itself, etc, etc. This is the chorus from their pasts, I inform them, comprising their parents, their siblings, and the nuns at the Sacred Font of Holy Water Grammar School. Ignore them all. They belong to the past. Trust your body. Your body is the present. It's also the most effective tool you have.

This chapter couldn't close without a few words about clues and red herrings for the folks who wish to write crime novels, mystery novels, or detective fiction. If you're going to write in one of these genres, it behooves you to know exactly what a clue is, what a red herring is, and how to place either of them in a scene.

Clues first. These are those pieces of information that, if interpreted correctly by the reader, can lead him to solve the case in advance of—or at least at the same time as—the detective. The most obvious kinds of clues are material objects: lipstick, a thread, a button, dirt, a tire track, a weapon. Then there are biological clues like blood, semen, saliva, skin, fingerprints, hair, vomit, fingernails, feces, urine. Beyond that, the absence of something that should be there—like the missing tube of white paint in Dorothy L. Sayers's *Five Red Herrings*—acts as a clue, as does information about timing: Who was where when? The verbal statements of suspects can contain clues, as can the testimony of witnesses. And finally, a person's background, education, experience, or profession can act as a clue if the crime requires specialized knowledge.

In contrast, red herrings are items planted in the story to deceive the reader, leading him to believe someone *other* than the guilty party is culpable of committing the crime. This, in fact, is the true red herring. Its cousin is the false clue, which occurs when characters lie outright to the police, the detective, or each other. The key in placing red herrings in the story is that they must have a *logical* explanation in the plot or in the subplot. They cannot just be placed in a scene like so many plums in a pudding, as P. D. James would say.

Clues and red herrings both play an important role in the creation of suspense because, artfully placed in an ongoing scene, they serve to flummox the reader since there should be no way of telling—upon a first glance at them—which is which. The only way for the reader to know for sure is . . . to keep reading.

Agatha Christie was the queen of clue and red herring placement. From her, I learned a great deal about how to construct a scene in which a vital clue appears. The trick, you see, is to place your clue in such a way that it does *not* scream, "Clue, clue, clue right here!" at the reader. What Agatha Christie did was to fashion her scenes so that the clue was present but so was the red herring. And the scene pivoted around the red herring, not around the clue. Brilliant.

All along, the writer has to play fair with the reader in her place-ment of clues and red herrings, though. They must arise naturally out of the plot or the subplot, coming from either story or character. Clues may serve as plot points, propelling the story forward. They may serve as reversals. They may operate as vehicles of suspense, chaos, destruc-tion, or anything else the writer would like them to be. But no matter how they're used, the detective in the story cannot ignore them if the reader sees they are clues. Doing this puts the reader ahead of the wave of the story instead of behind it, knowing more than the detective knows. And that destroys not only the story itself but also the suspense that the writer is working so hard to create.

PART IV

PROCESS

Baby Steps First

Creating characters is rough. Sometimes I think I have nothing new to say about anyone. I worry that I've already created these people before, in one book or another . . . The truth is that we can only write about that which we understand or have experienced or can project ourselves into, and I have been more skilled than a lot of other writers at doing this latter trick. But my personal experience has been limited . . . So I wonder if I'm capable of truly delving into the human heart and mind. Anyway, all I can do is my best. I can take the necessary steps one at a time. And that's it.

Journal of a Novel,
June 8, 2001

Every writer has to develop her own process: what works for her time and time again. Having no process is like having no craft. It leaves you dangling out there over the abyss, a potential victim of writer's block. Having no process puts you at enormous risk because writing becomes a threat instead of a joy, something that you are terrified to begin each day because you are at the mercy of a Muse that you do not understand how to beckon. If I had no process and no craft to fall back on, I would be paralyzed with fear every morning and, frankly, I see no fun in that. Because I have both process and craft to guide me, I approach my daily writing with anticipation, joy, and delight. Really.

I cannot force my process upon you, however. What I can do is tell you what it is, what I believe about it, and how it works for me. Your job is to discover your own process by trying this, that, or the other: whatever feels right to you over time. (Note that word *feel* again. Your body will tell you when you're doing what's right for you.)

So what follows is the process I use when I'm writing a novel. These are the essential steps that I've developed for myself over the creation of twelve books.

I don't begin until I have an idea. But this idea is more than just a glimmer, more than a potentially evanescent wisp of inspiration. For me, what the idea is is a complete thought that contains one of three elements: the primary event that will get the ball rolling in the novel, the arc of the story containing the beginning, the middle, and the ending, *or* (and please note that word *or*) an intriguing situation that immediately suggests a cast of characters in conflict. If I have one of those three elements, I have enough to begin.

Consider the story idea for my novel *In the Presence of the Enemy*. I knew I wanted to write about a kidnapping because I wanted to see if I could tackle the challenge. I needed a high-profile kidnapping in order to involve my Scotland Yard crew. I chose to kidnap the child of a Member of Parliament because the other apparent choices for a high-profile kidnapping (like a member of royalty or the child of a well-known entrepreneur) didn't excite me and because I'd not yet written about Parliament. Thus I had the chance to learn something new in the course of writing the novel, which always energizes me. So my story idea became: "This is a novel about the kidnapping of the child of a Member of Parliament."

This was well and good because it contained two of my three requirements for a story idea: primary event (kidnapping) and an intriguing situation suggesting a cast of characters (if we have a kidnapping, we must also have a victim, a kidnapper, the relatives of the victim, the police, the suspects, etc.). But since I wanted to include in the novel some of my continuing characters who are not police professionals, I had to add to the initial idea a reason why the police could not be involved at first in order to involve my nonprofessional investigators.

Why then, I wondered, would the Member of Parliament *not* want the police involved since, certainly, she could—by virtue of her position in the Government—call upon the best police officers the Met had to offer? Ah, I thought. If the child was illegitimate and if the identity of the father of the child was a secret that could destroy the career of the MP should it be revealed ... Now I had something that felt even more

exciting to me than the kidnapping alone. Consequently, the idea became: "This is a novel about the kidnapping of the *illegitimate* child of a Member of Parliament."

What was good about this idea was that it immediately prompted a number of questions that I had to answer before I could write. Those questions and their answers created for me the next step in my process: the expanded story idea.

The most obvious question to me was not "Who is the kidnapper?" but rather "Who is the father of this child, the revelation of whose name would destroy the career of the Member of Parliament?" Answering this question and the questions that grew from the answer expanded my simple idea into the more complicated story idea that follows:

"The illegitimate daughter of a female conservative MP (touted to be the next Margaret Thatcher) is kidnapped. The ransom note is sent *not* to the MP but to the child's natural father, a married, antigovernment, left-wing tabloid editor whose identity has never been revealed by the editor or by the MP to anyone. The note he receives says, 'Acknowledge your firstborn child on page one, and Lottie will be freed,' which leads the father to realize that his (and the mother's) most closely guarded secret is known by someone else. Because notifying the police will bring in the media (who will in short order destroy the MP's reputation in best British tabloid fashion) and because the MP believes that the editor *himself* is behind the kidnapping in order to bolster his newspaper's sales with a front-page confession of the affair he and the MP once had, Simon St. James (This is my forensic scientist.) is prevailed upon to get involved against his better judgment. Big mistake. The child is murdered, which triggers the involvement of the police. Next, the tabloid editor's *legitimate* son is kidnapped and the ransom is the same: 'Acknowledge your first-born child on page one.' The editor does this (to the MP's furious protests and to the tabloid-reading public's delight) but his son is *not* released. Instead he receives a message saying, 'You got it wrong.' Thus, he learns he has another illegitimate child, one older than the kidnapped and murdered Lottie. This older child is the kidnapper."

This paragraph answered all of the relevant questions about the initial idea. It gave me the sense of direction I needed to move onto the next step in my process: the research.

When I create an expanded idea, I next examine it to see what I'm going to need to learn about in order to write the novel. In the case of the expanded idea for In the Presence of the Enemy, I could see at once that I was going to have to learn about Great Britain's House of Commons and, if possible, I was going to have to gain access to the House of Commons and the larger Palace of Westminster in order to write about them with some degree of accuracy. I was going to have to learn how members of the House of Commons are elected and what they do on a day-to-day basis. I was going to have to become conversant in the lingo associated with the Government in England. I was going to have to learn about the hierarchy in the Commons, and I would need to know which civil servants might be involved in my story. This was a big order, but I thought I was equal to it. I recalled having dinner with a couple at the Manor House Hotel in Castle Combe a year or so previously on Christmas Day, and I remembered that their son was the BBC radio correspondent for the houses of Parliament. Perhaps he would be able to help me. I made a note of that.

Obviously, I was going to have to learn about the British tabloids, too. I needed to know how the employees work in the tabloid offices, and I needed to know how they go about digging up their stories. I would have to get inside the offices of a tabloid if I could, and if the editor of one of them was willing to meet with me, so much the better.

Next, I would have to learn how the British police investigate a kidnapping and a murder.

Finally, I would have to know where my kidnap victims would be held until the murder of one and the rescue of the other, and I would need to know where the body of the murdered kidnap victim would be placed.

To do all of this, I would have to go to England, which is what I always have to do before I begin to write a novel. In this instance, I knew that I could set up several things in advance, from the United States: I could contact the couple I'd met in Castle Combe and ask them if their son might meet with me (I did that, and he agreed). I could contact my police source from Cambridge, England, and ask him about the investigation into a kidnapping. And I could ask my editor in England if he could set up a meeting with the publisher or editor of a tabloid. As for where the children would disappear from, where they

would be kept once kidnapped, and where one of them would be disposed of . . . that was entirely up to me, on my own.

Since the children were going to be kidnapped from London, I didn't want them taken too far away, so I decided that either Somerset or Wiltshire would do. Both are within easy driving distance from town on one of the motorways, so I began reading about these counties, looking for places to stow my victims. Once I'd selected a variety of potential sites—from a cement factory to a castle and everything in between—I was finally ready to go to England.

I had a lot of work to do. Not only did I have to gather the relevant information from all my sources in London, but I also had to find the specific locations that would be part of the London section of the book: where all the London characters lived, where the children went to school, where the kidnapper hid out prior to the kidnapping, where the kids were snatched. Afterward, I'd trip out to the countryside for what one of my former editors would call "a nice bout of topographical gumshoeing."

So that's what I did. In London, I met with the delightful and articulate Michael Fairbairn, BBC's radio correspondent to the houses of Parliament. He ushered me right inside the House of Commons for an extended lecture on the British government; he dined me in the members' dining room, squired me around the halls and wings of the place, and generally educated me. With him answering all relevant questions and making pertinent suggestions when necessary, I was able to come up with the persona of my MP whose child is kidnapped: Eve Bowen, fictional MP from Marylebone. I also got a chance to see the Commons in session, watching from the press gallery as John Major—Prime Minister at that time—underwent the excruciating question and answer session that is a regular feature every week that the Government is sitting. By the time Michael had finished with me, I had a working understanding of British government, specific knowledge that would allow me to write about an MP with a fair degree of comfort, and details that I could use when possible to add to the verisimilitude of my novel.

At the *Mirror,* one of the few newspapers still operating from the Fleet Street area, I sat in on an editorial board meeting to soak in the flavor and the atmosphere of what goes on behind the scenes of one of

England's biggest tabloids. I interviewed the editor, the deputy editor, and one of the reporters, and from them I learned how tabloids manage to unearth the scurrilous pieces of information they use when they've decided to out someone, to destroy someone, or merely to bring someone down a few pegs, all of which appears to be great fun to them.

I gathered the necessary details about policing and kidnapping, and then I was ready to select my locations in London. I knew I would need to know Marylebone well, so I headed there first. I had to find a house for my MP, a school for her daughter, a spot from which her daughter could be kidnapped, and a place that the kidnapper could hide out, waiting to snatch the little girl. I also wanted specific details that would flesh out the location for my reader: the kinds of shops on the streets, the kinds of houses in the neighborhoods, the types of trees and plants in the gardens and the squares, the sounds, the smells. In short, I wanted everything I could perceive.

I set off for Marylebone—which is just south of Regent's Park— with my camera and my tape recorder and I began to hike around it. Up and down streets, through alleys, into the occasional dead-end mews. I photographed constantly and spoke into my tape recorder, naming the specifics that would become the telling details of the environment when I later wrote the novel. I didn't leave or give up till I had what I needed, and it all actually exists there in the neighborhood: Eve Bowen's house in Devonshire Mews, Cross Keys Close where Charlotte Bowen is kidnapped a short distance from her music teacher's house, St. Bernadette's School on Blandford Street, and—*mirabile dictu,* and this is the serendipity of researching that makes my heart sing—a row of abandoned buildings on George Street, one street away from Charlotte's school. Bingo. I had my place for the kidnapper to hide out.

Using this same approach, I found the rest of the London locations I would use in the novel as well: tabloid editor Dennis Luxford's house in Highgate, son Leo Luxford's school, the restaurant where Leo and Dennis have one of their talks, the spot in Harrod's where the MP and Dennis meet to discuss strategy, etc. All the time I photographed. All the time I spoke into my tape recorder. Each afternoon when I returned from my location research, I sat and transcribed from my recorder onto my laptop.

I used much the same technique in the countryside as I looked for where Charlotte Bowen and Leo Luxford would be held as kidnap victims, where the kidnapper would live, where Charlotte's body would be found, and any other relevant spots that might resonate when I saw them. Hence, I visited two windmills, the Kennet and Avon Canal, a trailer park built on the site of a ruined abbey, a cement factory, any number of castles, pubs, hotels, villages, churches, graveyards, and sites of mythological, archeological, and sociological significance. I knew that when I saw what I wanted, it would leap out at me if I simply kept my mind open. At locations where it was possible (the two windmills and the cement factory), I interviewed individuals as well. Ultimately, I decided on Wilton windmill for Charlotte Bowen's imprisonment, the Kennet and Avon Canal right outside a tiny hamlet called Allington for the site of her body, a combination of two castles for Leo Luxford's imprisonment, and a small town called Pewsey—which I changed to Wootton Cross—for the murderer's home. I found an additional hamlet for his girlfriend's home and a spot where a boys' school could be situated as well.

Again, all along I took dozens of photographs, which I always organize by type of place when I get home. I tape recorded my interviews. I taped my own running commentary on what I was seeing. Again, I looked for the details that make one place in England so completely different from another place. This, I knew, would allow me to create a spot that was real for the reader.

With my research completed, I returned to the United States for the next phase of my preparatory activities.

For me, this is the creation of characters, that moment when I am the god of the world I intend to produce for the novel itself. I work off a generic list first (mother, father, birth father, kidnapper, etc.), giving each character a name that resonates for me, one that is an accurate reflection of the character's position in British society and is potentially suggestive of certain traits that I wish the reader to pick up on. The name of the character will be the first chance I have to position the reader attitudinally toward that character, so I'm careful here. I consider what the name sounds like, how it falls upon the ears and what that fall implies when it occurs.

Once I've named the characters, I begin to create them, using the

process I've described for you earlier. Since I'm employing a stream-of-consciousness fashion, I freely write about them. I touch upon every area of their development and their lives, all the time trying to urge my brain out of its tendency to swing leftward toward tight structure and into the free-wheeling creative right side. I talk to myself right on the page, trying out this idea or that idea, positing this theory or that. All along, I am aware of what my body is telling me about the character I'm creating. When the information is right, I'll know it because I'll feel it: that surge of excitement that is my body shouting, *Yes, yes, yes!* about a character.

I write about each character in as much depth as I can manage, and I keep to one side of my computer the character prompt sheet that I mentioned earlier. This serves to keep me on track so that I don't spend five pages writing about some intriguing incident in the character's life that will not actually give me the depth I require to understand a character and, more importantly, to develop a voice for him or her. When I'm done, I generally have a document for the character that is three or four single-spaced pages. I find that sufficient.

Following this same process, I do all the characters who—as far as I can tell at the moment—appear to play a part in the story I wish to tell, in plot or subplot. When I've completed this long document, I read it and highlight the points about each character that I find crucial to understanding what drives him. I do this because six months from now and five hundred eighty-two pages into the rough draft, I'm not going to be able to remember everything I wrote about all these people I've created, and highlighting makes my job easier in those moments I anticipate when I'll have to be rereading the character analyses to refresh my memory about someone's motivation, throughline, or agenda.

The beauty of doing the character analyses, I've found, is that more and more elements of the plot start jumping out at me as I create and explore the characters I've generated from my initial idea. I begin to see how their lives interlock and affect each other. I begin to understand the theme of the novel I intend to write. Most important, I begin to develop a clear understanding of what the subplots are going to be. I would know none of this without the character analyses. Without the character analyses, I would be forced to create all this on

the spot during the rough draft. And I don't want to do that because I want the writing of the rough draft to be about *art* and not about *craft*.

Having created all the characters, then, I can develop the exact setting I'm going to use since now I know the world in which each one of them operates. I don't believe in generic settings: that idea of "set it in Manhattan because everyone knows what Manhattan is like and all I'll have to do is write *skyscrapers* to put the reader there." Instead, I believe in rendering a setting with as much authenticity as I render character and event, and sometimes this means that I have to create the setting, making it an amalgamation of a number of places I saw and explored when I was in the research phase in England. For my novel *Well-Schooled in Murder,* I developed the public school that I called Bredgar Chambers by first planning its physical layout on a large sheet of paper, then naming each one of its dormitory-type houses in which the students lived, then describing each of the buildings, then actually writing a prospectus that would be sent to parents who wished to send their children there to be educated (and in the case of one unfortunate lad, to be murdered). I based this school on all six of the schools I visited while I was on the research phase for the novel. So the chapel came from one of them, the exteriors from another, etc., etc. For my Cambridge novel—*For the Sake of Elena*—I created St. Stephen's College with its seven hundred years of architectural history. Building by building, and stone by stone, I made the place my own. I'd been to Cambridge University for two summer sessions at Trinity Hall, so I placed my college between Trinity Hall and Trinity College, and where Gonville and Caius College is, I put the court in which one of the lead characters has his office.

My point is this: I develop a place that I can *own* on paper because I want the reader to experience the setting right along with the characters. And I do this because I have always loved books that do this. Read *Rose* or *Havana Bay* by Martin Cruz Smith. Read *Mystic River* by Dennis Lehane. Read *Oyster* by Janette Turner Hospital. Read Faulkner and Steinbeck. Read *Dune* by Frank Herbert. Or go back into childhood and read Laura Ingalls Wilder or L. M. Montgomery. You'll see what I mean.

If I have a setting map that I've created, I post it on the wall of my study and then I move on to the step outline. As fast as I can, I list all

the events in the story that can be generated from the primary event and that have causal relationships between them. They may not be in the exact order they'll appear in in the novel, but when they're down on paper, I can look at the list and see how and if they are causally related to each other. I put them in the best dramatic order—and this will be the order that allows the story to keep opening up and not shutting down—and if I have fifteen of them, I'm one happy camper. Sometimes I have only ten events. That's okay, too. I aim for fifteen but if I can't make it that far, I do not assume that I have no novel.

When I'm listing these events—and, again, this becomes the step outline that I mentioned earlier in this book—I list them in abbreviated form. I don't write sentences; I don't always even write phrases. But I do write something that I will be able to understand when I look over the list later. I do this part by hand on a sheet of paper, not on the computer screen. This allows me to scratch things out, to draw arrows, to doodle, to do whatever I need to do to make sure I have dramatic questions and that I'm not playing my hand too soon.

I don't demand anything near perfection from myself while I'm doing this step outline. I just try to get down as many causally related scenes as I can. Then I'm ready to go on to the running plot outline.

As I described it earlier, this is a present-tense account of what's going to happen in a scene. It's the point at which I make several craft-oriented decisions. I'm choosing my point-of-view character, I'm choosing my scenic construction, and I'm deciding if a THAD is called for. Relying on my step outline to give me a sense of direction for the entire section that I'll be outlining at this point, I free write about how I see the scene playing out in my mind. I try to get into a stream-of-consciousness mode, and I include in the running commentary just about anything I can think of to bring it to life: telling details of character and setting, narrative, a bit of dialogue. I shape the scene roughly and then go on to the next one till I have addressed myself to all the scenes in the step outline.

Finally, after all this preliminary work has been done, I get to do the fun part: the rough draft. In other words, I now can engage in the art of writing, having seen to the craft. I'm like a painter who has stretched the canvas, arranged the subject, fiddled around with the composition, sketched the subject in charcoal a few times, selected the

brushes I intend to use, ground the paint, set up the easel . . . and now I can actually paint.

The painting itself—that is, the writing—is what I love. Everything else is preliminary stuff: what I do to make doing what I *really* do a freeing experience for me. Because I do all this work in advance, I generally don't have to sit in front of the computer agonizing about "what's going to happen next" or "how Mary Sue is going to react when she walks in on her husband and the family dog in a compromising position." I now can involve myself in the sheer artistry of writing, which is all about the beauty of our language.

So I write. I refresh my memory with the character analyses when I bring in a new point of view in order to get that character's voice right. Then scene by scene as I've molded them in the running plot outline, I begin to create the rough draft. There are surprises along the way. There are moments when inspiration strikes and I see a new way to steer things in the story. As I write the draft, new elements pop up, new dramatic questions are asked, new ideas spring forth. Some of these I embrace and use. Others I discard, knowing from experience that they represent wild hares that I'd better avoid, having once followed one for four hundred pages before I realized I was heading to disaster.

Moving back and forth among the step outline, the running plot outline, and the actual writing, I create the entire rough draft of a manuscript. I generally write five pages a day. I never write less than that. Sometimes I write more. I keep moving forward until the rough draft is done, knowing that if I suit up and show up at the computer, I *will* have the rough draft of a whole novel eventually.

When I do, I sit down and read a hard copy of that rough draft in as few sessions as possible. When my books were shorter, I could do this fast reading—which is what I call it—in one sitting over one day. Now it takes me two days. During this time, I don't make any changes in the book. I jot down notes on a sheet of paper as I recognize weaknesses, repetitions, places where the story is not clear, places where a character does not emerge well, moments where the writing gets purple, moments where— as the Brits say—I may have gone O.T.T. (over the top). I'm looking for a way to improve my novel during this read-through. I don't assume that I've just written the greatest story every told.

If I'm honest with myself and in touch with what my body is telling me, from this reading I'm able to get a sense of how to improve the book. So I sit down and write myself a nice little editorial letter, and in this letter I guide myself in the direction of what will become the second draft of the novel. Because I've done so much preliminary work, there's usually not a huge amount that has to be done at this stage. More often than not, I need to do a little more work to clarify issues between characters. Sometimes I have to work on a subplot. But mostly, what I'm trying to do in this part is to see where I can tighten up the structure of the book, improving its pace.

When I have this editorial letter done, I can do the second draft of the novel. This consists of working right on the hard copy: no scrolling up and down through pages and pages of electronic book now. I sit at my desk with the manuscript in front of me and I get my hands dirty with the actual pages. I delete, I add, I move, I cut and paste. If I need to create something longer than three handwritten pages, I may type it up. But what I don't do is start messing around with the pages on the computer itself. This will confuse me because the computer screen only allows me to see part of a single page at a time. I need to be able to leaf through many pages at once. That's how it works for me.

Thus, I create the second draft of the novel, this time at a rate of about fifty pages a day. When I have it done, I type in the changes and print up a new copy of the revised manuscript. I give it to a cold reader for an honest evaluation. The cold reader generally is a friend who is not a writer, who is a huge reader, and who is familiar with my work. Usually, I use someone from the public education system in California: either a teaching colleague from my days at El Toro High School or an administrator.

I don't let my cold reader just read the manuscript without guidance as to what I'm looking for in the way of criticism, however. Instead, I give the reader two documents that contain questions I would like to have answered. One set of questions consists of those items that I want the reader to be aware of *prior* to her reading of the manuscript, questions like "Does the setting emerge well?" The other set of questions I put in a sealed envelope for the reader to answer once she's actually completed her reading. These generally deal with the niggling doubts I have about plot or character or subplot or theme.

I don't want to influence my cold reader's reaction to the novel by letting her know what they are in advance, though.

When my cold reader has completed reading the novel in as quick a time as she can, she and I meet and talk about the book. If there are further changes that need to be made, that's when I make them. I generate a third draft from this meeting, and that's what I send to my editor.

So. You've read all this about my process and you're thinking, "This doesn't sound like much fun." You, after all, might really want to be an author, not a writer. You want to have your picture on the back of a book and you want to travel around signing autographs and giving speeches. You envision yourself talking to Katie Couric, Oprah, or one of the *60 Minutes* crew. You've been practicing your interview techniques, and you've been rehearsing what you'll say at all those conferences to which you'll be invited. For this, indeed, is the stuff of an author's life. It is not, however, the stuff of a writer's life. An author is what you become once you're published. For most writers, it's our least favorite part of the job.

Note that word. Job. That's it, you see. Writing is a job like any other. You succeed by virtue of working at it. Is it fun? Goodness no. Riding roller coasters is fun. Skiing is fun. Boogie boarding is fun. I don't require my profession to be fun. I require it to be satisfying. And, for me, writing is exactly that.

What I've learned is that for something to give me satisfaction, I must do it well. To do it well, I've developed a process that works for me. If you wish to do it well, you're going to have to have a process, too.

But you're going to have more than a process. That's what I would like to talk about next.

The Value of Bum Glue

This is the moment when faith is called for. Faith in the creative spirit within me, which is part of what I've been given by God; faith in the process; faith in my intelligence and my imagination. If I've managed to imagine these characters and this situation into being, doesn't it follow that I should also be able to imagine my way through to the end of the book? It seems so. Thus ... I suit up and show up. I sit down at the computer and I do the work, moving it forward a sentence at a time, which is ultimately the only way there is to write a book.

Journal of a Novel,
July 6, 1998

Australia's Bryce Courtenay, author of megaseller *The Power of One,* lists a number of rules of writing that one might follow should one wish to succeed. My favorite deals with the possession of bum glue: that which keeps one's bum (which is Aussie for butt) firmly attached to the chair in which one sits at the computer or the typewriter. Bryce argues that he who possesses the best bum glue wins. I don't disagree.

Here's my story.

My history is a very simple one: I always knew that I was supposed to be a writer, and I started the process of knowing this when I was seven years old. At this time I began making visits to the Mountain View Public Library, which, in the 1950s, was housed in an old storefront in the crumbling *pre*-pre-Silicon Valley days. Now downtown Mountain View is alive with restaurants, bars, coffee houses, bookstores, and Asian supermarkets. Back then, it was a sleepy little place with a great old meat market on one corner, a Purity Grocery with saw-

dust on the floor on another, and State Delicatessen somewhere in between, where they sold the best *pecorino romano* west of the Mississippi. On El Camino Real the Japanese owners of a canvas-sided, cement-floored green grocery called Green Haven would put a big scoop of peanuts in a bag for a nickel. Down the street Johnny Mack's served up pop music on chrome, tabletop jukeboxes along with french fries, hamburgers, and Cokes. McKelvey Field was where the boys played baseball when they weren't tormenting Freddie the Freak from Boulder Creek, who managed the place. The creek on Mountain View Avenue grew poison ivy and one magnificent California live oak, and once there was so much water in it from a storm that blew in, that it overflowed its banks right onto the road. We lived on Todd Street a short distance from that creek but we played everywhere because you could do that back then: kick-the-can at the Robertsons' house, grocery store at the Ryskiewiczes' house, hide-and-go-seek at the Larrieus' house, Simon says and tag at the Boltons' house. There was an abandoned garden on Dennis Lane where we played fort, and on hot summer days we rode our bikes to Los Altos, where we went swimming in the public pool.

But my favorite place was the library: dark, dusty, smelly, and not very well lit. Once I could read, my father drove me there regularly, and I checked out books that I would begin the moment we returned to the old green Dodge for the drive home. Sometimes I'd have the first of them read before we got there. But that was okay because I had a stack of them. The following week, I'd have another.

More than anything, I loved to read. There wasn't much television in those days, and we didn't own a record player, let alone a stereo. For toys I had a couple of dolls, a bag of marbles, and a chalkboard, and when one of the neighbor kids was given the game Clue, my brother and I liked it so much that we made our own from cardboard and paper. We weren't allowed pets, and the only team sport in those days was Little League, which my brother couldn't play because he'd been shot in the eye with an arrow when he was six, so his depth perception was destroyed. Summer days we played with the neighborhood kids, known as the Todd Street Gang. The rest of the time we went to school. For entertainment we mostly read.

On Christmas Eve every year, we were allowed to open one present apiece, and my mom always guided us toward the books that were

wrapped, waiting under the tree. She knew that once we unwrapped the biography of Clara Barton or Thomas Edison or Stephen Foster, we would be set for the rest of the evening, out of her hair, no longer bugging her to let us "just open one more, Mom, *please . . .*"

Thus, I was more or less conditioned to the writing life through exposure, straitened financial circumstances, and the encouragement of my parents. My dad was a great reader as well, and he shared his love of the written word with my brother and me from the very first. So I gravitated to writing quite naturally. When it came time to write in school for my teachers, I never found the activity a chore.

I turned to creative writing almost as soon as I knew how to put letters together to form words. I began with short stories, and they were pretty much what you would expect a seven-year-old to write. In them, large families went off to visit Grandma for one celebration or another, and through them I imagined into existence all the relatives that I had been denied through my father's insistence that our small family of four move several thousand miles away from the large Italian clan into which my mother had been born and had lived till she was thirty-five.

When I was twelve years old and in seventh grade, I wrote my first novel, a Nancy Drew type of story that, as I recall, was titled *The Mystery of Horseshoe Lake.* We lived in Chico, California, at that time, and Horseshoe Lake actually existed, up in the higher reaches of Bidwell Park. A neighbor girl and I would ride our bikes there and go out into the lake on rafts. We'd deliberately fall off the rafts into the water, fully clothed, and one time—although I never told my mother—we nearly drowned when we had trouble climbing back up the slick curved wooden side of our little craft. But Horseshoe Lake provided me with the inspiration for my tale of counterfeiting and intrigue, and my heroine, Cathy Longheart, solved the case with all the aplomb of a Nancy Drew. Like a character from the life of my dreams, she, too, came from a complicated family situation in which her best friend, Pauline, was also her aunt, the much younger sister of her neurosurgeon father.

Having finished that book, I went on to short stories, and I wrote a slew of them in my first years in high school. They all took place in England, and they involved quite a cast of characters: a crippled chemical engineer, his American wife, his best friend who was fabulously wealthy—old money, I presume—his wife and his brother—who was a

multitalented artist—and *another* friend and *his* wife. I knew nothing about England except that I liked to read about it myself, and that was good enough for me.

Midway through high school, I wrote my second novel, a book that I called *The Glass Pillar.* That project took me two years, during which time I also created the worst poetry ever written by a seriously depressed and angst-ridden teenager.

I won the award for English when I graduated from grammar school and the award for senior English when I graduated from high school. I received A's on my essays and lots of encouragement. My mom gave me her old Remington 1930s typewriter and then, when they could afford it, a portable Smith Corona. All signs pointed to the writing life. But I took a different direction.

I've always been fairly low key and self-effacing. I consider talking about myself or my success something akin to pulling down my pants in public. I come by these qualities honestly, however: Throughout my life I lacked confidence, I doubted my talent (even writing that word *talent* gives me the willies), and I feared rejection. When I started college, I decided to major in psychology (I think everyone decides that initially), then I switched to Spanish (for which I have no facility whatsoever) and ultimately to English because in English classes I could read novels and plays, which was what I loved to do. During this time I continued to write—short stories, mostly—but I showed them to no one. Instead, I avoided creative writing classes (save for two that I took at Foothill Community College in the late sixties) and instead went on to get my teaching credential in English and, later, my master's degree in counseling/psychology. As you can imagine, all of this took years. As you can no doubt diagnose, all of this also constituted an elaborate avoidance device. I call it the Divine Dance of Avoidance, and its steps are defined by the following truths: One cannot simultaneously teach English at the high school level and write novels, since teaching English *well* at the high school level is generally a twelve-hour-a-day job. Also, one cannot write a novel while one is attempting to teach English at the high school level *and* work on one's master's degree in an unrelated field. Cannot be done.

So I was able to avoid my calling, desire, and need to write for a number of years. But there was a problem.

When I avoid something that I know I must do, I end up feeling guilty.

So every year as summer approached and I had ten weeks of free time, my anxiety level would begin to climb. I knew that I had two and a half months in which to write if I wished, and I was terrified to begin because I had a number of fears that I just did not want to face. The first was that, despite my love of language, I might have nothing to say. I additionally feared that I would not be able to plot a novel. Also, I worried that I couldn't bring a character to life for the readers as so many wonderful writers had done for me. I was terrified that instead of a novel, I would have only a paragraph once I actually began. Also, I have a tendency to be overly emotional as a reader, and I doubted my ability to move people as I had been moved over and over again. Finally, I worried that I would not be able to finish what I started, and I hated the thought of that because it was *failure* writ large.

Push came to shove in 1983 when my husband bought a state-of-the-art IBM PC on which to type his Ph.D. dissertation. He had no intention of paying some typist to do it when he could do it himself *and* end up with a computer for the same price. This moment constituted put-up-or-shut-up time for me. Here it was in my home: a piece of equipment that could, if I learned to use it, make my "life" as a writer much easier. I could write what I wanted and edit and cut and paste and just plain old play around with the machine. If a book came out of it, all the better.

I wanted to write, and when that computer arrived on 13th Street in Huntington Beach, I was faced with the simplest life question I've ever had to answer. I asked myself whether, on my deathbed, I wanted to sigh and say, "I could have written a novel" or "I wrote a novel." Believe me, the answer was simplicity itself.

I just couldn't live in avoidance any longer, so on June 28, 1983, I asked my husband how to set up a file that I could call *Simon*. He showed me how to do it, and for that summer we shared the IBM PC. On September 5 of that same year, I stood up, having completed the first draft of the first novel I'd written in nearly twenty years.

I expected to feel incredibly fulfilled as a result of this activity. I'd done what I set out to do: I'd written an English crime novel. I'd created Simon St. James, Lady Helen Clyde, Thomas Lynley, Deborah and Joseph Cotter. They'd journeyed up to Richmond in Yorkshire for a family party, with death and mayhem ensuing. I wrote it all from beginning to end: five hundred pages in a single summer. And what I felt was awful, grief-stricken, and empty. I discussed this odd reaction with my husband, who was always

the personification of solution-oriented. He recommended that I try to get the novel published, which was something I'd never considered.

So I began sending the novel out. Presciently, I'd titled it *Something to Hide*. That was pretty much the recommendation of those who read it, too. It was terrible. But I *was* lucky enough to get pulled off the slush pile at Charles Scribner's Sons and at Dial Press where first Suzanne Kirk and then Richard Marek read it. While they both rejected the novel, they were complimentary about my writing. Suzanne Kirk asked to see more when I had more. That was good enough for me.

In the summer of 1984, I wrote a second novel after returning from a trip to Cornwall with a girlfriend. I made some improvement in style and technique, and when the novel was done, I shipped it off to Suzanne Kirk, who promptly rejected it as well. At this point, I began looking for an agent, and when 1985 rolled around and I still wasn't published, I wrote a third novel that I called *A Great Deliverance*.

As I was writing that book, I felt certain that I finally had it: the story that would sell, the structure that moved the story along, and the twist that would fool the reader. I was so confident in what I was doing that I wrote the entire rough draft of the novel in three and a half weeks. When it was completed, with successive drafts improving the story, I sent it off to an agent. She sold it to Kate Miciak at Bantam Books, knowing that Kate was launching a hard-bound line of mysteries and striking while the iron of Kate's intention was hot.

A Great Deliverance more than any of my novels serves as a shining example of what high-quality bum glue can do for a writer. When I began it upon returning from a trip to Yorkshire, England, I had only forty-two days before I had to go back to El Toro High School and teach English for another year. I wanted to get the novel done in that time, so I wrote from eight to sixteen hours a day in order to accomplish it. Throughout this period, I tried to stay committed to the beliefs that had carried me through the two earlier discouraging experiences at novel writing:

1. That it's important to write what you *want* to write, not what you think is going to sell: I wanted to write a British crime novel in the tradition of the golden age of crime writing, the sort of novel that I myself liked to read, which I call the literary mystery.

2. That it's crucial for you to write to your passion, and my passion was and has always been England.

3. That it's important to write what interests you, and what interests me is human psychopathology and the particular psychopathology of the family.

When I began my series of English crime novels, what was hot was the romance novel. I didn't want to write that; I couldn't begin to see myself writing that. Instead, I wrote what I wanted to write, and I continue to do that to this day.

So bum glue is about commitment on every level: to the self, to the dream, and to the process. I like to believe that my novels serve as demonstrations of my commitment. My plots don't insult the reader's intelligence, and I try to construct them so that they have no holes. I attempt to create characters who are real, who demonstrate what William Faulkner called "the human heart in conflict," and I work to make these characters fully realized by examining every facet of their lives, their needs, their personalities, and their behaviors prior to writing a single word of the novel. I put a significant amount of effort into the creation of the setting so that the reader might have that sense of actually being there. Finally, I never pass a draft on to my editor until I'm satisfied that I've taken it as far as it can go without her feedback.

There are, naturally, consequences to making this sort of commitment. The writing life is one of extreme isolation, and for the person who needs the continual stimulation of other people, attempting this as a career is a choice fraught with anxiety, unmet needs, and frustration. Writing well also requires forced introspection. For people who've spent their lives avoiding their lives, creating believable characters who *aren't* doing the same thing is an enormous challenge. Additionally, characters have to feel something in order to be real, and if a writer can't feel anything herself, there's very little chance her characters are going to be able to feel anything. And if the characters don't feel anything, neither does the reader, who will soon abandon the story.

Committing yourself to writing is placing yourself in a highly exposed position. Once your novel is written and published, you are at the mercy of the critics, the readers, your fellow writers, your family,

your friends, and your former colleagues. It's truly a case of if-you-can't-stand-the-heat, and frequently the creation and publication of a novel become rife with stress and tension.

But there are benefits that arise from making the decision to write, too. In my case, I've been able to travel widely to promote the novels as well as to research them. This has offered me the opportunity to meet people I would never have met: fellow writers who are dear to my heart, readers who have been moved by my work, publishing teams who have believed I have the talent to write a novel, booksellers who have encouraged new readers. I've gained some recognition from what I do, and there have been a few fun perks: champagne and conversation with Kenneth Branagh and Emma Thompson one Sunday afternoon in their home in West Hampstead, dinner with Britain's former prime minister John Major and his wife one night not far from the American Embassy in London, lunch with former President Bush and his wife, and time spent with writers I deeply admire.

That kind of stuff is terrific, admittedly. Heady experiences for the girl from Holy Cross High School who went on fewer than ten dates during those four years of her life. But the biggest benefit, the one I treasure the most, has been gaining the relative peace of knowing I'm doing what I was meant to do. That outweighs all the rest, believe me.

I write because I was meant to write, I was called to write, I was told to write. I write because that's who I am.

Tidbits from Q & A

I move tentatively now. I'd like to speak loftily about my attempts to mold the characters and to reach great heights of wisdom when all I'm trying to do is to tell a story that holds together.

Journal of a Novel,
June 27, 1994

There are questions that readers and unpublished writers invariably ask when I'm doing a book signing or a public speaking event, and I'd like to answer in this format those questions that directly apply to my own writing or the writing life I lead.

The first question relates to my writing life, and people ask it when they want to know what the day of one particular writer actually looks like. I'm not quite sure why people ask this question, but I get it often enough to assume it must bear some relationship to developing one's process.

I write five days a week, every week when I'm creating the rough draft of a novel. When I get to second and third drafts, I generally write seven days a week. My day always begins the same: I get up around six o'clock, and after I feed the dog and take my vitamins (sorry you asked, aren't you?) I do my workout. I've learned that working out the first thing in the morning assists me in battling the depression that otherwise stalks me. I ride my exercycle for thirty minutes and then I weight train for thirty-five minutes. During the former, I also read from a daily meditation book followed by an inspirational book followed by the current novel that I happen to be reading. During the lat-

ter, I shamelessly watch *The Today Show*: Katie Couric's megawatt smile always cheers me no end.

After my workout, I meditate. I'm a rank beginner at this, so right now I only meditate for about ten minutes. I generally use an affirmation to keep my mind from straying. Sometimes it works; sometimes it does not.

I get to the computer in my study around eight-thirty or nine because I also have to organize my assistant's work for the day. When I sit down, however, I don't begin to write all at once. Instead, I read for about fifteen minutes in a great piece of literature. For my most recent novel, *A Place of Hiding,* I read *Sense and Sensibility* and then *Persuasion*— both by Jane Austen—during this time.

When I've completed that reading, I pick up my Journal of a Novel for the last novel that I wrote. For the last three or four novels, I've copied John Steinbeck's activity from *East of Eden,* and I've begun every day by writing in a journal, sometimes about the writing I'm doing, sometimes about what's on my mind at that moment. So for each novel I now write, I create a new journal entry, but before I do that, I read a day in the *last* Journal of a Novel for the previous novel. This allows me to see that, whatever I might be experiencing at the moment, I have experienced it and survived it before.

Once I've done that reading, I create my journal entry for the new Journal of a Novel, the one I'm creating as I write the current book. This may be a single paragraph; it may be a page or two. But I write it consistently because I know that later on, it will help me through whatever bad time I may encounter in the process.

Having made my journal entry, I am now ready to write. I consult my running plot outline, I review whatever scene I might have been in the middle of when I stopped yesterday, and then I move on. I write a minimum of five pages. Sometimes this is a huge struggle. Sometimes it's easy. But I always do it. I do it at home; I do it on the road. If ski season arrives and I'm in the middle of a novel, I get up early and write my five pages before I ski. If I'm on a book tour, I tell my publicist to make sure no day begins before ten A.M. so that I can get my writing done. Although this sounds compulsive (what else is new?), doing it allows me to stay *situated* in the novel. Thus, I don't have to go back

after a big vacation and try to figure out where the heck I am in the book. Because my novels are large, long, and complicated, knowing the story and where I'm heading and where I've been is critical.

There are times when I have my five pages done by eleven in the morning. This is grand. I then have the freedom either to write more or to play. Sometimes I have a lunch scheduled with a friend, so that's what I do. Sometimes I'm creating a scrapbook (one of my outside hobbies), so that's what I do. Sometimes I take my dog to the park. Sometimes I go to visit my brother. Sometimes I garden. I have regular appointments and meetings that I attend, so they're part of my free time, too.

I don't mind schedules. My sister-in-law once told me that if she had to live by a schedule, she'd just die. She loves spontaneity. Dinner is a moving target at her house. I've learned to take a cooler of food with me when I go to visit, because chances are good that there won't be a meal when I need one. Once she invited me, my fiancé, and my cousin Sue to Thanksgiving lunch . . . and finally got around to serving it at five-thirty in the afternoon.

I'm not like this. I'm my sister-in-law's polar opposite. I was a high school teacher for thirteen and a half years, and there's not much in life more rigorously scheduled than the life of a teacher . . . unless it's the life of a recruit in the army. But this is much to my benefit as a writer because the only way to succeed at the writing life is to be able to live according to a schedule that accommodates time to write. When Glenda—that's the sister-in-law—told me she'd just die if she had to live with a schedule, I replied that I would simply lose my mind if I *couldn't* live with one. This doesn't mean that there is no spontaneity in my life. It just happens during the time that I have scheduled for it!

People also like to ask about my favorite authors, and I always reply in the same way. I don't have favorite authors. I read up, looking for people whose work I admire, and I always buy certain authors in hard bound as soon as they have a book in print: John le Carré tops this list. Accompanying him are Ian McEwan, Graham Swift, John Irving, Margaret Atwood, Barbara Kingsolver, P. D. James, J. Wallis Martin, Martin Cruz Smith, Alice Hoffman, Pat Conroy, Gabriel García Márquez, T. Jefferson Parker, and Robert Crais, among others. If I had to name the single writer who had the biggest impact on me both as a

reader and as a writer myself, however, it would be the incomparable John Fowles. Author of *The Magus, The Collector, The French Lieutenant's Woman,* and other works, John Fowles was always *out* there, never writing the same book twice. He took big risks. Sometimes they paid off and sometimes they didn't. But the fact that he was always willing to put himself, through his work, in an exposed position is something that I deeply admire. His command of language is beyond anything I've ever seen.

My favorite book of all time, however, is *To Kill a Mockingbird* by Harper Lee. Perhaps this is because it was the first serious novel I ever read. I was about eleven years old when it was first published and it was given to my dad as a joke gift because a mockingbird had taken up residence in a tree outside my parents' bedroom and had kept my dad awake for weeks. A neighbor thought it would be an excellent joke to pick up a copy of this "how to" book for my dad. I read it shortly thereafter.

I've read *To Kill a Mockingbird* at least ten times since then. It never fails to move me. I consider it a perfect novel, a triumph of point of view and narrative voice. I have *never* read it without getting something new out of it. Perhaps when I cease getting something new, I'll stop rereading it. But I don't think that's going to happen.

The next question people have is the agent question. How, how, how? I got my first agent the old-fashioned way: I queried agents who represented crime writers. I believe I queried thirty before I got a nibble. My first nibble was from Lucy Kroll Agency, where, for about ten months, a woman called Kathe Telingator attempted to sell my first version of *A Suitable Vengeance.* She also tried *A Great Deliverance* once, but she and I parted ways after it was rejected by Suzanne Kirk at Charles Scribner's Sons. I then moved on to another agent I had queried, Deborah Schneider at what was then called John Farquharson Ltd., an arm of an agency in London, although I did not know it at the time. Deborah took on both of those books, selling *A Great Deliverance* immediately. She represented my first eight novels before I moved to William Morris Agency, where Robert Gottlieb took me on. When Robert started his own agency, I moved along with him to Trident Media. That's where I remain to this day.

People also like to ask me why I write British novels. The answer is

simple. I write British novels because I like Britain. Always have, probably always will. I like the landscape of Great Britain; I like the way in which it changes from one county to another. Lancashire looks nothing like Shropshire. Kent and Cornwall are completely different. Architecture changes, building materials change, walls change, fences change, flora change. Yet this is a very small group of countries: England, Scotland, and Wales. They could all probably fit cheek by jowl into California, and yet they are all completely different.

I like the history of Great Britain. I like its traditions, its literature, its sense of ceremony. I loathe its class system and snobbery, but that's not a problem because I can write about both and take potshots at them from afar. I like the way the country has changed . . . but has also remained unchanged. I love the fact that I can get in a car and drive to Bosworth Field where Richard III died, and it's still *there,* more than five hundred years (!) after the event. There's no Wal-Mart built there. There's no mini-mall with its obligatory Pizza Hut, dry cleaners, donut shop, KFC, and Starbucks. I can go to Alnwick Castle and know that Shakespeare's impetuous Harry Hotspur *walked* there just as I walk there six hundred years later. For me, you see, it's not a question of why I write about Great Britain. It's a question of why *everyone* doesn't write about Great Britain.

People also want to know what I think about writing critique groups. I belonged to one briefly, but I didn't use it much. I prefer now to use the services of a cold reader when the book is done. But if you're going to belong to a group, check it out carefully before you commit yourself to joining. If there's someone in there with an ax to grind, don't become a member. If the group isn't solution-oriented, just saying things like "I have a problem with X" (your character, your plot, your scene, or whatever) without proposing a solution to the problem or a way to approach developing a solution, just pass them by. If you don't feel good about the group dynamic, trust yourself and don't join up.

Clear your life of the things that keep you from doing the actual writing. If you are a habitual conference attendee, check that out. Be honest with yourself. Are you going because you truly believe there's more to learn? Are you going because you believe there's a magic connection to be made? Are you going to avoid writing altogether? Is conferencing actually *helping* you? I don't know the answer to these ques-

tions. Only you do. As for me, I never went to a conference until I had a book contract because I didn't even know they existed. I just sat home and wrote. Other authors—like *Where the Heart Is* author Billie Letts, and *The Joy Luck Club* author Amy Tan—got discovered at conferences. All I'm recommending is that you be truly honest with yourself about your attendance at these functions. If you note that they're beginning to cut into your writing time, it's the moment to circle the wagons.

Finally, people like to know what happened to my first attempt at the British crime novel, that book that was rejected by everyone. It stayed rejected. I went on from it to write another, having learned a great deal from that first adult experience of novel writing. I did not rewrite and rewrite and rewrite, hoping against hope that I could somehow "get it right." I'd created a group of compelling characters, and I wanted to see what was going to happen to them. There was only one way to do that, I'm afraid. I just had to keep writing in order to find out.

You do the same. Gather knowledge about the craft of writing. Immerse yourself in the art of it. Then write. Write yourself silly. Write yourself mad. Write yourself blind. Trust the excitement that builds within you when the idea is good and the writing is superb. You can do it, but that's the hell of it as well as the exultation of it.

You have to do it.

PART V

EXAMPLES AND
GUIDES

Gimme a Map, Please

Beginning a book is terrifying. I can see why some writers go from book to book at a pace that allows them virtually no time off. I don't want to live that way, and as a result, I have to face my demon fear each time I begin a novel. But Steinbeck faced it; Marquez continues to face it. If Nobel Prize winners can admit their fears, so can I.

Journal of a Novel,
June 1, 2001

Sometimes people feel insecure without a guide. They like rules and regulations. They experience that lost-at-sea sensation unless they have some sort of template to superimpose upon their idea, molding it till it fits a predetermined form. Sometimes, though, people just like to know all their options, and the purpose of this chapter is to put you in the picture about the options you have with regard to plot.

Please keep in mind that the only rule is there is no rule, and this is especially true when it comes to formats for plots. Try plotting out *Absalom! Absalom!* if you don't believe me. My guess is that the last thing William Faulkner worried about was how he was going to plot his story.

However, there *are* certain guidelines you can follow if you need the security of a pattern. And there is nothing wrong with having a set pattern if it gives you the kind of fallback position you need to keep writing in moments of pure despair. So I'm going to go over some plot structures for you. But you have to keep in mind that novel writing does not have to be confined to any of these.

THE SEVEN-STEP STORY LINE

This particular format breaks a novel down into seven distinguishable parts, which can be identified as the major structural components in a story.

The *hook* comes first, and as its name implies, its purpose is to snag the reader's attention by making him wonder what's going to happen in the unfolding story. As I noted earlier when I was discussing narrative hooks, this section of the novel needs to expose the reader to conflict, emotion, excitement, intrigue, suspense, mystery, sheer human interest, or human drama. If it doesn't do any of that directly, then it needs to stimulate in the reader the *anticipation* of one of those elements.

As the writer constructs the first section of the novel, introducing characters, creating or relating back to a primary event that interrupts the status quo of the main characters, she begins to address the conflicts in the story as she leads up to *plot point #1,* which can generally be found about a quarter of the way through the book. At this point in the story, ongoing events change in some way: Perhaps unexpected information is received; perhaps facts previously unknown come to light; perhaps a personal discovery is made or an agreement is reached; perhaps a new character shows up. But in any case, the result of the plot point is that the story pivots, suddenly propelled forward by whatever constituted the plot point. Sometimes a change of scene is involved, but even if that is not the case, reader interest is heightened as the story moves in a new direction, burdened with additional complications.

All of this—and the renewal of reader interest that it creates—leads up to the *midpoint,* which comes at the center of the story. At this spot in the novel, further information increases the intensity of the drama. Perhaps someone arrives unexpectedly; perhaps a character uncovers a threat; perhaps a death occurs; perhaps a divorce happens; perhaps a natural disaster hovers on the horizon. At any event, the reader's interest is once again heightened, and as a result, the story is propelled forward another time.

Plot point #2 completes the complication phase of the novel. There is nothing new to be added at this point and the only possible solution

to the crises that have occurred is an ineluctable journey to the climax of the novel. Either that, or the hero just gives up the ghost, which isn't likely to occur. Tensions should be at their highest point right now, and the protagonist must make a decision about what he's going to do to deal with the situation.

This is what happens in the *narrative climax*. The protagonist decides. The wife decides that leaving her cheating husband is the only answer. The detective decides upon a way to trap the killer. The widower decides to take a risk and leave his house for the first time in six months. The wheelchair victim decides to take an action that will alter his life forever. The decision involves risk: mental, physical, emotional, or psychological. But it's the only option left.

After the protagonist makes that decision, the highest point of the drama occurs in the *dramatic climax*. In action novels, this is the chase, the fight, the assault, the battle. In courtroom dramas, this might be the verdict, but it also might be the closing arguments, the revelation of the true guilty party, or the sentencing of the convicted. But during this part of the novel, the antagonist gets his punishment, and justice is meted out: whether it be psychological, physical, emotional, or poetic. According to the Greeks, the emotional peak of the story—for that's what the climax is—is supposed to lead to catharsis, an emotional release. Satisfaction is what we're looking for here: a reason to have read the story in the first place.

Finally, the last pieces of the story click into place in the *denouement*. If there are any loose ends, they are tied up now. Explanations are given; analyses are made. The story reaches its inevitable conclusion in a way that satisfies the reader's desire for logic in an illogical world.

THE HERO'S JOURNEY[1]

In his fine book *The Writer's Journey*, Chris Vogler offers Joseph Campbell's tried and true hero's journey as yet another way to consider plotting. This model divides a story into twelve parts that follow a pattern long established in Western mythology.

The story begins in the *ordinary world* of the hero. During this section of the tale, the writer establishes for the reader what the life of the protagonist is like prior to the primary event (that's my own term, not

Vogler's), which will alter his world forever and send him on the journey that is the story itself. The reader, in short, learns about the status quo of the hero.

Into this world comes *a call to adventure* in the form of something that alters the status quo. In *The Deep End of the Ocean,* for example, the protagonist's toddler son is kidnapped, altering her world forever. In *Pride and Prejudice,* Mr. Darcy shows up at the ball and Elizabeth sets her mind and heart against him. In *Rebecca,* Maxim de Winter suddenly proposes to the narrator. What's important to remember if you wish to use this pattern that Vogler sets out is that you don't have to be writing a suspense novel or a thriller in order to follow it.

When confronted with the call to adventure, the hero's first inclination is to *refuse the call.* Sometimes this refusal comes in the form of simple reluctance, a marked hesitation as the protagonist weighs the pros and cons of engagement. Sometimes this period is marked by outright and reasonable fear. In either case, the hero's initial unwillingness to become involved in the unfolding situation requires the intercession of another character for the story to move forward.

This is the *mentor,* the older person who prepares the protagonist for his or her journey into the unknown. There are obvious mentors in literature: Gandalf in *The Lord of the Rings* comes to mind at once. And there are less obvious ones: John le Carré's agent runner Joseph in *The Little Drummer Girl* is a particularly interesting use of the mentor. But in any case, the mentor serves as a source of inspiration or encouragement for the protagonist.

Thus, the hero sets out on his journey, and when he enters the world of the story, he is *crossing the first threshold,* which is the next stage. This constitutes his agreement to engage in the activities called for in the novel, and it's the point at which the story gets rolling, sometimes in actuality and sometimes metaphorically. Action is called for, and the protagonist declares himself just the person to take such action.

This leads him to *tests* in the form of challenges that he encounters on the way. During this time of tests, he makes friends who'll be his *allies* and he begins to understand the nature and identity of his *enemies.* He's gone from the world he understands to the new world of his adventure, and it is during this portion of the story that he learns

about the nature of the new world. Picture a child sent to a boarding school: The Harry Potter novels come to mind, and the events that illustrate how Harry comes to understand the world of his school of wizardry.

He learns important lessons along the way, and these eventually lead him into danger, which, in the hero's myth, is represented by the *approach to the inmost cave.* For the hero, this is a place of fear as well as danger. In an adventure story or a myth, the fear is of something physical and very real. But fears can also be deeply psychological. They can be metaphorical as well. Don't think of the inmost cave in strictly concrete terms. As with everything else in the hero's journey, it can be interpreted symbolically.

Encountering his worst fears or his biggest enemy, the protagonist faces an *ordeal.* He may confront the possibility of death, having to do actual battle with an enemy. Or it may simply be his blackest moment when, for example, he doesn't know if a relationship he values is going to survive a blow that has been dealt to it. In any event, this constitutes a moment of real suspense for the reader, as he wonders if the hero is going to prevail.

But, of course, in this particular kind of story, the hero *does* prevail, and like all good heroes who slay dragons and rescue princesses, he earns his *reward.* This might be the love of a good woman. It might be the resolution of a personal conflict with another character. It might be the realization that that which he was seeking is inherently without value. Or it might be an actual physical reward: like the sword in the stone that young Arthur grasps.

Having been rewarded, the protagonist is set up for *the road back,* which marks the point in the story at which the hero decides to return to the world that he left. But things are not going to be the same in that world because the hero is not the same person who left it in the first place. So the road back has its own dangers he must confront, even if, once again, those dangers are those of the mind or soul. In *Ordinary People,* for example, the road back for father and son is a road on which the mother will no longer be traveling. There is grief in this, even as there is joy in knowing that they have, at least, found each other.

The penultimate part of the hero's journey is *resurrection.* This is

generally that one last moment in which something occurs to test the solidity of what the hero has learned on his journey. The bad guy might make one final appearance (as happens so depressingly often in films where someone presumably dead rises up to attack the good guy one last time). The hero might confront his personal demons yet again but in a different way. In any case, surviving this final ordeal leads to the transformation of the protagonist. He has, in effect, been reborn through his experiences in the story.

Finally, he *returns with the elixir.* This is the lesson he learned from his adventure. Or it's the actual treasure he was seeking. Most often it's an abstract elixir: knowledge, compassion, love, or wisdom.

Both the seven-step story outline and the hero's journey are ways of looking at the plot through a succession of events. There are, additionally, diagrammatic ways of examining plot, and for the visual learner, these work well.

GUSTAV FREITAG'S PYRAMID

Oakley Hall describes this diagram in *The Art and Craft of Novel Writing.* Its appearance is an imperfect triangle that looks like this:

CLIMAX
Revelation
Recognition
(Crisis)

COMPLICATION DENOUEMENT
Deepening of oppositions Reappraisal
Intensification of tension Showdown
(The plot thickens)

SITUATION RESOLUTION
Relationships (Stability with
Compulsions change)[2]
Oppositions
Conflict
(Instability)

Looking at the diagram, you can see that in the initial stages of the novel, the writer's concern is with the art of establishing: She's setting up the relationships between the characters, as well as illustrating what they want in the novel (their compulsions, i.e., what is going to compel them to act). Conflicts come to light, placing the characters in opposition to one another. As a result, we have a situation of instability.

During the complication phase, the action rises. So do the tensions and the conflict among the characters as their wants, needs, and intentions begin to meet resistance from each other and from outside forces.

Things heat up for all of them, propelling them toward the climax. At this point, they're on overdrive and overload, and a crisis arises. A high point of the action ensues, and tensions are released.

This leads the novel into its denouement, the point at which a reappraisal is made of "life as we know it." Ultimately, all the changes undergone by the characters lead to resolution. But the situation is different for the characters now, because of the things that have happened to them all in the course of the novel.

THREE-ACT STRUCTURE

Both the seven-step story line and the hero's journey can be fit into the three-act structure of a novel. And all motion pictures are written following this format as well.

In act one, the status quo is established. As this is being done, the writer introduces her characters and begins to make clear their individual throughlines. The primary event occurs to disrupt the status quo; the conflict becomes clear, and the stakes are set. Act one concludes with the plot point that either charges up the action or reverses it in some way.

In act two, the action rises. Conflicts intensify and tension increases. Confrontations occur; crises happen. It is during act two that the climax of the novel develops and explodes into action.

The resolution takes place in act three. The act one status quo of the characters will never be quite what it was. Perhaps new alliances have been forged, new relationships committed to, new knowledge attained. But change is the order of the day.[3]

VARIATIONS

It's crucial to remember that there are no hard and fast rules. For example, you probably are seeking answers to unanswerable questions about length: How many pages do I have till I get to act two? How many pages till plot point #2? You're probably wanting the truth about structure: Can I have more than one climax? Can I create a completely false climax? (Well, it sure worked for Thomas Harris in *Red Dragon*.)

But if I could leave you with one truth to remember and to fall back on in moments of doubt, it would be this: There are no rules; there are only informed choices. But you can't *make* an informed choice if you remain uninformed.

Thus, it's wise to know that there are other plotting maps you can use in creating a novel.

The *double plot* uses an upstairs-downstairs approach.[4] On the one hand, you have the main plot, with characters who are the object of our main attention and sympathy. They are caught in a situation that is somewhat similar in circumstance or theme to characters who are in the subplot. John Fowles's *The French Lieutenant's Woman* is a good example of a double plot. On the one hand, we read about the love triangle of Charles Smithson, his fiancée Ernestina Freeman, and the enigmatic and eponymous Sarah Woodruff, who walks the Cobb and gazes out to sea, mourning—so the local legend goes—the French lieutenant who betrayed her. On the other hand, we have the love story of the servants Sam Farrow and his Mary. As we progress through the story, we see these two plots in contrast to each other, and we're treated to John Fowles's observations on everything from their lives to the prospect of their loves. We're always aware, however, that the major plot is that of Charles, Ernestina, and Sarah. But this would not have been the case had the author chosen a different construction.

The *hourglass plot* follows two sets of characters whose importance bears equal weight in the novel.[5] But unlike the double plot in which the two stories intermingle, in this particular structure the two plot-lines run separately like two parallel lines for a portion of the novel. Then they converge at one point, after which they separate again. Each plot can stand alone. Each is important. Our curiosity is piqued, and we wonder how and when we'll see the relationship between the two

plots. All the time we have the sense that we are heading inexorably toward a moment in time when clarity is achieved through convergence.

Finally, the *picaresque plot* shows a series of episodes in the lives of the main characters, and these episodes are not related to each other causally. They may be related thematically and they may be related by the identity of their actors. The essential ingredient, however, is adventure.[6] Even with an end in sight—such as the discovery of the Holy Grail—it's the journey that is the author's emphasis, not the ultimate destination.

All About Character

Creating characters is rough. I worry that I've already created these people before, in one book or another. I long for them to be different from everyone I've already created—different the way each human being is different—but when I write them, I wonder if I'm just going back to cover old ground.

Journal of a Novel,
June 6, 2001

As I promised earlier, this section of the book is going to give you examples from my own work, as well as helpful lists and prompt sheets that you can choose, if you wish, to stimulate your own creativity.

The character prompt sheet that follows is something that I use when I'm writing my character analyses. I use it only as a guide. I set it up next to my computer screen and I occasionally glance at it as I free write about the character. I *do not* fill in the prompt sheet. That would be useless activity. Single-word descriptions will never stimulate the right side of anyone's brain, and it's only through getting into the right side of the brain that I know I can be in full creative mode, allowing my stream-of-consciousness writing to tell me what each character is like. But I use the prompt sheet to remind me of things I might forget. I generally don't use every one of the categories on the sheet, by the way. They're merely devices to keep me going in my rapid, free-writing analysis about the character, like a psychiatrist, autobiographer, and analyst, you'll remember.

I'd recommend you do that same thing with this sheet. Type it up on a piece of paper or print it on a card. When you get to the stage of

your writing to create characters, just put it next to your workspace and give it a look now and then. Allow yourself the freedom of writing from the top of your head. Clear your mind right on the page if necessary. But give your characters a chance to tell you what part they're going to play in your novel. Believe me. They will.

CHARACTER PROMPT SHEET

[Use this as a prewriting activity to stimulate ideas for your written character analysis.]

Name:
Age:
Height:
Weight/Build:
Birthplace:
Color hair/eyes:
Physical peculiarities:
Educational background:
Sexuality:
Best friend:
Enemies:
Family (mother, father, siblings, etc.):
Core need:
Pathological maneuver:
Ambition in life:
Gestures when talking:
Gait:
Strongest character trait:
Weakest character trait:
Laughs or jeers at:
Philosophy:
Political leaning:
Hobbies:
What others notice first about him/her:
What character does alone:
One-line characterization (actual line from a narrative):

Will reader like/dislike character:
Does he/she change in story? How:

Significant event that molded the character:

Significant event that illustrates the character's personality:

Next, you'll find the actual analysis that I did of one of the main characters from In the Presence of the Enemy. Here's what I knew about Eve Bowen going into the analysis: I had written a novel called Missing Joseph about a good mother who commits a crime to protect her child. She was a decent person and a nurturing, loving, single parent. Having created her, I wanted to write a book about a woman who was her polar opposite, a woman who should never have had a child but who did so for political reasons. She would be the antithesis of that character from Missing Joseph. So I created Eve Bowen.

What follows, then, is the analysis of her character. I'm including it without a single correction so that you can see how I go about this process. You can see that I don't stop to find out if something I'm writing is true or even possible. Rather, when I get to that point, I simply make a note telling myself that I will have to find out and indicating a potential source of that information.

I consider the character analysis a bit of private conversation between me and myself and often I throw ideas up on the screen one after another until I get one that feels right for the character. I don't have any preconceived notions about a character when I begin unless that person is the killer, in which case I know I'm designing a killer, or unless I'm attempting to do something specific with a character, as I was with Eve Bowen when I decided to create Juliet Spence's antithesis.

Here, then, is the raw material of character: what I wrote about Eve Bowen long before she put in an appearance on the pages of my rough draft.

CHARACTERS

In a novel—yet unnamed—the theme of which is, at least for the time being, the price of hypocrisy.

EVELYN (EVE) BOWEN: Eve Bowen is the mother of the murder victim in the novel and one of the central characters. She is 40 years old and a member of Parliament for the fictional constituency of Marylebone. (See notes from Parliament visit for the boundaries of this constituency.) She is a member of the Conservative Party and a Parliamentary Private Secretary for the Secretary of State for Health (check this with Michael Fairbairn. . . . it may be that she has to be the PPS for a junior minister instead . . . or could she herself be a junior minister at her age?)

She was born in Canterbury and educated at St. Winifred's Grammar School in Kent. She is one of two children. Her older brother, a captain in the Army, was killed either in the Falklands or in the Gulf War. Her parents still live on the farm in Canterbury where Eve and her brother Jonathon grew up. Her father is a fruit and vegetable farmer to this day. Her mother is a farmwife and housewife. They are down-to-earth people who love the country and love the land. They have made their living off the land and they have never expected a single thing from the government. They instilled in their children a strong sense of "doing their part" which was always left rather nebulous in the minds of the kids. Jonathon interpreted it as going into the Army. Eve interpreted it as being self-supporting.

Although her parents wanted her to go to the University of Canterbury and hence be close to home, Eve felt that her mother was too controlling (as she

herself is) and too clinging (as she herself isn't).
Thus, she went to the University of Lancaster—in
part to get away from her family—where she read
politics.

Her relationship with her parents was a careful
one, perhaps best described as cautious. She always
felt they preferred Jonathon's sense of what it
meant to "do his part" to her sense of what it
meant. Their house, in fact, is filled with pictures
of Jonathon's military career, and neither of her
parents have been able to come to terms with their
grief over his death. He was 36 years old when he
died, engaged to be married to a woman who—in their
minds—far too quickly married someone else. Eve has
always felt judged by her parents and she has always
felt that she had to project a certain image for
them in order to gain their approval. The image she
projected—dutiful daughter, good student—was not
who Eve felt she was, but she grew rather used to
the persona: Good, solid, respectable, middle class,
self-starter, worker, team player, etc. Over time
the act became the reality and she convinced herself
that she actually was what she pretended to be.
That's the major quality about Eve: Pretence.

She started her career in journalism, working
for a newspaper in Manchester after she left uni-
versity. She moved to London when she was twenty-
six and became a political journalist. She knew
Dennis Luxford from the University of Lancaster
only because they wrote opposing columns in the uni-
versity newspaper and always took opposing posi-
tions in the debating society. She was not friends
with him—he considered her far too straight-laced
for his tastes. She had not maintained contact with
him—there was no reason to do so. And when she came
to London, she moved in a vastly different social



circle from his. She met up with him again at a Conservative Party Conference in Brighton. She was covering it for her newspaper. He was at that time deputy editor of his newspaper. He recognized her from the university and joined her for lunch one day. They had a sharp and witty conversation which attracted him to her. So it was at this conference that she had her fling with him and became pregnant. Neither of them was married at the time, and he was willing to marry her, but she already had political ambitions and with his leftwing leanings, he was a liability. Or perhaps he didn't want to marry her and while she didn't want to marry him either because of her future, she still hasn't forgiven him for not wanting to marry her. She knew that she couldn't have an abortion in her past if she was to win a conservative seat. So she had the baby. Luxford has always been aware of the child's existence but he respected Eve's decision to keep the child's paternity under wraps. Why? Maybe he was engaged? Maybe he was already married? Maybe he was relieved that she didn't want to marry him because he knew it wouldn't work out.

Eve's physical appearance: All the accents here are on tradition and conservatism. She is traditional in appearance, with a page-boy hairstyle that is easy to take care of, quite attractive, and not fussy looking. It frames her face smoothly and touches the tops of her reading glasses. These are tortoise-shell, and round like Mr. Peeper's glasses and they are her signature feature since she pops them on and off when she is speaking and uses them to gesture with. Her hair color is brown, the color of fallen beech leaves in late autumn. Her eyes are hazel. Her skin is extremely good and she looks about 32. Her only facial disfigurement—if it can

be called that—is a scar that runs through her
right eyebrow and another that creates a cica-
trix starburst from her right eye to her temple.
This scar is the result of an accident when she
was ten years old. She was playing with her
brother in the little conservatory that her
father attached to the farmhouse for his wife's
forty-fifth birthday. They were rough-housing
and Eve fell through one of the windows face
first. She harbors a grievance against her par-
ents for this, because she's always felt that
Jonathon wasn't blamed enough for what happened
to her. But this grievance, like all her other
grievances against her parents, she keeps buried
inside. Her parents don't know she feels these
grievances, but she takes her feelings out on
them in subtle ways: like forgetting a birthday
or failing to show up for a dinner or being
unavailable at Christmas, etc. She always has an
excuse for these little acts of punishment, how-
ever. When she was growing up, it was that she
had schoolwork, or she had to stay at the univer-
sity. When she came to London, it was a story she
had to pursue. When she became an MP, it was par-
liamentary business.

 Eve can't forgive injuries. That's her great-
est weakness. Once you're her enemy, you're her
enemy forever. Perhaps she feels enmity for Dennis
Luxford now, not because he wouldn't marry her
(because he was willing to do so) but because he
got her pregnant in the first place. Or possibly
for both.

 She is about five feet six inches tall. She exer-
cises at a gym early in the morning. She wears
makeup and wears it well, the sort of application
that ends up looking like she doesn't have any on in

the first place. She wears only a wedding band, a gold watch, and the same kind of earrings all the time: button types that match her outfits.

Her clothes are tailored. She always wears suits. Unlike some of the women in the House of Commons who seem to favor bright colors in order to make their presence felt, Eve determined from the first that her presence was going to be felt by virtue of its being her presence. So she wears grey, black, charcoal, or navy suits, either solid or pinstriped. Her blouses are generally tailored as well. If it rains, she has a black trenchcoat and an Aquascutum raincoat. She is always careful to buy English only, right down to her shoes. These are either pumps in solid colors for work, or high spiked heels for dressing up.

Her core need in life is to prove herself and to be seen as The Genuine Article. She is ambitious but the ambition is directed toward proving herself. The more she achieves, the more she can convince herself and others that she is what she appears to be. When she is thwarted, she becomes furious and vengeful. She believes that people should suffer for the injustices that they do to her, and she defines injustice as anything that keeps her from achieving her goals and proving herself as quickly as she would like to do. She is expert at getting back at people, mostly behind their backs. A little word there, a little innuendo there. She feels she is justified in this because these people did something unjust to her.

Her relationship with Alexander Stone is one in which she gets nurtured by Alex who is essentially a caretaking kind of personality. She loves Alex as much as she is capable of love, but she isn't good at expressing it and she also isn't good at receiv-

ing it. She married him because he is an asset to
her politically since he is a businessman who built
his business single-handedly from the ground up.

Sexually, Eve is usually distant. She finds
sex frightening and inside she labels her fright
"a reaction to a bestial and distasteful
encounter" but outside, she pretends otherwise.
She operates best sexually when she has had a few
drinks. She and Alex have regular sex because she
knows that they're supposed to. She has never had
an orgasm with Alex, but she has always faked it
because in her mind, real womanly women are sup-
posed to have orgasms. She wasn't overly sexual
as a student at the university. But it was there
that she had her first sexual experiences, just
with two young men in the time she was there and
both of them were boyfriends. With neither of
them did she reach orgasm. Dennis Luxford repre-
sents the only time she had sex with someone with
whom she wasn't involved. He also represents the
only time she had sex and enjoyed it. He brought
her to orgasm and perhaps she can't forgive him
for that—for that momentary loss of control—
either.

Of course the person she can't forgive the most
is herself: for having too many drinks, for getting
involved with Luxford, for enjoying the sex so that
she wanted to have—and did have—sex again with
him during that conference, for getting pregnant.
Perhaps she is such an overachiever because over-
achieving is the way she's going to be able to for-
give herself.

She is a fine chess player and she and Alex
always have a chess game in progress in their sit-
ting room. Sometimes they only have time to make one
move each a night. Charlotte has been punished

severely at least once for monkeying around with her
mother's chess board.

She also is a fine horsewoman and once rode dres-
sage (check this) in Kent. She has youthful photo-
graphs of this as well as ribbons and trophies.

What molded Eve into a person who felt she
had to prove herself is something that had to do
with Jonathon, her older brother. It would be a
situation in which she was asked by her mother
in exasperation: Why can't you be more like your
brother? Perhaps the mother volunteered both
children to do something for old people at a
pensioners' home or at a geriatric ward in a
hospital. Eve, with an aversion to old people, did
it once but was disgusted and refused to do it
again. Perhaps it was reading to them and she hated
the fact that you had to sit near them. Perhaps it
was taking baby farm animals in to see them. No, I
like reading to them. And maybe some old man felt
her up or better yet slipped her hand under his
covers to feel his erection and once that happened,
she didn't want to return but wouldn't tell her
mother why. This reading to the old folks was an
activity started by their church and Eve's mother
signed both kids up to do it, thinking it would be
good for them and it would be a way for them to "do
their part." Jonathon did his part obediently. Eve
didn't. Perhaps that was always the story of their
lives. Jonathon doing his part according to his par-
ents' wishes, Eve wanting to do her part according
to her own wishes. So what she's had to prove all
her life is that her decisions have been the right
ones even though they weren't the sort of decisions
Jonathon made.

Guilt is her underpinning. Guilt over the fact
that she was glad when Jonathon died. Guilt over the

fact that she doesn't love Lottie. Guilt over the
fact that Lottie dies.
 Ultimately she is undone in the novel. She loses
everything.

Recall that when I complete an analysis, I read through it and
highlight any part that I want especially to remember when I'm writ-
ing the rough draft. And I don't begin that rough draft, you will
remember, until I have all the characters created since so much of what
comes out when I *do* create them tells me about the story itself.

You will also recall that I try to give my characters either a job or a
sideline that gives the reader a hint as to who they are. A few years ago,
one of my writing students compiled a list of potential places of
employment for characters, and I've drawn upon this list more than
once in a pinch when I'm casting about for inspiration. Here it is.

Where People Work

Hospital	Bank	Trading card store
Morgue	Building supply	Teacher supply store
Newspaper	Sheriff's office	Martial arts
Adult bookstore	Telephone	supplies
Video store	Operator	Printer
Pet groomers	School	Upholstery
Car lot	Beauty salon	workroom
Car wash	Computer store	Interior decorator
Shoe repair	Doctor's office	Veterinarian
Drive-through dairy	Movie theater	Oil refinery
Hardware store	Stereo store	Farm
Library	Piano store	Water slides
Restaurant	Piano teacher	National park
Mechanic	Grocery store	Fire department
Price club	Food plant	Pawn shop
Dress shop	Pest control	Health spa
Lawyer's office	Truck driver	Cruise ship
Escrow office	Gas station	Airport

Accountant
Unemployment
 office
Air conditioning
 service
Insurance office
Plumber
Gardener
Flight training
 school
Antique dealer
Aquarium service
Art gallery
Auctioneer
USDA
Church
Ophthalmologist
Miniature doll
 houses
Stained glass
 manufacturer

Beauty supplies
Caterers
Industrial kitchen
Food lab
Crack house
Architect office
Recorder's office
Government
 office
Jeweler
Limousine driver
TV repair
Locksmith
Sporting goods store
Lamp repair
Analytical
 laboratory
Mobile screen
 repair
Garbage collector
Florist

Driving school
Computer training
 school
Beauty college
Friends of the Sea
Lion
Rescuing unwanted
 furry friends
Medieval times
 jouster
Carpet cleaner
Janitor of school
7-Eleven
Mobile library
Ice cream man
Hit man
Bodyguard
Lounge singer
Wigmaker
Telescope seller
Clockmaker

This is useful, but it's not all inclusive. Never turn up your nose at common resources you have right at hand: The Yellow Pages comes to mind at once. But so does travel in a car since from the windows of your vehicle, you have access all the time to telling details of sidelines or employment. In my novel *A Traitor to Memory*, the character Yasmin Edwards makes wigs for cancer victims and abused women simply because I was driving home along Pacific Coast Highway one day and I saw a wig shop in Newport Beach.

Finally, characters often need to engage in THADs. These are the previously described Talking Head Avoidance Devices, those elements of a scene that illustrate character or illuminate his state of mind at the same time as they obviate the possibility of a scene's becoming nothing more than he said/she said. Remember that a THAD is more than just window dressing. It should serve a greater purpose than pre-

senting the reader with a visual element during what would otherwise be only dialogue.

There is no limit to the THADs you can come up with. The only limit is your imagination.

But that's true of most of the phases of the novel-writing process. The key is to move past your fear and your internal editor and to let your mind roam where it will.

THAD

Eating a meal
Cooking a meal
Lifting weights
Playing darts, chess, etc.
Rowing
Gardening
Working on a car
Programming a VCR
Coloring hair
Changing a diaper
Electrolysis, bikini wax
Grocery shopping
Drinking
Mixing drinks
Feeding a child
Feeding a pet
Training a dog
Editing film
Grooming a horse
Doing laundry
Doing dishes
Robbing a liquor store

Learning how to ski
Washing windows
Putting on makeup
Building a campfire
Getting a tattoo
Casting a spell
Autopsy
Cleaning a swimming pool
Fishing
Massage
Buying a Coke from machine
Figuring out Xerox
Kids pimping for beer
Batting cage
Driving range
Rifle range
Moving
Rearranging furniture
Hanging pictures
Building a structure
Erector set, puzzle

Laying carpet
Sculpting
Changing sheets
Doing homework
Mowing a lawn
Applying suntan lotion
Window dressing
Getting a bee into a jar
Catching a lizard
Knitting
Rolling yarn
Playing video game
Trampoline
Washing a car
Examining stamps
Trying on shoes in a store
Developing film in dark room
Surgery
Wrapping a present
Putting a puzzle together

Standing in line
Beating a rug
Sweeping a floor
Shopping
Packing
Hiking

Cleaning a garage
 or attic
Interviewing for
 job
Getting sworn in
Voting

Rescuing someone
Posing for portrait
Going through
 photographs
Digging for clams
Killing ants

Turning Places into Settings

I've been giving myself a bad time about my writing lately because I don't write like Barbara Kingsolver or Alice Hoffman. Isn't that just about the most ridiculous thing on earth? I am so impressed with the way they render setting that I beat myself up because I start believing that I can't do likewise. I forget that people tell me how real I make a place. Indeed, I forget that people have actually gone to and recognized the sites that I use . . . Sheesh. I don't give myself an even break. Ever.

Journal of a Novel,
July 23, 2001

This is pretty obvious, but I'll say it nonetheless. A place is a location you visit when you're trying to decide where you want to set a specific scene in your novel or, for that matter, your novel in its entirety. It's a location you explore thoroughly once you've made your decision. After you have visited and explored it thoroughly, the location then transforms itself—through the magic of your words—into the setting of your masterwork.

Earlier, I told you how I research a setting: the advance reading, the selection of possible sites, the travel-and-tramp of the actual journey, the photographs and the tape-recorded commentary. I explained how I type up the daily commentary each night on my laptop, how I organize all of the photographs by category when I return home to California.

What I'd like to do now is to show you exactly how I've used a few of those photographs in the writing of the novel.

I've chosen some pictures from two of my books: *Missing Joseph* and *In*

Back End Barn, Lancashire, England.

the Presence of the Enemy. I set the first book in the month of January, which
was when I visited Lancashire, England, to do the location research for it.
I set the other book in late spring, although I researched it in the midst of
winter.

When I found Back End Barn, I was in the middle of the Lancashire
moors. I did not know the name of the place at the time (I found it
later on an ordnance survey map), and I had no idea how or even if I
would use it in the novel I intended to write. But the remoteness of
the location struck me: this old stone barn surrounded by the moors.

I could see it from the road, so I pulled over and hiked out to it. I
took several pictures out there in the wind and the cold, and I offer
two of them to you in this section of the book. I wasn't attempting
anything artistic. (Alas, I have very little talent with the camera,
although I wish that were not the case.) All I wanted to do was to
record the place so that if I indeed used it, I would have pictures from
which I could draw the necessary descriptions.

When I reached the climax of the novel, I found a use for Back
End Barn. The guilty party, Juliet Spence, is running from the police at
this point. I needed a location in which "the bang within the bang"
could occur. I got out my ordnance survey map and examined it. I saw

Back End Barn, Lancashire, England.

the notation for Back End Barn and I found the structure among my
photographs.

I needed to change the atmosphere of the day in question, since
my chase across the moors occurs in the snow. But that was the only
thing I changed. Otherwise the barn that I describe in the book and
the barn in the pictures are one and the same. So here is how it came
out in the novel.

They approached the road that connected High Bentham
and Winslough. The distance from Keasden to this crossroads
was a little over three miles. It had taken them nearly half an
hour to drive it.

They turned left—heading south in the direction of
Winslough. For the next half mile, they saw the occasional
lights from other houses, most of them set some considerable
distance off the road. The land was walled here, the wall itself
fast becoming just another white eruption from which indi-
vidual stones, like staggered peaks, still managed to break
through the snow. Then they were out on the moor again. No
wall or fence served as demarcation between the land and the

road. Only the tracks left by a heavy tractor showed them the way. In another half hour, they too would probably be obliterated.

The wind was whipping the snow into small, crystal cyclones. They built from the ground as well as from the air. They whirled in front of the car like ghostly dervishes and spun into the darkness again.

"Snow's letting up," Shepherd remarked. Lynley gave him a quick glance in which the other man obviously read the incredulity because he went on with, "It's just the wind now, blowing it about."

"That's bad enough."

But when he studied the view, Lynley could see that Shepherd was not merely acting the role of optimist. The snowfall was indeed diminishing. Much of what the wipers were sweeping away came from what was blowing off the moors, not falling from the sky. It gave little relief other than to make the promise that things weren't going to get much worse.

They crept along for another ten minutes with the wind whining like a dog outside. When their headlamps struck a gate that acted as a fence across the road, Shepherd spoke again.

"Here. The barn's to the right. Just beyond the wall."

Lynley peered through the windscreen. He saw nothing but eddies of snowflakes and darkness.

"Thirty yards from the road," Shepherd said. He shouldered open his door. "I'll have a look."

"You'll do what I tell you," Lynley said. "Stay where you are."

A muscle worked angrily in Shepherd's jaw. "She's got a gun, Inspector. If she's in there in the first place, she isn't likely to shoot at me. I can talk to her."

"You can do many things, none of which you're going to do right now."

"Have some sense! Let me—"

"You've done enough."

Lynley got out of the car. Constable Garrity and St. James

joined him. They directed their torches' beams across the snow and saw the stone wall rising in a perpendicular line from the road. They ran their beams along it and found the spot where its flow was interrupted by the red iron bars of a gate. Beyond the gate stood Back End Barn. It was stone and slate, with a large door to admit vehicles, a smaller door for their drivers. It looked due east, so the wind had blown the snow in large drifts against the barn's face. The drifts were smooth mounds against the larger barn door. Against the smaller, however, a single drift was partially trampled. A V-shaped dent ran through it. Fresh snow dusted its edges.

"By God, she made it," St. James said quietly.

"Someone did," Lynley replied. He looked over his shoulder. Shepherd, he saw, was out of the Range Rover although he was maintaining his position next to its door.

Lynley considered the options. They had the element of surprise but she had the weapon. He had little doubt that she would use it the moment he moved against her. Sending in Shepherd was, in truth, the only reasonable way to proceed. But he wasn't willing to risk anyone's life when there was a chance of getting her out without gunfire. She was, after all, an intelligent woman. She had run in the first place because she knew that the truth was a moment away from discovery. She couldn't hope to escape with Maggie and go unapprehended a second time in her life. The weather, her history, and every one of the odds were dead set against her.

"Inspector." Something was pressed into his hand. "You might want to use this." He looked down, saw that Constable Garrity had given him a loud hailer. "Part of the kit in the car," she said. She looked embarrassed as she tipped her head towards her vehicle and buttoned the neck of her coat against the wind. "Sergeant Hawkins says a DC's always got to know what might be needed at a crime scene or in an emergency. Shows initiative, he says. I've a rope as well. Life vests. The lot." Her eyes blinked solemnly behind the wet-streaked lenses of her spectacles.

"You're a godsend, Constable," Lynley said. "Thank you."

He raised the loud hailer. He looked at the barn. Not a sliver of light showed round either of the doors. There were no windows. If she was inside, she was sealed off completely.

What to say to her, he wondered. Which cinematic inanity would serve their purpose and bring her out? You're surrounded, you can't hope to escape, throw out the gun, come out with your hands up, we know you're inside . . .

"Mrs. Spence," he called. "You have a weapon with you. I don't. We're at an impasse. I'd like to get you and Maggie out of here without harm being done to anyone."

He waited. There was no sound from the barn. The wind hissed as it slid along three graduated tiers of stone projections that ran the length of the barn's north side.[1]

Having the photographs of the barn allowed me to deal in specifics: the structure's two doors, the wall leading up to it, the red gate closing it off. The photographs also gave me a sensory device I could use when, in the novel, the wind hits the three tiers of stone projections on the building's side. But more than anything, it gave me an opportunity to add to the novel's verisimilitude, and I took it gratefully, knowing it had paid off well to hike around the moors of Lancashire on one of the coldest days of the year.

Pendle Hill looms large in the history of Lancashire, which I had learned in my research of the area prior to traveling there, so I wanted to include a reference to it in the novel as well. Lancashire is witch country in England, and it was from the area immediately surrounding Pendle Hill that a number of women were rounded up, accused, and persecuted as witches in a circumstance not terribly unlike that which occurred in Salem, Massachusetts. I didn't want to make a big deal out of Pendle Hill, but I wanted it there.

I needed to see it first, of course. I found it on my trusty ordnance survey map and off I went in the car to check it out. Considering the amount of daylight which exists in the north of England in January—very little—and considering the weather, I didn't climb Pendle Hill. I merely photographed it in the distance and when it appeared in the novel—seen from the village of Downham—it acted as a simple backdrop to the action in the scene.

Pendle Hill, Lancashire, England.

I put it this way: "Pendle Hill's grey-green slopes hulked in the distance with fingers of frost curling down from the summit, but [St. James and Deborah] were not intent upon a hike towards this."[2] That's it. Odd how it works out, though. I had no more idea how much or how little of Pendle Hill I'd use in the novel than I knew Back End Barn would be the site of the climax. That's the serendipity of writing.

One spot I was fairly certain I'd use was Dunnow Hall, the abandoned home once built for a member of the distinguished King-Wilkinson family in Lancashire. I'd met John King-Wilkinson and interviewed him about life in Lancashire, and during our conversation he told me about a great house that had been built for one of his relatives but had never been lived in. He gave me its general location, and I set out to find it.

This proved to be no easy matter, since I went at it from the wrong direction and ended up hiking in the rain through a field in which sheep droppings steamed in the icy air. After a ten-minute trek, I saw the gray gables of a very large house in the distance, among some trees. With cameras slung over my shoulder, I climbed over a drystone wall and made my way to the abandoned structure. As soon as I set eyes on

Dunnow Hall, Lancashire, England.

it, I knew I would use it in the novel. No question about it. It screamed atmosphere.

Here, then, is how Dunnow Hall appeared in the novel, transformed to Cotes Hall and seen from the point of view of my detective, Thomas Lynley.

IN BEST VICTORIAN FASHION, COTES HALL was a structure that seemed to consist solely of weathervanes, chimneys, and gables from which bay and oriel windows reflected the ashen morning sky. It was built of limestone, and the combination of neglect and exposure to weather had caused the exterior to grow unappealingly lichenous, with streaks of grey-green descending from the roof in a pattern that resembled a vertical alluvial fan. The land that immediately surrounded the Hall had been taken over by weeds, and while it commanded an impressive view of the forest and the hills to its west and its east, the bleak winter landscape in conjunction with the property's general condition made the idea of living there more repellent than welcome.

Lynley eased the Bentley over the last of the ruts and into the courtyard round which the Hall loomed like the house of Usher. He gave a moment's thought to St. John Townley-Young's appearance at Crofters Inn on the previous night. On the way out he'd encountered his son-in-law plainly having a drink with a woman who was not his wife, and from Townley-Young's reaction it appeared that this was not the younger man's first such transgression. At the time, Lynley had thought that they'd unwittingly stumbled upon the motive behind the pranks at the Hall as well as the identity of the prankster. A woman who was the third point of a love-triangle might go to extreme lengths to disrupt the tranquillity and the marriage of a man she wanted for herself. However, as he ran his eyes from the Hall's rusting weathervanes to the great gaps in its rainpipes to the snarl of weeds and patches of damp where the base of the structure met the ground, Lynley was forced to admit that that had been a facile and largely chauvinistic conclusion. He, who didn't even have to face it, shuddered at the thought of having to live here. No matter the renovation inside, the exterior of the Hall, as well as its gardens and park, would take years of devoted labour to turn round. He couldn't blame anyone, wedded blissfully or otherwise, for trying to avoid it in whatever way he could.[3]

You can see, I hope, that I use the photo as a jumping-off point. To it I add details that will, I also hope, increase the visual experience for the reader. Cotes Hall, then, doesn't just sit there like a generic great house in England. It becomes real because it *is* real. I merely changed the name and added to what was already there just waiting for me to lift it from the landscape and put it into my book.

I used much the same technique when writing *In the Presence of the Enemy*, my kidnapping novel that takes place in London and Wiltshire. I knew essentially what I would have to find in the countryside—a place for the kidnapped child to be held as well as a place where her body would be found—but I didn't know where that place would be, and I was relying on my gut instinct to start shouting, "This is it!" when I saw the spot that was going to work.

Wilton Windmill,
Wiltshire, England.

As luck would have it—although I didn't know this at the time—
the first stop on my itinerary in Wiltshire turned out to be the spot
that I used. This was Wilton Windmill, and as you can see from the
photograph, I visited it on a very rainy day. I had made arrangements
in advance to be allowed inside, and a gentleman called A. E. Swaine
squired me around in my Wellingtons. We began outside with a walk
around its exterior and an explanation of its external working parts,
and then we went inside and climbed all over the structure. I took
photographs and recorded Mr. Swaine's explanations, gathering more
information than I ever used in the novel itself for the simple reason
that I didn't know at the time how much—if any—of the information
I would need.

In the opening of *In the Presence of the Enemy,* Charlotte Bowen awak-

ens in a cold, dark place. She doesn't know where she is and she remembers only snatches of what has gone before this moment. The reader is kept in the dark as well, because the last thing I want to do is to play my hand too soon, answering an essential dramatic question in such a way as to close instead of open the story. Later, when the appropriate moment comes for Constable Robin Payne to take Detective Sergeant Barbara Havers to what he has deduced is the site of Charlotte Bowen's captivity, it's appropriate to describe the place. The scene happens at night, so here is how Wilton Windmill appeared at night in my novel.

Robin slowed his Escort perhaps a half mile beyond this village. When he made a right turn, it was into a lane so narrow and overgrown that Barbara knew she would not have been able to distinguish it from the rest of the night-shrouded landscape had she been alone. This lane began to rise quickly towards the east, bound on one side by the glitter of wire fencing, bound on the other by a line of silver birches. The roadway was potted by craters. And the field beyond the fencing was knotted by weeds.

They came to a break in the birches, and Robin turned into it, onto a track that jostled them over boulders and through ruts. The trees were thick here but shaped by generations of wind; they loomed over the track like sailors bending into a storm.

The track ended at a fence of wire and posts. To their right, an old rail gate hung at an angle like a listing boat, and it was to this gate that Robin led Barbara, after rooting through the Escort's boot and bringing out a torch, which he handed over to her. He himself took out a camping lantern, slinging it over his arm and saying, "It's just this way."

This way led through the old gate, which Robin shoved forward roughly into a hillock of dried mud. The gate closed off a paddock in the middle of which a huge conical shape rose into the sky, looking in the darkness like a spaceship come to land. This structure was on the highest point of ground in the surrounding area, and field after field fell away from it into the black on three of its sides while on the fourth—perhaps fifty

yards in the distance—the shadowy form of a crumbling building near the road they'd driven in on gave testimony to a former dwelling.

The night was perfectly silent. A chill was in the air. The heavy smell of damp earth and sheep dung hung over them like a cloud about to burst. Barbara grimaced and wished she'd at least thought to bring a jacket to ward off the cold. The smell of the place she would have to endure.

They tramped across a heavy webbing of grass to get to the structure. As they did, Barbara raised her torch to shine against its exterior. She saw the bricks. They soared up into the darkness and were capped with an ice cream mound of white metal roof. Angling upwards and downwards from the circular eave of that roof were the splintery remains of four long wooden arms the length of which had once been covered by what looked like shutters. Now there were ragged gaps in the arms where storms had torn the shutters from their housings through the years, but enough of the original shape remained to make it instantly clear what she was looking at when Barbara shot her torchlight against it.

"Windmill," she said.

"For the wheat." Robin swung his unlit lantern out in a gesture that encompassed not only the sloping fields to the south, east, and west of where they stood, but also the unlit dwelling that hulked to the north of them, back near the road. He said, "Time was, there were flour mills along the River Bedwyn, before water was diverted to make the canal. When that happened, places like this sprang up and took over. They went great guns till there was factory roller milling. Now they're falling to ruin, if someone doesn't take an interest in saving them. This one's been vacant for a good ten years. The cottage as well. That's it back by the road."

"You know this place?"

"Oh, I do." He chuckled. "And every other place within twenty miles of home where a randy little bloke of seventeen used to take his favourite bird on a summer's night. It's part of growing up in the country, Barbara. Everyone knows where to

go if they want a bit of trouble. I'd expect the city is much the same, isn't it?"

She would hardly know. Neither spooning in the mooning nor snogging in the fogging had ever been among her regular pursuits. But she said, "Quite. Right."[4]

I made very few changes in the windmill. In fact, come to think of it, I'm not aware of having made any changes at all: It's in the same location as the real windmill; it's surrounded by the same fields, trees, and fences; its exterior is identical as is its interior. The only change I made is to make my windmill one not opened to the public.

Next, I needed a location for poor Charlotte's body to be found, and for this I chose the Kennet and Avon Canal. The site is suitably remote, and more important, it's utterly bleak. This would, I believed, be in keeping with the tone of the scene I would write.

From my ordnance survey map, I could see that a number of roads crisscrossed the countryside in the general location of the canal. I could also tell from this same map which of the roads spanned the canal as well. I set out in the morning, then, to explore these roads. In the way of all things in the English countryside, I found myself on narrow lanes the width of a tractor. In the case of the lane I ultimately chose, it became reduced to two tire tracks as it approached the arched bridge that you see in the picture.

I found a spot to park when I got to the bridge and saw the narrow canal beneath it. As soon as I looked around, I knew that this site would perfectly suit my needs. I crossed over the bridge and found the wide footpath that you can see in the picture. I did my usual thing with camera and tape recorder, giving myself as much information as I could. I wasn't yet sure exactly where Charlotte's body would be found in this location, so I photographed it from every possible angle, including from beneath the bridge itself. I took note of what lay in the fields all around me, and when I returned to the main road, I stopped to photograph a minuscule hamlet that was the nearest human habitation to the narrow body of water.

When it came time to write the scene in which the body is discovered, I went at it three different ways before I found the one I liked: First, I tried the scene through the point of view of the young couple

Kennet and Avon Canal, Wiltshire, England.

who actually stumble upon the body. In their haste to moor the narrow boat they've rented for their honeymoon—so as to enjoy a few pleasures of the flesh below deck—they glide to the bank, start to drive a stake into the soil to tie up, and thus stumble upon the body. The scene worked, but it was far too long. So I tried another approach with a home nurse out walking the dog of a man who has just died of AIDS. This was nice, too, but it was the same problem. It was too long, I thought. (I used that nurse in a later novel, by the way. She and the dog moved up to Derbyshire and discovered the body in *In Pursuit of the Proper Sinner,* proving that no effort is actually wasted, even when you cut it from a manuscript.) Finally, I settled on having the young and anxious detective constable getting the call to come to the murder site. It's his first, and he's understandably nervous. This is what it looks like in the book.

The hamlet of Allington lay in a curve of the road, like the knob of an elbow. It consisted of two farms whose houses, barns, and assorted outbuildings were the most significant structures in the area. A paddock served as the hamlet's boundary, and in it a herd of cows were lowing, their udders

swollen with milk. Robin skirted this paddock and cut through Manor Farm, where a harried-looking woman was shooing three children along the verge in the direction of a thatched, half-timbered house.

The lane DS Stanley had described to Robin was really just a track. It fronted two houses with red-tiled roofs and made a neat incision between the fields. Exactly the width of a tractor, it bore ruts from tyres and along its centre ran a vein of grass. Barbed-wire fencing on either side of the track served to enclose the fields, all of them cultivated and all of them verdant with approximately twelve inches' growth of wheat.

Robin's car lurched along the track, in and out of the ruts. It was more than a mile to the bridge. He babied the Escort along and hoped its suspension wasn't suffering any permanent damage from yet another exposure to a country thoroughfare.

Up ahead, he saw the track make the slight rise that indicated it was passing over the hump of the Allington Bridge. On either side of this bridge, vehicles were drawn over to the strip of white dead nettle that served as the verge. Three of them were panda cars. One was a van. The other was a blue Ariel Square-Four motorcycle, DS Stanley's preferred mode of transportation.

Robin pulled up behind one of the panda cars. To the west of the bridge, uniformed constables—of which group he'd so recently been a part—were pacing along either side of the canal, one set with eyes cast down upon the footpath edging the south bank of the canal, the other set meticulously making their way through the thick vegetation on the opposite side, five metres away. A photographer was just completing his work beyond a thick growth of reeds while the forensic pathologist waited patiently nearby, white gloves on his hands and black leather case at his feet. Aside from the clucking of mallards and teals who paddled on the canal, no one was making a sound. Robin wondered if this was a reverence for death or merely the concentration of professionals on the job. He pressed his palms against his trousers to rid his hands of the sweat of anticipation. He swal-

lowed, ordered his stomach to settle, and got out of the car to confront his first murder. Although no one had called it a murder yet, he reminded himself. All DS Stanley had said was "We've got a child's body," and whether it would be classified as a murder or not remained in the hands of the medical examiners.[5]

In this instance, I changed nothing. The site I'd seen was perfect in every way, and I never mess with something that's perfect.

Had I not continued my location research at that point—having not fully decided upon Wilton Windmill—I would have missed out on what turned out to be the location for the climax of the book. The plot itself was somewhat sketchy to me, since I had only the expanded story idea to work with. But I had a feeling someone else might get kidnapped and, anyway, I knew that there might be a better spot to hold Charlotte, so I continued on my way. For this reason, I discovered Old Wardour Castle out in the middle of nowhere, which I combined with Farleigh Hungerford Castle to come up with the spot where the second kidnap victim is held, where Sergeant Havers confronts the kidnapper, and where the climax of the novel plays out. I called the place Silbury Huish Castle, and I put it in as remote a location as Old Wardour Castle, adding to it the fascinating burial crypt that I'd seen in Farleigh Hungerford Castle.

In that latter location, three lead coffins sat behind a grille, a few inches off the floor on small stone plinths. A stone trough of water led through this crypt, probably an old draining system from another section of the castle. The crypt itself was accessible at one side of the castle's chapel. I just made it a little more accessible for purposes of my story.

When I wrote the book, then, this is how the two castles melded together into one.

Barbara manoeuvred her Mini to the edge of the track just outside the closed gate. She switched off the ignition and clambered out, keeping well to the left side of the track where the hillside rose, overgrown with trees and with shrubs. A sign on the gate identified the structure as Silbury Huish Castle. A secondary sign indicated that it was open to the public only on

the first Saturday of every month. Robin had chosen his loca-
tion well. The road was bad enough to deter most tourists
from wandering in, and even if they ventured this far on an
off-day, they'd be unlikely to risk trespass for the opportunity
of gazing upon what appeared to be little more than a ruin.
There were plenty of other ruins in the countryside, and those
far easier to get to than this one.

Ahead, Robin's Escort stopped near the castle's outer wall.
His headlamps made bright arcs against the stones for a
moment. Then they were extinguished. As Barbara crept for-
ward to the split-rail gate, she saw his shadowy form get out of
his car. He went to the boot and rustled round in it. He
removed one object that he set on the ground with a *clink*
against stone. A second object he held, and from it a bright cone
of light shot forth. A torch. He used it to light his way along the
castle wall. It was only a moment before he was out of sight.

Barbara hurried to the boot of her own car. She couldn't
risk a torch—one glance over his shoulder to see he was being
followed and Robin Payne would make her dead meat. But she
wasn't about to venture into and among those ruins without a
weapon of some sort. So she threw onto the ground the con-
tents of the Mini's boot, cursing herself for having used it for
so long as a receptacle for anything she had a mind to stow.
Buried beneath blankets, a pair of Wellingtons, assorted maga-
zines, and a bathing suit at least ten years old, she found the
tyre jack and its accompanying iron. She grabbed this latter.
She tested its weight in her hand. She smacked the curved end
of it sharply into her palm. It would have to do.

She set off after Robin. In his car he'd followed the track
to the castle. On foot, following the track wasn't necessary. She
cut across a stretch of open land. This was a vista that long ago
would have given the castle's inhabitants visual warning of a
coming attack, and Barbara kept this fact in mind as she
dashed across it. She moved in a crouch, knowing that the
moonlight that made her progress less difficult also made her
visible—if as a shadow only—to anyone who happened to look
her way.

She was making quick, easy, unimpeded progress when nature got in her way. She stumbled against a low shrub—it felt like a juniper—and unsettled a nest of birds. They shot up in front of her. Their *chack, chack, chack* bounced and echoed, it seemed, round every stone in the castle walls.

Barbara froze where she was. She waited, heart pounding. She made herself count to sixty, twice. When nothing stirred from the direction Robin had taken, Barbara set off again.

She reached his car without incident. She looked inside for the keys, praying to see them dangling from the ignition. They were gone. Well, it had been too much to hope for.

She followed the curve of the castle wall as he had done, picking up the pace now. She'd lost the time she'd intended to gain by avoiding the track. She needed to make up that time through any means. But stealth and silence were crucial. Aside from the tyre iron, the only other weapon she had was surprise.

Round the curve of the wall she came to the remains of the gatehouse. There was no longer a door attached to the old stones, merely an archway above which she could dimly see a worn coat of arms. She paused in an alcove created by the half-tumbled gatehouse wall, and she strained to listen. The birds had fallen silent. A night breeze susurrated the leaves on the trees that grew within the castle walls. But there was no sound of voice, footfall, or rustling clothes. And there was nothing to see except the two craggy towers raised towards the dark sky.

These contained the small oblong slits which would have shed sunlight on the spiral stone stairways within the towers. From these slits some defence of the castle could have been made as men-of-arms raced upward to the crenellated roof. From these slits also, dim light would have shone had Robin Payne chosen either of the towers in which to hold Leo Luxford hostage. But no light filtered from them. So Robin had to be somewhere in the building whose roof Barbara had noted some twenty yards from the farthest of the towers.

She could see this building as a shadowy form in the dim light. Between the gable-roofed structure and the archway where she stood in what felt like a teacup of darkness, there

was little enough to hide her. Once she ventured out of the gatehouse and beyond the trees and shrubs at the wall, there would be only the random heaps of foundation stones that marked the sites where once the living quarters of the castle had stood. Barbara studied these heaps of stones. It appeared to be ten yards to the first group where a right angle of rubble would give her protection.

She listened for movement and sound. There was nothing beyond the wind. She dashed for the stones.

Ten yards closer to the castle's remaining structure allowed her to see what it was. She could make out the arch of the Gothic lancet windows and she could see a finial at the apex of the roof sketched against the dusky sky. This was a cross. The building was a chapel.

Barbara glued her gaze to the lancet windows. She waited for a flicker of light from within. He had a torch. He couldn't be operating in total darkness. Surely in a moment he'd give himself away. But she saw nothing.

Her hand felt slick where it held the tyre iron. She rubbed it against her trousers. She studied the next stretch of open ground and made a second dash to a second heap of foundation stones.

Here she saw that a wall lower than the castle's outer walls had been built round the chapel. A small roofed gatehouse whose shape mirrored the chapel itself acted as shelter for the dark oblong of a wooden door. This door was closed. Another fifteen yards gaped between her position and the chapel's gatehouse, fifteen yards in which the only shelter was a bench from which tourists could admire what little remained of the mediaeval fortification. Barbara hurtled herself towards this bench. And from the bench she dashed to the chapel's outer wall.

She slithered along this wall, tyre iron gripped fiercely, scarcely allowing herself to breathe. Hugged to the stones, she gained the chapel's gatehouse. She stood, her back pressed to the wall, and listened. First, the wind. Then the sound of a jet far above. Then another sound. And closer. The scrape of metal on stone. Barbara's body quivered in reply.

She eased her way to the gate. She pressed her palm against it. It gave an inch, then another. She peered inside.

Directly in front of her, the chapel door was closed. And the lancet windows above it were as black and as sightless as before. But a stone path led round the side of the church and as Barbara slid within the gate, she saw the first glimmer of light coming from this direction. And that sound again. Metal on stone.

An unattended herbaceous border grew profusely along the outer wall that bounded the chapel's environs, overspreading the stone path with tendrils, with branches, with leaves, and with flowers. Here and there this overgrown border had been trampled, and observing this, Barbara was willing to bet that the trampling hadn't been done by some first-Saturday-of-the-month visitor who had risked his car's suspension by venturing out to this remote location.

She glided across the path to the chapel itself. She sidled along the rough stones of its external wall till she gained the corner. There, she paused. She listened. First she heard the wind again, a swelling and receding that rustled through the trees on the hillside nearby. Then the metal on stone, more sharply now. Then the voice.[6]

You can see from the following pictures that I've used the exterior of one castle and I've placed my castle in similar circumstances, adding the odd bush here and there where necessary. I include the growth of bushes just inside the far external wall of the structure, but once Sergeant Havers breaches that wall, I make a switch to the other castle. From that point on, I use the ground plan of Farleigh Hungerford Castle. What you see in the photographs are the entrance to the crypt and the crypt itself on the grounds of that castle. You'll note that no one is allowed into Farleigh Hungerford's crypt, but this was not the case in the imaginary castle I developed for *In the Presence of the Enemy*.

That, then, is what I always do when I'm creating a setting. I don't rely on my imagination alone because left to my own devices, I'm afraid I'd sink into either hopeless cliché or generic descriptions. Some people

Old Wardour Castle, Wiltshire, England.

*Old Wardour Castle,
Wiltshire, England.*

Entrance to the crypt, herbaceous border to the left. Farleigh Hungerford Castle.

Entrance to the crypt.
Farleigh Hungerford
Castle.

Crypt with lead coffins. Farleigh Hungerford Castle.

would argue that's okay by them: Everyone knows what you mean when you use the word *castle*, after all. But I remember how real actual locations have become for me in novels that I've loved. And then to actually see these places . . . What fascination there was in looking upon L. M. Montgomery's *real* Lake of Shining Waters! How amazing it was to climb Jane Austen's Box Hill! To walk on the Cobb at Lyme Regis, to see Granny's Steps, to experience the wild moors of Yorkshire and the atmosphere of Dartmoor . . . to see how an author has taken a spot that really exists and then made that spot equally vibrant for the reader . . . Reading doesn't get better than that. Neither does writing.

21

Final Words

I've completed twelve scenes in the running plot outline, so now I'm going to begin the rough draft. "This is it" is what my body and my mind are telling me. I'm excited but I'm also slightly anxious. I want the book to be a leap forward. More than that, I want the writing itself—the individual sentences and paragraphs—to be good. I want the style to be my own, and I want it to soar. I pray each day to access the God-given creativity within me to be able to write a book that deserves a good readership and has the potential to stand the test of time. That's all I really hope for. But it's a lot.

Journal of a Novel,
June 28, 2001

Here's what I tell my students on the first day when I teach one of my creative writing courses:

You *will* be published if you possess three qualities—talent, passion, and discipline.

You will *probably* be published if you possess two of the three qualities in either combination—either talent and discipline, or passion and discipline.

You will *likely* be published if you possess neither talent nor passion but still have discipline. Just go to the bookstore and pick up a few "notable" titles and you'll see what I mean.

But if all you possess is talent or passion, if all you possess is talent *and* passion, you will not be published. The likelihood is you will never be published. And if by some miracle you are published, it will probably never happen again.

Some of us are blessed with self-discipline, and I admit myself to

be one who is. It's something I inherited from my mother: that ability and willingness to do what needs to be done *first* and then to play later. A lot of writing is simply showing up. A lot of writing is being willing to show up day after day, same time and same place. A lot of writing is being able to put the work first simply because it *is* the work. A lot of writing is being able to delay gratification.

Lots of people want to have written; they don't want to write. In other words, they want to see their name on the front cover of a book and their grinning picture on the back. But this is what comes at the end of the job, not at the beginning. To reach that end, you have to be willing just to set it aside, knowing that it may never happen at all but not much caring because it's the writing that matters to you; it's the mystery and the magic of putting words on paper that are truly important. If you don't feel this way, then you want to be an author, not a writer.

Authors are those guys who hope to get rich quick with a big sale to a big publisher followed by a lucrative movie deal. They write the same novel over and over and they declare at the beginning of their careers that if they don't get published, they'll give it up.

Writers, on the other hand, are those guys who'd write anyway. They have to breathe, after all. They have to live.

~~~

# The Process in a Nutshell

*So much of writing is showing up. Sometimes I wonder if that's a message that people don't give themselves when they're trying to do a book. It's the consistency of being at the computer every working day, of not waiting for inspiration to come because it's not necessarily going to come in the way one might expect it. So much of inspiration rises—at least for me—from the act of writing in a stream of consciousness manner in the plot outline, which seems to get me in touch with a well of creativity that I'm not able to tap into in my everyday life. And I'm certainly not able to tap into it when I'm sitting around thinking about the book. It doesn't work that way for me at all.*

*Journal of a Novel,*
*June 25, 2001*

Some people like to have a quick and easy guide to refer to, and this chapter is for people like that. It takes my process and lists it for you, giving you additionally the relevant section of this book to look at if you decide to try it out.

Step One.
> The Idea (Chapter 4, Chapter 5, Chapter 15)
> The Expanded Idea (Chapter 5, Chapter 15)
> The Primary Event (Chapter 4)

Step Two.
> People the world of the expanded idea and the primary event
> (Chapter 5, Chapter 15)
> List characters generically (Chapter 5, Chapter 15)
> List characters specifically (Chapter 5, Chapter 15)

Step Three.
   Research (Chapter 15)

Step Four.
   Create characters (Chapter 1, Chapter 3, Chapter 5, Chapter 15,
   Chapter 19)

Step Five.
   Create Setting(s) (Chapter 2, Chapter 3, Chapter 15, Chapter 20)

Step Six.
   Step outline till there's nothing more to say (Chapter 6, Chapter 15)

Step Seven.
   Plot outline (Chapter 6, Chapter 7, Chapter 14, Chapter 15,
   Chapter 18)

Step Eight.
   Write the rough draft (Chapter 7, Chapter 8, Chapter 9, Chapter
   10, Chapter 11, Chapter 12, Chapter 13)

Step Nine.
   The fast reading (Chapter 15)

Step Ten.
   The editorial letter (Chapter 15)

Step Eleven.
   The second draft (Chapter 15)

Step Twelve.
   The cold reader (Chapter 15)

Step Thirteen.
   The third draft, if necessary (Chapter 15)

Step Fourteen.
   Celebrate. You've written a novel.

   Remember this. Not everyone can write a novel. In fact, very few
people can do it. But you might be one of them.
   There's only one way to find out.

*The writing. I'm approaching the end of the rewrite, so I'm scared. July seems so close. I have so much work to do. I'm feeling afraid. I'm feeling as if I don't have an adequate handle on the story. God knows that's the truth; I don't. But what I'm going to do is this: I'm going to move the novel forward by five pages every day. I'm going to believe that I'm doing what I was intended to do by God: to write. I'm going to believe that the words are there within me, the ideas are there within me. I'm going to believe that I'm fully capable of seeing this project through. I'm going to remember that I've always been afraid and I've always worked through the fear and past the fear, turning it into faith. There is a saying: "Courage is fear that has said its prayers." I do that daily, as I try to address myself to yet another project. Boy, is this a difficult way to make a living. It makes teaching look like a cakewalk. What is a cakewalk, by the way? I've always wondered. I think I'll look it up. Later.*

*Journal of a Novel,*
*November 4, 2001*

# Notes

Chapter 1. Story Is Character
   1. Anne Bernays and Pamela Painter, *What If? Writing Exercises for Fiction Writers* (New York: HarperCollins, 1990), p. 42.
   2. Harper Lee, *To Kill a Mockingbird* (New York: J. P. Lippincott, 1960), pp. 183–185.
   3. Toni Morrison, *Beloved* (New York: Alfred A. Knopf, 1987), pp. 3–5.

Chapter 2. Setting Is Story
   1. Elizabeth George, *For the Sake of Elena* (New York: Bantam Books, 1992), p. 313.
   2. Michael Dorris and Louise Erdrich, *The Crown of Columbus* (New York: HarperCollins, 1991), pp. 102–104.
   3. T. Jefferson Parker, *Laguna Heat* (New York: St. Martin's Press, 1985), pp. 93–95.
   4. Bernays and Painter, *What If?*, p. 45.
   5. Barbara Kingsolver, *The Bean Trees* (New York: Harper & Row, 1988), pp. 39–41.

Chapter 3. Nothing Without Landscape
   1. Martin Cruz Smith, *Rose* (New York: Random House, 1996), pp. 25–26.
   2. Michael Dorris, *A Yellow Raft in Blue Water* (New York: Warner Books, 1987), pp. 29–30.
   3. Elizabeth George, *Well-Schooled in Murder* (New York: Bantam Books, 1990), pp. 251–252.

Chapter 4. Plotting: "It Is the Cause, My Soul"
   1. Bernays and Painter, *What If?*, p. 97.

Chapter 6. Onward from Idea
   1. James N. Frey, *How to Write a Damn Good Novel* (New York: St. Martin's Press, 1987), p. 30.
   2. Ibid., pp. 33–34.
   3. Ibid., p. 36.

Chapter 7. The Start: Decisions, Decisions
    1. Robert Ferrigno, *The Horse Latitudes* (New York: William Morrow, 1990), p. 9.
    2. P. D. James, *A Taste for Death* (New York: Alfred A. Knopf, 1986), p. 3.
    3. Elizabeth George, *A Great Deliverance* (New York: Bantam Books, 1988), p. 1.
    4. William Shakespeare, *King Richard the Third*.
    5. Ferrigno, *The Horse Latitudes*, p. 9.
    6. Ken Follett, *The Key to Rebecca* (New York: New American Library), p. 3.

Chapter 8. As There Is Viewpoint, So Is There Voice
    1. Bernays and Painter, *What If?*, p. 59.
    2. Frey, *How to Write a Damn Good Novel*, pp. 98–99.
    3. Oakley Hall, *The Art and Craft of Novel Writing* (Cincinnati: Writer's Digest Books, 1989), p. 28.
    4. Ernest Hemingway, "Indian Camp," *The Enduring Hemingway* (New York: Charles Scribner's Sons, 1974), pp. 22–23.
    5. Stephen King, *The Dead Zone* (New York: Viking Press, 1979), pp. 356–358.
    6. Alice Hoffman, *Second Nature* (New York: G. P. Putnam's Sons, 1994), pp. 13–15.
    7. Susan Isaacs, *Shining Through* (New York: Harper & Row, 1988), p. 1.
    8. Martin Cruz Smith, *Havana Bay* (New York: Random House, 1999), pp. 1–2.
    9. Barbara Kingsolver, *The Poisonwood Bible* (New York: HarperCollins, 1998), p. 13.
    10. Ibid., p. 20.
    11. Ibid., p. 22.
    12. Elizabeth George, *A Traitor to Memory* (New York: Bantam Books, 2001), p. 17.
    13. Ibid., pp. 34–35.

Chapter 9. Voice: You Gotta Have 'Tude
    1. Elizabeth George, *Payment in Blood* (New York: Bantam Books, 1989), p. 258.
    2. George, *For the Sake of Elena*, pp. 310–311.
    3. James, *A Taste for Death*, p. 55.
    4. Dorris and Erdrich, *The Crown of Columbus*, pp. 251–252.
    5. Ibid., pp. 10–11.

Chapter 10. Dialogue: Speak the Speech, If You Will
    1. George, *For the Sake of Elena*, pp. 94–96.
    2. Hall, *The Art and Craft of Novel Writing*, p. 94.
    3. Dennis Lehane, *Mystic River* (New York: William Morrow, 2001), pp. 11–12.
    4. William Faulkner, *Light in August* (1932; 1970), pp. 15–16.
    5. Elizabeth George, *In the Presence of the Enemy* (New York: Bantam Books, 1996), pp. 210–211.

Chapter 11. Tricks of the Dialogue Trade
    1. George, *A Great Deliverance*, p. 56.
    2. Elizabeth George, *In Pursuit of the Proper Sinner* (New York: Bantam Books, 1999), pp. 271–273.
    3. E. M. Forster, *A Passage to India* (Orlando, Fla.: Harcourt Brace & Company, 1924; 1952), pp. 192–193.
    4. Bernays and Painter, *What If?*, p. 85.

Chapter 12. The Scene: Okay, So It *Is* Rocket Science

  1. Jim Harrison, "Revenge," *Legends of the Fall* (New York: Delacorte Press, 1978), pp. 3–6.

  2. Forster, *A Passage to India*, pp. 192–193.

  3. James, *A Taste for Death*, pp. 212–213.

  4. John Irving, *Cider House Rules* (New York: William Morrow, 1985), pp. 22–23.

  5. George, *Payment in Blood*, pp. 51–53.

  6. George, *For the Sake of Elena*, pp. 89–90.

  7. George, *In the Presence of the Enemy*, pp. 79–80.

  8. Elizabeth George, *A Suitable Vengeance* (New York: Bantam Books, 1991), pp. 311–313.

  9. George, *For the Sake of Elena*, pp. 13–14.

  10. Ibid., pp. 261–262.

  11. George, *Payment in Blood*, pp. 143–144.

Chapter 13. Knowledge Is Power, Technique Is Glory

  1. William Golding, *Lord of the Flies* (New York: G. P. Putnam's Sons, 1959), p. 25.

  2. Ibid., p. 142.

  3. Elizabeth George, *Deception on His Mind* (New York: Bantam Books, 1997), pp. 52–53.

  4. James, *A Taste for Death*, pp. 167–169.

Chapter 14. Loose Ends

  1. Ferrigno, *The Horse Latitudes*, p. 9.

Chapter 18. Gimme a Map, Please

  1. Chris Vogler, *The Writer's Journey* (Studio City, Cal., 1998), pp. 15–25.

  2. Hall, *The Art and Craft of Novel Writing*, p. 64.

  3. Ibid., p. 65.

  4. Ibid., p. 73.

  5. Ibid.

  6. Ibid.

Chapter 20. Turning Places into Settings

  1. Elizabeth George, *Missing Joseph* (New York: Bantam Books, 1993), pp. 475–477.

  2. Ibid., p. 288.

  3. Ibid., pp. 229–230.

  4. George, *In the Presence of the Enemy*, pp. 375–376.

  5. Ibid., pp. 187–188.

  6. Ibid., pp. 487–490.

# Index

# BOOKS BY ELIZABETH GEORGE

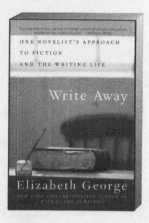

### WRITE AWAY
**One Novelist's Approach to Fiction and the Writing Life**

ISBN 0-06-056044-4 (paperback)

Elizabeth George offers would-be writers exactly what they need to know about how to construct a novel. She provides a detailed overview of the craft and gives helpful instruction on all elements of writing, from setting and plot to technique and process.

### A MOMENT ON THE EDGE
**100 Years of Crime Stories by Women**

ISBN 0-06-058821-7 (hardcover)

A stunning collection of 26 crime stories, selected by Elizabeth George, from some of the best practitioners of the genre, who also happen to be some of the most successful women writers of our time.

"From start to finish, a first-rate anthology."

—*Booklist*

NEW IN HARDCOVER

### WITH NO ONE AS WITNESS
ISBN 0-06-054560-7 (hardcover)

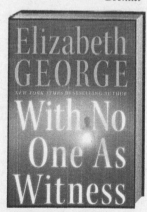

When an adolescent boy's nude body is found mutilated on the top of a tomb, it takes no large leap for the police to recognize the work of a clever killer, a psychopath who does not intend to be stopped. Detective Inspector Thomas Lynley is on the case.

ISBN 0-06-056330-3
(abridged audio CD)

ISBN 0-06-056329-X
(unabridged audio CD)

ISBN 0-06-075940-2
(large print)